₩₩₩₩₩₩₩₩₩₩₩₩ <7 W9-ARQ-519

A FOUNDATION COURSE IN DRAWING

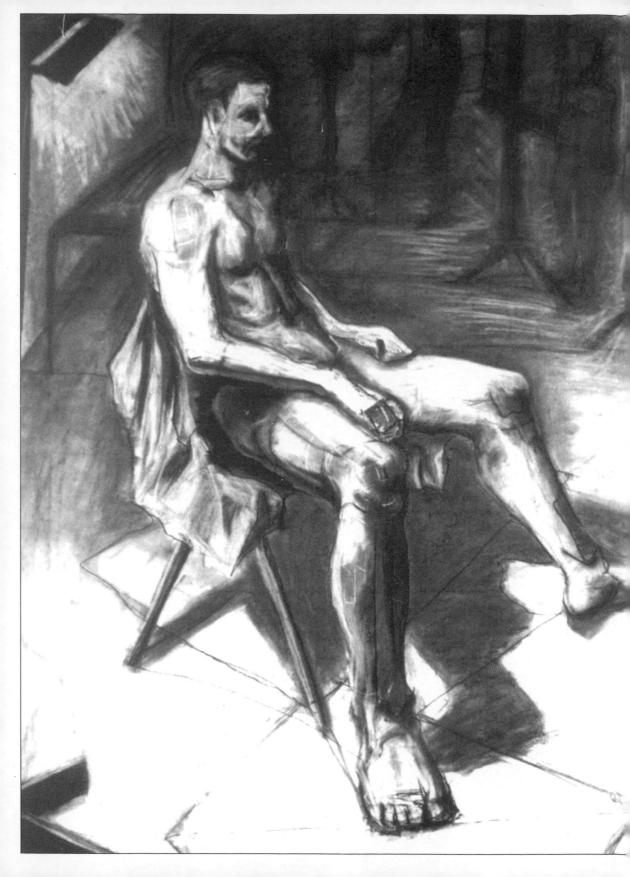

A FOUNDATION COURSE IN DRAWING

PETER STANYER & TERRY ROSENBERG

Watson-Guptill Publications/New York

© Arcturus Publishing Limited/P. Stanyer, T. Rosenberg

Text for Life Drawing, Abstract Drawing, and Drawing Systems: Terry Rosenberg Text for Still-Life Drawing and Landscape Drawing: Peter Stanyer

Design: Wilson Design Associates

ACKNOWLEDGEMENTS

The authors and publishers would like to thank the following students for lending drawings for reproduction in the book: Gaynor Baker, Liz Bernard, Rowena Blood, Paula Bodington, Philip Bodington, Jemima Broadbridge, Neil Carter, Francesca Cesati, Rebecca Evanson, Miriam Freitag, Tom Flint, Elaine French, Carl Grafham, Robert Grose, Jane Johnson, Ian Johnstone, Miriam Kelly, Sue Kennington, Jeremy Linton, Ken McCleod, Lisa Meaney, John Moussey, Deborah Pearse, Sylvia Pizzinnato, Iranwin Reece, Jenny Scott, Josephine Shepherd, Janet Sum, David Todd, Marco Toro, Debbie True, Ruth Weinstock; and thanks to all the students who donated drawings for possible inclusion.

Additional drawings by Peter Stanyer and Terry Rosenberg. Rembrandt etching reproduced by kind permission of the Rijksmuseum, Amsterdam. *Bathers, Asnières* by Georges Seurat reproduced by kind permission of the National Gallery, London.

The authors would like to thank London's City Literary Institute and the Chelsea School of Art and Design, where they teach many of these drawing programs.

First published in the United States in 1999 by Watson-Guptill Publications, a division of BPI Communications, Inc., 1515 Broadway, New York NY 10036

Library of Congress Catalog Card Number: 99-63740

ISBN 0-8230-1867-9

All rights reserved. No part of this publication may be reproduced or used in any form or by any means—graphic, electronic, or mechanical, including photocopying, recording, taping, or information storage and retrieval systems—without written permission of the publisher.

First published in the United Kingdom in 1996 by Arcturus Publishing Limited I–7 Shand St., London SEI 2ES Printed and bound in India This edition first printed, 1999

| 2 3 4 5 6 7 8 9/07 06 05 04 03 02 01 00 99

CONTENTS

INTRODUCTION	6
LIFE DRAWING	9
Introduction	10
Chapter 1: Hand, Eye, and Mind	12
Chapter 2: Through the Window	28
Chapter 3: A Progression of Tone	e 40
Chapter 4: Building Blocks	54
Chapter 5: Inside Out, Outside In	n 66
Chapter 6: Marking Time	77
Conclusion	88
STILL-LIFE DRAWING	89
Introduction	90
Chapter 1: Space and Light	92
Chapter 2: Texture	106
Chapter 3: Fundamental Form	117
Chapter 4: Drapery	132
Chapter 5: Objects in Space	144
Chapter 6: The Moving View	157
Conclusion	168
ABSTRACT DRAWING	169
Introduction	170
Chapter 1: Flat as a Pancake	172
Chapter 2: Making Space	184
Chapter 3: Finding Form	196
Chapter 4: Beyond the Look	211
Chapter 5: Associations	224
Chapter 6: On Your Marks	236
Conclusion	248

LANDSCAPE DRAWING	249
Introduction	250
Chapter 1: Preconceptions	252
Chapter 2: Landscape Textures	266
Chapter 3: Classical Space	281
Chapter 4: The Cityscape	292
Chapter 5: The Natural Landscape	304
Chapter 6: Expressionism	317
Conclusion	328
DRAWING SYSTEMS	329
Introduction	330
Chapter 1: Projection Systems	332
Chapter 2: Linear Perspective	344
Chapter 3: Perspective Grids	358
Chapter 4: Trimetric Projection	372
Chapter 5: Sciagraphy	382
Chapter 6: The Picture Plane	396
Conclusion	408

ost people draw at times, doodling on a phone pad, explaining a route, drawing an idea. Any time that we deliberately leave some kind of "trace," we draw. Drawings can be composed of any material–light, charcoal, lead, leaves, stones, air, and so on–both as "support" (the thing the drawing is laid on) and "trace" (the drawing itself).

Before beginning, ask yourself why you wish to draw. If you draw anyway, how can you improve? You may draw distractedly, to fill in time, or for some other reason. However, even in these drawings, you are drawing to express, represent, understand, show, or comment on yourself and the world.

We presume that in beginning this book, your purpose is to draw, and therefore that drawing must have a purpose for you. You may not be fully conscious of this purpose–indeed many people are often deliberately not so–but it is found both in the impetus to draw and in the fact of the drawing's existence. In addition, a drawing performs a social function–it is located on a wall in a frame, on a table at a building site, as a doodle on a pad–and its function governs the kind of drawing that is made.

A drawing is a product of perception. There is a link between the particular nature of picture perception and natural, everyday perceptual activity. Drawings convey information through a set of agreed-upon, nonarbitrary codes. However, these codes issue from our perceptual activities. There is a causal link between a depiction (drawing) and the real world. A drawing is also a product of the person presiding over the materials, who organizes it or them in particular ways to encompass and explain a perception and purpose, which may be in place in advance, discovered "in the process" of drawing, or understood only afterwards. The materials used and the means of production are part of the meaning of a drawing.

A drawing, therefore, has a purpose, is born and exists as a perception, and is produced. What we are trying to accomplish is the fusion or bonding of our purpose and our perception in the production of a drawing. We therefore need to attend to the three p's-purpose, perception, and production-in elaborating a curriculum for drawing.

A drawing is infused by the person drawing, speaks of itself and the culture of drawing, and reveals and is something of the world. We need also, then, to place our examination of the three p's against the context of the person drawing, the drawing itself, and the "something" represented in the drawing. It is with these fundamental concerns that we advance the projects that follow.

USING THE BOOK

The projects explore theories and practices in drawing for people of different ability levels. The course is divided into five distinct topics: life drawing, landscape, still life, abstraction, and drawing systems. Each topic is a discrete section and may be worked through independently of the other sections. Reading and drawing through each section, a chapter at a time, is one way of using the book. Alternatively, you could work through one chapter from each section in turn: reading Chapter 1 in each section, then Chaper 2 in each, and so on. By using the five sections simultaneously, and overlapping the subject matter of each in this way, you can proceed on a broad front.

What we present here has been derived from the experience of fifteen years' teaching in art schools in London. Rather than a single, absolute method for drawing, our series of projects and explanations attends to drawing as an act that reflects the complexity of human experience.

The book should be used as a companion, guide, and teacher in the place where you draw. But since we do not have the benefit of person-to-person communication with you, we also urge you to respond to something—a voice—beyond the words

7

of the book. Imagine the voice encouraging you to progress a drawing through that moment when it appears hopeless and you feel the only course open to you is to abandon it.

As you work through the projects, you are not only drawing, but also learning how to draw. Do not posit some other drawing as a goal for yourself and try to match it. You will only improve by addressing your own ideas and perceptions.

MATERIALS

Most of the projects in this book rely on the following standard drawing materials, all of which are available in art supply stores:

Pencils: You should have on hand grades 2H, HB, 2B, 3B, 4B, 5B, and 6B (*H* being harder and *B* being softer). If no specific grade of pencil is specified, use an HB pencil.

Conté chalk and crayons: *Conté chalk* is a compressed, crumbly material and *conté crayon* is a waxy, oil-based crayon.You will need sienna, black, and white colors of each.

Charcoal: except when otherwise specified, use *vine charcoal*, which comes as a flaky, dark brown/black stick. *Compressed charcoal* is denser and like chalk in texture. *Charcoal pencils* are charcoal-based pencils. **Pastels:** You should have both oil-based and non-oil-based crayons in shades of black and white.

Felt-tip pens: Use a black, medium-sized, water-based pen–nothing too heavy.

Ballpoint pens: Use only black ballpoint pens.

Erasers: Use either a *kneaded eraser* or a *plastic eraser*. The kneaded eraser is much more malleable and removes only softer markings, while the plastic eraser is used for removing darker and stronger marks. **Paper:** Unless otherwise specified, use drawing paper with a medium tooth. Some projects ask specifically for *newsprint paper*. This is a coarse, inexpensive, lightweight paper.

Drawing board and easel: Use a drawing board and easel that will allow you to work with 22- x 30-in or 30- x 44-in paper sizes.

Other Materials: Some projects require additional materials, such as glue, scissors, colored pencils, tracing paper, and so on. Be sure to review the materials list provided for each project before starting and make sure you have everything you need.

LIFE DRAWING

he life room is a peculiar place and life drawing is a bizarre activity. A group of people crowd round and draw a-usually naked-figure who they, more often than not, do not know. They try to wrest a likeness of the model by dint of effort and skill. However, often they do not reflect on the ways in which they are doing this or to what end. Before embarking on a program of life drawing, you need to ask yourself how and why you are doing it. Your answers to these two questions should qualify each other. How you draw is contingent on why you are drawing.

We do not dispute that life drawing is an important aspect of an art education, but if it is to be significant, it must extend into the rest of life and begin to touch upon things that matter to you. Otherwise it is an empty activity-the development of a skill with no purpose. It is necessary to point out the limitations of the life room so that you may eventually use the activity fruitfully. People bring many preconceptions to the figure. We tend to know it too well and in too many ways. We know the human body from within and without. This knowledge is essential for drawing, but if it isn't edited it can be inhibiting in both drawing and seeing. We need to find equivalents for our feelings, thoughts, and observations of the figure in the ways we see and depict it.

As we draw the human figure, we both reveal and hide ourselves, and it. We need to be aware of what it is we need to reveal. What is the occasion and purpose of the drawing? Is it a rite of magic, or worship? A reflection of the domestic or public figure? A figure to be venerated or hated? Further, how does it speak of drawing itself?

On the opposite page is a wonderful etching by Rembrandt. Its subject is life drawing. Rembrandt depicts himself seated, drawing.

Etching by Rembrandt of himself drawing the model.

Over his right shoulder a figure with quill and measuring staff watches over him. A muse? A spirit of drawing? In front of Rembrandt is a model, modestly clutching a drape hiding part of her body. She is the subject of his drawing, the object of his gaze. The quill of the muse is exaggerated in the palm that is in the model's space. In the background, on a ledge, a bust looks down on the proceedings, distanced but involved.

The etching looks unfinished, but is it? A number of different approaches to drawing are revealed: different speeds of drawing and looking; different perceptual attitudes; different truths.

The artist himself is realized through a flurry of marks (which we shall understand later in the book as gestural drawing); the muse and the model are realized more particularly in a line contour, and the bust through a progression of tone.

The idea that there is one true way of representing the figure is anathema. Human vision is complex, and a drawing cannot contain the full panoply of our perception. Drawing is something else, albeit causally linked to our perception. To draw, one needs to seek that which connects drawing to the real and to know that there is a space between "reality" and a drawing; and that this space is the space of invention.

Within the limits of this section, we aim to open up some of the possible ways of drawing the figure. These are, for the most part, approaches used in the Western tradition. There is much, still, that remains outside the section's domain, but we hope that it will lay the groundwork for future explorations. CHAPTER 1

HAND, EYE, AND MIND

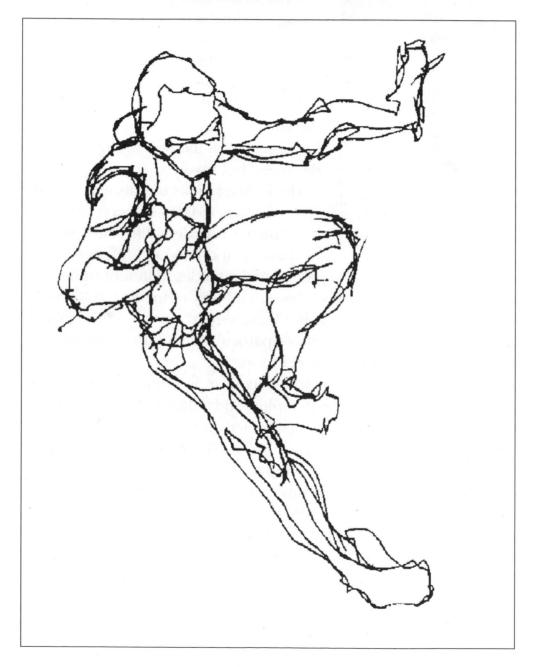

Before you start to draw, you will need to organize yourself, your equipment, and the model. It is important that you arrange the best possible situation in which to draw. Position yourself so that you can see the whole figure. Place your drawing paper on a firm board and fix it with clips, masking tape, or pins. Then position the board so that the look from the figure to the drawing involves just a slight turn of your head. Do not position the board in front of the figure or you'll have to move to see around it.

If you are using 22- x 30-in paper (which is recommended for the projects), it is best to stand at an easel. If an easel is not available you can make do, but try to stand far enough away from the drawing while you work so that you can see all or the greater part of it in one view. If this is impossible, keep moving back from the drawing to look at it from a distance. Also, try to organize your position so that the hand you draw with is the one furthest from the model. Your drawing arm will not then obstruct your view. See that the paper is at a good height: your eye line should be about one-third of the way down from the top of the paper. This will avoid the distortion, called *error of parallax*, that occurs when you look at a sheet of paper at an acute angle.

PRELIMINARY DRAWING

One twenty-minute drawing Materials: 22- x 30-in paper, pencil or charcoal

When you are ready, start on an undirected drawing of a figure. Imagine you are in a class situation and draw continuously for twenty minutes. Do not exceed the time allotted and do not renege on the drawing. When the twenty minutes are up, consider the following questions:

- What were you trying to convey in the drawing?
- What did you convey?

- What eluded you?
- Were there other ways in which you could have captured it?
- How were you drawing-in terms both of looking at the model and making the drawing?
- What would you have done differently if the drawing time were longer-six hours, say?
- What would you have done in five minutes?
- Would you take more care over the six-hour drawing? In what way? Would you make it more accurate? If so, what does that mean and why is it desirable? And how could it be achieved?

A drawing is a product of the time in which it is done, and its speed of production is part of its meaning, so the way you look and draw needs to be appropriate to the time you have. Keep the drawing you have done as a comparison for what comes later.

The projects in this chapter require you to place yourself in a number of unorthodox situations in your confrontation with both the model and your drawings in an attempt to encourage you to reflect on the mechanics and mechanisms of drawing–sense and motor-sense, looking and the process of looking, pencil and paper. The projects will also help you see drawing as an attempt to understand what it means to draw in terms of the optical, mental, and physical apparatus involved. It would be churlish not to admit that the projects are also an attempt to break down, or at least question, preconceptions and ingrained habits that you may have about drawing.

At the same time, these exercises are intended to be fun and should be approached in that spirit, because it is through lighthearted disruptions of our normal methods of drawing that we can open up new questions and opportunities. Please try to shed any restricting expectations, such as trying to match the look of another drawing. Drawing is a creative process; it is not the matching of something that already exists. To try to do so is affected and mannered and has no place in "real" drawing. Having said that, during the process of drawing you will experience times when what you have in the drawing does not accord with what you feel you should have. This is inherent in the creative act. Stick with it because it is essential to progress the drawing beyond these points. You will not know what is possible in a drawing unless you have a determination to push it beyond its sticky moments.

THE GESTURE

A gesture is an action that has significance-the gift of a bunch of flowers, or the movement of a pencil on a sheet of paper. In drawing, gesture is the action of the hand and drawing tool as they follow the movement of the eye while it scans the figure.

The activity of looking is selective and goal-directed: the eye darts over the field of vision, seeking and selecting pertinent features in the field and dovetailing these with the mind's means of making sense of them. The gestural drawing is one that follows the eye's search for meaning; it should be a quick search, seeing and placing the whole figure almost at once.

PROJECT 1

GESTURAL DRAWINGS

Three five-minute drawings

Materials: 22- x 30-in or newsprint paper, pencil Pose the model and draw with speed and pressure. Take a full five minutes for each drawing.

Use your 22- \times 30-in sheet of paper in landscape format so that you can get all three drawings on one sheet. Ask the model to take a different pose for each drawing, and try to get all or most of the figure on the page. Draw at a reasonable scale in relation to the size of the paper because fear for and of a drawing results in a reduction

in scale and timid marks on the paper. You need to approach this with confidence. After all, you are only risking the cost of a sheet of paper. Regard your hand as connected to your eye; do not fix your sight or pencil on detail, but work from the general to the specific. Let your pencil work through the drawing with a cursive line, swinging from top to bottom and side to side until the figure is drawn out.

> It is obvious from the illustrations that there is no recourse to outline. At times, when students try this type of drawing, they declare that they cannot see the lines they are drawing. That is the case with any type of drawing. This confusion arises from a tendency to confuse the drawing with the real world. The lines you are drawing should relate to the way in which you are looking. They should be infused with seeing, following the eye as it roves across the figure. In effect, this type of drawing is a scribble, but it is not an affectation or imposition. It relates directly to seeing.

Far left and this page: Gestural drawings

1

PROJECT 2 GESTURAL DRAWINGS

One three-minute drawing, one one-minute drawing, and one five-minute drawing

Materials: 22- x 30-in or newsprint paper, pencil

Do another three drawings, taking different lengths of time over each. The different times allocated for the three poses demonstrate the stages in seeing and depicting more obviously. It is important that the oneminute and five-minute drawings both capture the whole figure. Again, in these drawings you should move from the whole to the particular.

PROJECT 3 HAND-EYE COORDINATION

Two five-minute gestural drawings

Materials: 22- x 30-in or newsprint paper, pencil The approach in this project starts to break down any preconceived notions that you might have about how you want the drawing to turn out.

In these two drawings your eyes should be on the model continuously while you work. All the time that your pencil is moving, you should be looking at the model. Although this is difficult, try not to cheat. You can look at your drawing a couple of times, but not while your pencil is on the paper.

What we are attending to here is hand-eye coordination. When playing tennis, if you are to do it well, you watch and address the ball. You do not watch the racquet on its path to the ball. You know that your arm will act in accordance with information from the eye and instructions from the brain. The same type of sense is highly developed in most artists.

PROJECT 4

GESTURAL DRAWING-UNFAVORED HAND

Two five-minute drawings **Materials:** 22- x 30-in or newsprint paper, pencil

The movements of your favored hand are rooted in habit-from writing, work, or other kinds of drawing-whereas the unfavored hand will open up the creative, less predetermined side of drawing.

The drawings in this project are to be done with your unfavored hand. If you are left-handed, use your right hand, and if right-handed use your left hand. The lines made in these drawings will have an expressive quality lacking in drawings made with the favored hand, and this approach will help you develop an expressiveness that can only emerge when your intentioning faculties are suspended.

THE CONTINUOUS LINE

The continuous line is much as it sounds. The drawing is done continuously and at a constant speed without lifting the hand from the paper. Progress through the drawing rhythmically, continuously comparing the elements and features of the figure and setting to cach other. Here the line is produced more slowly than in a gestural drawing. Rather than being a scribble, the drawing looks as if it has been done with a length of wire. (You could consider realizing some of your completed continuous-line drawings in wire.)

PROJECT 5

CONTINUOUS-LINE DRAWING

Three five-minute drawings **Materials:** 22- x 30-in or newsprint paper; pencil, conté crayon, or charcoal pencil For each of these drawings, place your pencil on the paper and convince yourself that it is a particular point on the model. Move your eye and hand at a steady rate around the model, locating the features without looking at the drawing. You will have to move over areas without edges in your search, comparing and locating points in relation to each other as you go. The rough proportions of the figure will become established in this search.

PROJECT 6

HOLDING THE DRAWING IMPLEMENT

Three five-minute drawings

Materials: 22- x 30-in or newsprint paper; pencil, charcoal, felt-tip or ballpoint pen

The different movements of our bodies create different marks on paper, so we need to question further the actions involved in making a drawing. We can generate marks through movements of the fingers, or from the wrist, elbow, or shoulder, or even the whole body. Try all approaches, and you will find that each demands that you draw on a different scale and brings about a different type of expressiveness. The following exercises explore the different ways in which a drawing tool can be held and moved.

First, hold the drawing implement like a dagger being used in a crime of passion: in the palm of the hand with your fingers wrapped around it and the drawing point by your little finger. Draw for five minutes with a continuous line.

Then, hold the pencil between your thumb and index finger as far away from the drawing point as possible. Draw for five minutes.

Finally, do a drawing without using your hands-try holding the implement in your mouth (make sure you are not using charcoal!) or foot. Again, draw for five minutes.

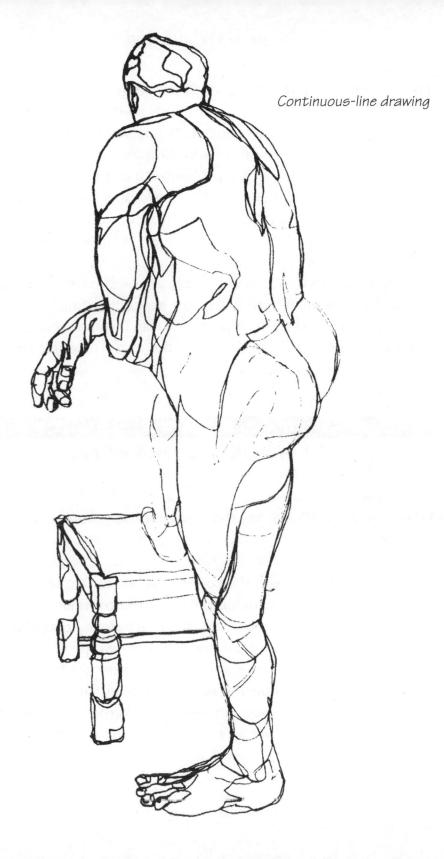

HAND, EYE, AND MIND

THE LINE DRAWING OR LINE CONTOUR

The line drawing or line contour needs to be done with a confident, incisive line. Do not use a feathered line-one that moves back on itself before proceeding again-as this type of line doesn't overcome any of the problems that it tries to overcome. It just reflects its own uncertainty. A line drawing requires confidence and arrogance on the part of the artist because you have to believe that you are going to get it right. (Your untutored drawing may have been an attempt at a line drawing.)

The question that you need to ask yourself while doing this type of drawing is: Where is the line actually going? The silhouette is a good starting point for this inquiry because it shows the edge that is made where the surface of the figure curves away, out of sight.

PROJECT 7

SILHOUETTE DRAWING

One ten-minute drawing

Materials: 22- x 30-in or newsprint paper; pencil, charcoal, or conté crayon; plastic eraser

This drawing has links with the continuous line in that the outside edges of the figure should be described with a continuous line, but one that is made more deliberately and more slowly than the continuous line as you used it in the previous two projects.

In a silhouette drawing, the line must not enter the form at any point, but you should draw the spaces between, for example, arm and body through which you can see the background-known as the *negative spaces*. You can use an eraser to correct mistakes.

HAND, EYE, AND MIND

PROJECT 8 POSTURE

Three three-minute drawings **Materials:** 22- x 30-in or newsprint paper; pencil, charcoal, or conté crayon; plastic eraser In this project, lines are used to capture the model's posture.

Posture lines have little to do with the silhouette, but instead record the way the pose is held, describing and accenting the angles made by and between different parts of the body: for example, the angles across the shoulders, down the middle of the body, across the top part of the body, along the limbs, across the brow, and down the middle of the face. The result is a drawing that looks a little like a stick figure.

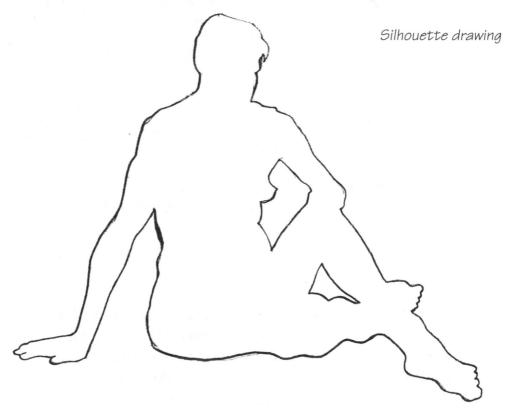

HAND, EYE, AND MIND

PROJECT 9 DISTILLING A LINE

Distilling a line

Three three-minute drawings

Materials: 22- x 30-in or newsprint paper; pencil, charcoal, or conté crayon; plastic eraser

To distill the pose to its essential lines, find one line to follow that describes the pose as fully as possible.

The line can move from the silhouette through the posture. This exercise is linked to the continuous-line drawing in that it runs from one edge to another across the form, using an opportune feature to do so. Then add two more lines to the first to give a clearer indication of the whole pose. The lines should have confidence and dynamism.

PROJECT 10

THE LINE OR LINE-CONTOUR DRAWING

Three twenty-minute drawings

Materials: 22- x 30-in paper, pencil or felt-tip pen Line can be used to describe the edge of a form, working with the line on the other side to encompass the whole form.

The silhouette drawing works if the lines around the figure continue across the masses they are describing so as to cup them. If a mime artist were to act out catching a ball, his two hands would work together to hold it. They would cup the ball, each hand forming a convex arc around the sphere of the ball. In a similar way, the line drawing seeks to describe the volume of the trunk, head and limbs by using the line and its inflection (the line on the other side of the form) to capture the form. However, it is a little more complex than

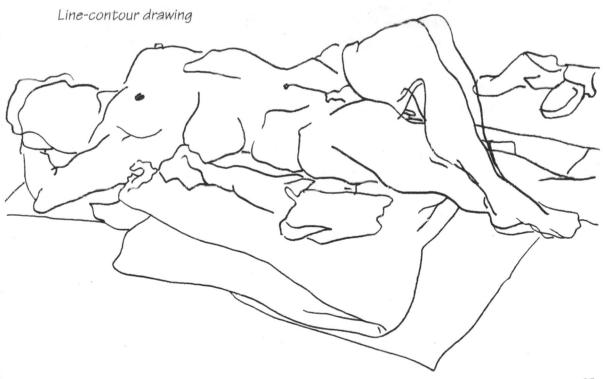

Bodybuilders seek to build their muscles up so that they are dramatically "cut"-the muscles are clearly defined through the skin. In using a line to describe a contour, you are bringing the line into the form to seek the edges of the volume of muscle or fat-in other words, using the "cut" of the form to describe how one volume sits in front of another. Make sure that the illusion of overlap works the right way to show which volume sits in front of which. that. The figure is not a puppet; the limbs, body, and head are not composed of simple, standard volumes (see Chapter 4, "Building Blocks," pages 54-65). Muscle, fat, and bone also need to be described. The drawing on the previous page shows how the line can break away from the silhouette and enter the form to seek such internal volumes. Using a line in this way, you can explore how one form sits in front of another.

Do three line-contour drawings with pencil or pen, spending twenty minutes on each one.

PROJECT 11

THE CONTINUOUS LINE AS A NET

Three fifteen-minute drawings **Materials:** 22- x 30-in paper, pencil

In these final drawings, you are going to revert to the continuous line and use it to lasso the environment and model with a fluid, roving line that moves around the whole arena of observation. Your eye, and the line, should seek to locate features and work out relationships freely and intuitively.

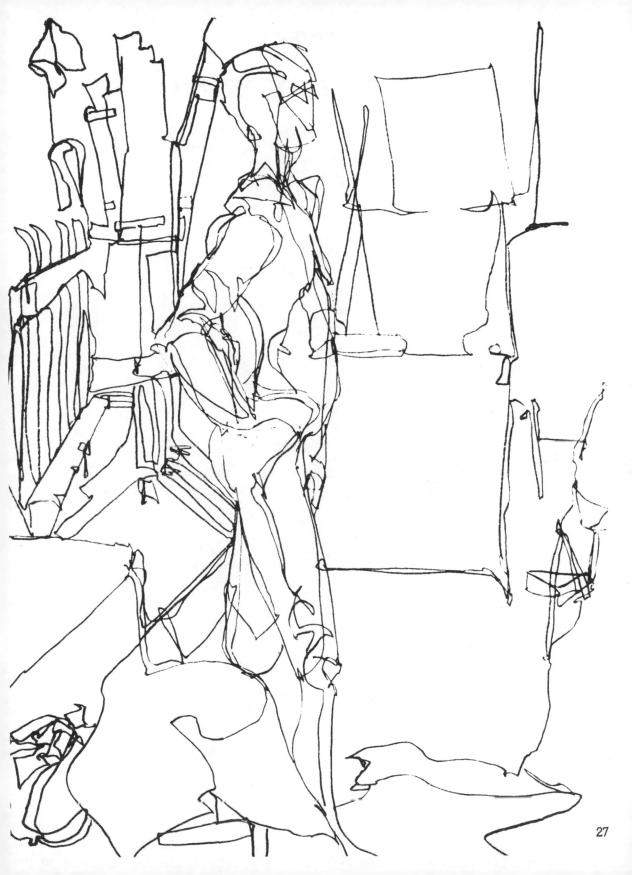

CHAPTER 2

THROUGH THE WINDOW

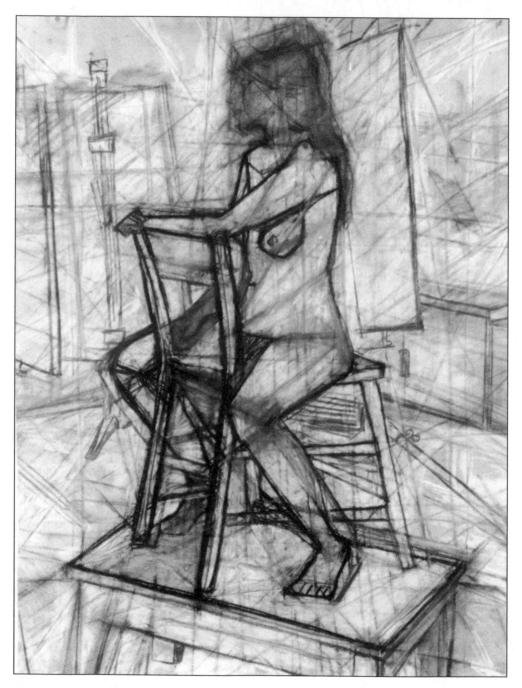

THROUGH THE WINDOW

In our attempts to understand the visual world, we note and organize categories of similarity and difference, seeking connections and relationships in the subjects we are looking at, apportioning relevance and meaning. So, in a drawing, what are these proportions that elude us and what methods are there for bringing them about?

In the projects in the previous chapter you were encouraged to draw with freedom, unencumbered by strict methods of measurement and mapping. Yet you *were* measuring, in the sense that your mind directed your eye to seek and organize the relationships between features and elements in the figure, and you sought to find equivalents for that search with your pencil on the paper. And as you become more practiced and experienced, you will be able to assess proportions more easily in this fluid way.

There is conceptual agreement on what is proportional. We know proportion to be a scale of comparison. But what is the scale against which we are calibrating the constituents in a drawing? Many different scales are used in different types of art. In the art of Ancient Egypt, the size of a figure was relative to his or her position in society. The pharoahs were drawn larger than their soldiers, noblemen larger than their slaves. Children's drawings exhibit another type of scale of importance. For the child, the face carries more information than the body. It is where identity and moods-the features of social intercourse that are most important to a child-are located. In a child's drawing, therefore, the face is given emphasis, and the body is diminished in size. Architects and designers may scale down actual sizes in their drawings to provide clearer instructions. Different cultures use different scales for the objects and elements in the world contingent on their viewpoint, the story, and the purpose of the

THROUGH THE WINDOW

drawing. All of these are valid and have specific uses in visual communication.

What we have unwittingly conformed to in the drawings in the previous chapter, and what we consciously buy into when we talk of correct proportion and measurement, is a system of seeing and depicting known as *linear* or *peephole perspective*, which was evolved as a theory by the Renaissance painter and architect Leon Battista Alberti (1404-72), and immediately taken up by other Renaissance artists, such as Filippo Brunelleschi (1377-1446). Linear perspective is a system for organizing the geometrical relationships of the three-dimensional world on a two-dimensional surface. Alberti equates the picture plane and the drawing surface with a window where a one-eyed, motionless artist mechanically observes and maps the petrified scene on the far side of the window onto the plane of the window-the picture plane.

In his notebooks, Leonardo da Vinci (1452-1519), describes a procedure for drawing that illustrates Alberti's theory:

"Have a piece of glass as large as a half sheet of royal folio paper and set this firmly in front of your eyes, that is between your eye and the thing you want to draw; then place yourself at a distance of ²/₃ of a braccio [a bracchio = approximately 1 yd/1m] from the glass, fixing your head with a machine in such a way that you cannot move at all. Then shut or cover one eye and with a brush or drawing chalk and draw upon the glass that which you see beyond it."

Put more simply, hold up a sheet of glass between you and the scene you wish to draw. Cover one eye and find a way to fix the relationship between your eye, the sheet of glass, and the scene by lining up specific points in the subject and the background. Then, keeping absolutely still, intercept the visual rays projected from the objects of your gaze onto the retina at the point where they pass through the sheet of glass. In other words, diligently trace what lies beyond the window.

If this is followed assiduously, there shouldn't be a problem in getting different features in proportion to one another. All that is needed is some kind of mechanism for holding all the relationships constant. In Leonardo's notebook, there is a sketch of an apparatus to help in this kind of drawing. In Albrecht Dürer's treatise, *On Measurement and Proportion* (1525), four drawing machines are illustrated. These were evolved to determine and fix relationships between the eye, the window, and the scene in a systematic way in order to locate and plot the lines projected from the scene to the eye on the sheet of glass.

During most of our drawing we do not have the luxury of a sheet of glass or other transparent surface onto which to trace the world; nor do we have an apparatus to hold all the relationships as fixed and allow us to plot them (although a rudimentary machine can be constructed). We therefore need to imagine Alberti's window lying between us and the scene, and find strategies and procedures for transferring what we see at this imagined window onto our opaque and unaligned sheet of paper. The three projects that follow describe three different procedures for analyzing the information at Alberti's window and transferring it onto the drawing support. They require a great deal of concentration and assiduous method.

The drawings in the previous chapter employed strategies to disrupt the part of our seeing that links itself to spoken and written language (controlled by the left hemisphere of the brain) and to tap into the less rational, more intuitive part of the brain (the right hemisphere). That is, they were designed to remove from your endeavors a literal way of seeing. Ultimately, however, drawing should not be limited by confining our thinking to one hemisphere or the other. It relies on both the intuitive *and* rational methods of approach. Some students have difficulties with the following exercises because they find the way of seeing and thinking that is demanded too methodical and too weighted in the left hemisphere of the brain. However, although you may never want to set about a drawing in such a systematic way again, the methods of determining proportion and position will nevertheless help in future drawings, and you can adapt the methods put forward here to suit your own ends.

METHODS OF ANALYSIS

In the following exercises you will try to extract the information observed at Alberti's window and transfer it onto the drawing paper. To do this, you need to take measurements and directions from the window. The straight line is the most appropriate means of fixing the relationship between two points because it is constant in both trajectory and length.

The best way to determine the angle between two points is to place a straight-edged instrument (a pencil or ruler will do) flat on the imagined plane of Alberti's window. Make sure it is flat on the imagined plane, not tilted into it in any way. Swing the straightedge between the two points to be assessed and then transfer the angled instrument to your picture. Hold the straightedge against the paper and draw the angle in the appropriate position. You can also find the angle by assessing it against an imaginary horizontal or vertical line.

To determine the length and position of elements in a picture, a predetermined unit of measurement is needed that can be used to read off measurements in the correct scale at the "window" and transfer them to the drawing. There are three ways in which this can be done. The windowframe itself can be used as a measuring device. The axes of measurement can be applied to the subject at the window and consequently to the drawing. Or the features of the figure and scene can be used as units of measurement.

PROJECT 1

USING A WINDOW-MOUNT AS A MEASURING DEVICE

One three-hour drawing **Materials:** 22- x 30-in paper, charcoal or pencil This exercise uses a rough piece of drawing apparatus to measure the angles in the model.

MAKING A WINDOW-MOUNT

Take a piece of card stock or stiff paper and cut a rectangle out of the center in the same proportions as your drawing paper.

Divide the inner edges of the rectangle into quarters and mark these divisions at the edge of the window with a pencil. If you wish, you can run a piece of thread between the appropriate divisions to set up a gridded window-mount. The window should not be too large or too small–10 in (25 cm) along the longest side is about right.

Compose the model, yourself, and your easel or drawing rest and fix your position in relation to the model's. Next, find your composition using the window-mount. Move the window-mount to the left and right, and backwards and forwards, until you have found the scene you wish to draw. Fix the window-mount in relation to yourself. Some students fix the frame to the top edge of their drawing board. If this isn't appropriate, hold the mount in your hand and make a mental note of the distance and position of your hand in relation to your eye. Close one eye and see how features in the scene align with the markings on the window-mount so that

THROUGH THE WINDOW

you can return the mount to the same position should you move.

Lightly mark the divisions of the window onto your drawing surface. Using one eye to measure, proceed to draw by finding the place where a feature starts at the edge of the mount (e.g., the floor/wall line, a tabletop, or the figure itself) and then finding the comparable place on your drawing surface. Now find the place where the same feature ends at the edge of the mount, and then find the same place on your paper. Connect the two places on your paper, thus drawing in the angle of the feature (Step I). Try to produce a silhouette through the analysis of vectors, or straight lines, while using the frame to

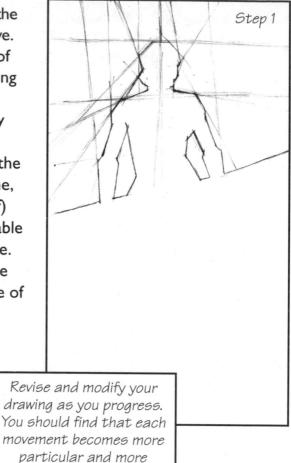

find the positions of different features (Step 2). Work through the whole figure and its setting in the same way, determining direction and angle from the sides of the frame (Step 3).

specific.

Remember that you are trying to draw your mode of analyzing the subject in front of you, not the subject itself. There should only be straight lines in this drawing; break down curves into a series of vectors. Do not use a ruler for these lines, but draw them freehand. An effective method is to track the line with a light, repeated movement so that you feel the trajectory, extending the vector

beyond the contour into the space, setting up a web of measurement that captures the particulars of the view. The drawings of Alberto Giacometti (1901-66) are good examples.

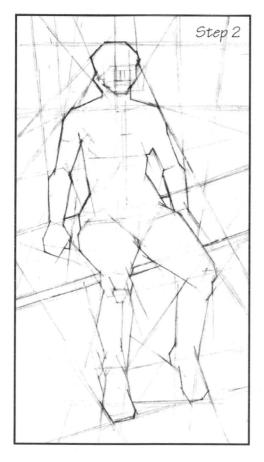

Opposite and above: Measuring with a window-mount It is a good idea to mark around the model, your feet, and the feet of the easel or rest with chalk or charcoal in order to fix the relationships between the three. Then, when you or the model take a break, you can both easily return to the same position.

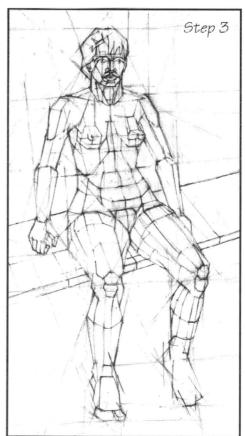

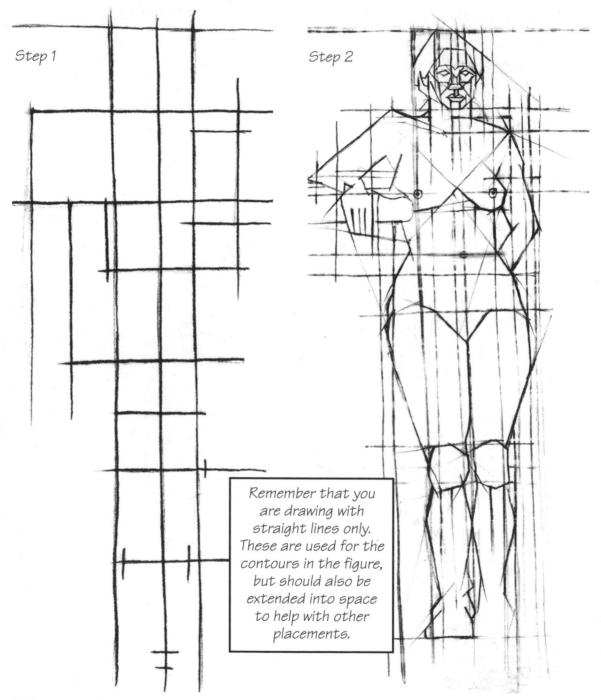

Using axes of measurement

PROJECT 2 AXES OF MEASUREMENT

One three-hour drawing

Materials: 22- x 30-in paper; pencil, conté crayon, or charcoal pencil This project dispenses with the frame as a measuring instrument. Instead, horizontal and vertical axes are going to be established within the picture, against which the subject can be measured.

Draw a vertical line on the sheet of paper at the place where you wish to place the figure. Decide the scale at which you want to draw, and mark where you want the top and bottom of the figure to fall on the vertical line. At the top point of the figure draw a horizontal line.

Hold your pencil (or other straight-edged instrument) up to the model. Hold it at arm's length as this fixes absolutely its distance from your eye. Make the top of the pencil coincide with the top of the model's head. Move your thumb down to mark the bottom of the chin. Other elements of the figure can be used, but the head is the preferred unit for measuring. See how many of these units-heads-fit into the full length of the figure. Divide the vertical line on your paper into the same number of units. The head size on the pencil need not be the same as the head in the drawing. Just remember that you are fixing the scale of the drawing against the head so that other elements can be determined as so many heads or as fractions of the head. Mark off a number of "head" units on the horizontal axis (Step 1).

Develop the drawing using the horizontal and vertical axes drawn on the paper, extending other horizontal and vertical lines from these to determine the scale of features in the composition. Place the larger components first, using postural analysis (see "Hand, Eye, and Mind," Project 8, page 23) to determine the angles and scale of the pose (Step 2). Continue until the drawing is complete.

PROJECT 3

FEATURES USED AS MEASURING UNITS

One three-hour drawing

Materials: 11- x 17-in paper, HB pencil

In this drawing you will tackle a portrait. This is probably the most difficult subject when you are trying not to be too literal. Keep to the method described, however, and it should turn out all right.

You are going to evolve this drawing by relating the features in the drawing to each other. It is easier, and perhaps better, to work from the whole head shape (called the *blank*) to the features, but you can also proceed from feature to feature,

Consider the quality of line that you are using and aim to develop a feeling of precision in its movement.

although the room for error is greater with this method. Just as in the last project, you need to set one unit as a constant for

Features used as measuring units

measurement. This can be anything-the length of the nose, for example, or the distance from forehead to chin. Mark the unit on the page at the scale you want for the drawing. Assess and mark on the paper the points at the limits of features and movements. Draw in the contour as you proceed. It need not be drawn with a straight line in this drawing. Keep your drawing fluid through the process, allowing yourself to review and revise throughout.

FORESHORTENING

Foreshortening has been a source of dread for a great number of drawing students. It is a particular feature of peephole

perspective that occurs when the figure, or part of the figure, is not on a parallel plane to the picture; i.e., it lies back in the illusory

space. Our normal expectations of the proportions of the body will be quite alarmingly confounded by the projections of the proportions of the body onto the picture plane. Near elements will seem exaggeratedly large, far elements incredibly small. Trust your measurement and method: hold

Foreshortened figure

your disbelief in check, and when you produce the whole context, the drawing will be accurately foreshortened.

The first known drawing of a foreshortened figure appears in a panel of Paolo Uccello's Battle of San Romano (c.1450) in the National Gallery, London. It is a marvelous if somewhat reduced figure.

CHAPTER 3

A PROGRESSION OF TONE

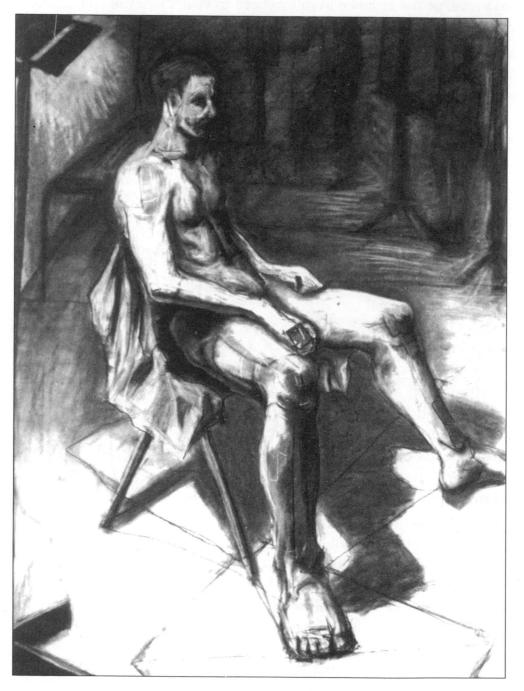

t is in light and through light that we see. Consequently, drawing is a product of light, and all marks on paper are read in and by light. When we deposit a ribbon of pigment on a support, what we read is the contrast in lightness and darkness between the pigment and the support. Even the inscribed or etched line is picked out through light. A blind person may feel the contour of the engraved or raised line, but the line is envisioned in light.

In drawing, *tone* (sometimes called *value*) is an index of light. Lines, marks, rubbings, and smears can be made with drawing materials of different tonal values to create different gradations of light or dark. You can also achieve this gradation using one drawing medium, by increasing and decreasing the pressure you apply as you draw, thus leaving varying amounts of pigment on the drawing surface. On many occasions in the life room, and indeed in other drawing situations, students will "add tone" to their drawings by placing a series of smudges on the figure in the hope of making it look more "real." Students may be trying to describe the texture or the anatomy of the figure, but in many cases all that they achieve is a dirtying of the picture because the marks they have made do not equate with the optical, intellectual, or expressive aspects of looking. As a result, students are often frustrated by the effect that they have created.

The different ways in which tone can be used need to be addressed in order to avoid this confusion. Let us consider four distinct applications: outline, modelling, color, and cast shadows.

THE OUTLINE

The outline, as we have already witnessed in the silhouette (see "Hand, Eye, and Mind," Project 7, page 22), declares the limits of the volumes of the figure when projected onto the picture plane. You need to consider the weight of the line that you use to draw the outline because you can establish different expressions and

different readings of the three-dimensional world that you are depicting, depending on how you use the line.

Tone can be used to modulate the outline of a figure. In Greco-Roman, Byzantine, medieval, and folkloric art, and in the drawings of modern artists such as Pierre-Auguste Renoir (1841-1919) and Aristide Maillol (1861-1944), a dark tone or value is bled into the form from the outline, creating a *penumbra*, or graduated shadow, around the inner edges. Artists use this technique to emphasize the volume of the forms–in other words, as an elementary type of modelling.

Shading can also be used outside the forms to qualify the space around them, creating the effect of air by emphasizing the difference between form and space. A highlight can also be used inside or outside the figure to model either the forms or the space. The technical terms for the deployment of tone in this way are *endotropic* (if it is used inside the form) or *exotropic* (if it is used outside the form), *shadow* (if it is a darker value) or *highlight* (if it is a light value).

Endotropic and exotropic tone can also be used (with restraint) where different areas of the same tonal value meet, in order to distinguish the edge where the two abut. In this case, tone should be applied with a broken mark along the edge, and it should become more diffuse as it moves into the area being

worked. The edge needs to be broken in order to state that it is a tonal mark and not a second outline. These shadows and highlights are not actually seen in the subject, but they are part of the artifice of drawing and help to emphasize particular aspects of what is observed.

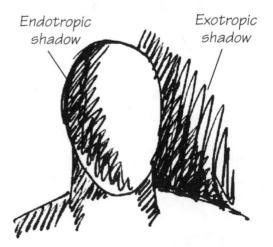

MODELLING

Shadow can be used to model forms. By darkening the inside edges of convex forms (endotropic shadow), you can make the forms' edges appear to push further into the picture space, causing the lit middle area of the form to come forward. This notion of the plasticity of form, however, assumes that light is hitting the form smack in the middle, and that the edges are, therefore, in partial or full shadow.

In the drawings of Renaissance artists such as Raphael (1483-1520) and Michelangelo (1475-1564), for example, there isn't a universal light source for the whole figure. The forms of the muscles are dealt with as discrete masses, each meriting its own light source. Light is used to model each form as and when

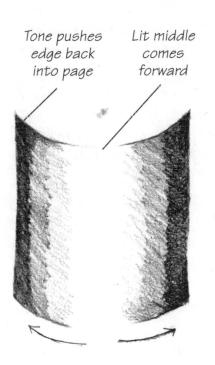

necessary; no matter where the muscle or muscle group is, it is lit centrally.

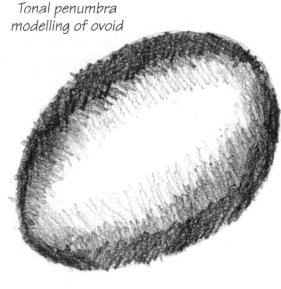

COLOR

Both the figure and its environment are colored. Different colors carry different tonal values. In a drawing, light yellow, for example, may appear as a very light gray, and deep purple as a very dark gray. When using a monochromatic scale–one without a hue (red, yellow, blue, and so on), but consisting of a range of grays from white to black–tonality is the only aspect of color that you can convey in a drawing. However, you can use tone as a pigment–filling in areas of a drawing to create contrasts for their aesthetic merit (drama, balance, and so on)–rather than as a description of light.

CAST SHADOWS

When light from a particular source falls on an object, the surfaces of the object that face the light source will be lit and the surfaces that do not face it will be in shadow. A shadow is produced that is an echo of the object, and falls (or is *cast*) onto another surface. This *cast shadow* is modified by its distance from the form and by the nature of the surface on which it is cast.

By taking into account and addressing the effect of light from particular sources (there may be several light sources, or you may elect to address only the primary source), you can produce a progression of tone on the picture surface that duplicates the pattern of light in the scene, giving further clues to depth and form. In many instances, you need draw only the shadow produced by one strong light source to achieve a strong reading of a figure, face, object, or scene.

While you are drawing the effect of directional light on a scene, it is crucial that you keep the mechanism of the eye constant; that is, you need to keep the pupils at a constant aperture (as in the f-stop of a camera). The pupils usually expand and contract as they move through dark and light areas of the scene, and this will confuse the tonal information for a drawing. By squinting, you can

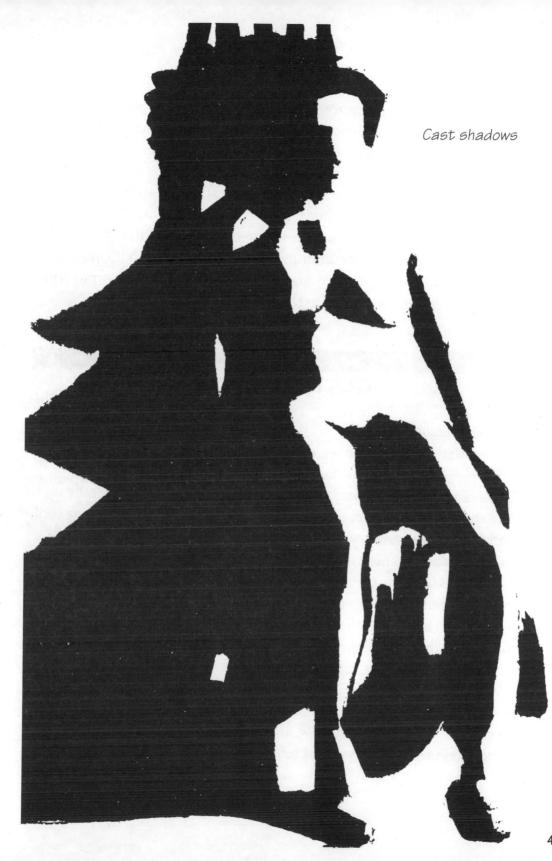

restrict the pupils to one "setting," allowing you to make consistent judgements across the complete scene. You can then make particular comparisons for details with your eyes open.

When you are doing a drawing that rests on observations of a directional light, your main aim should be to locate and record the effect of that light; you are describing the surfaces in light and those in shadow, and portraying the shadows that are being cast. Materials and textures affect the impression of light that we receive-the effect of light falling on fur differs from that on glass. However, in this chapter we are looking at light in relation to form and space rather than surface texture.

PROJECT 1 GESTURAL TONE

Two thirty-minute drawings **Materials:** 11- x 17-in paper, conté crayon or fine felt-tip pen

These drawings should be done almost lackadaisically, like a doodle. Pose the model and start to draw gesturally, swinging your drawing tool around the paper and trying to locate the whole scene at once, fluidly and easily. Aim to encapsulate the major aspects of the model in the first five minutes. Do not concern yourself with tone yet. Next, light the scene, positioning the light to one side so that the subject is lit dramatically. Darken the room too, if this adds to the drama. Be careful not to light the model from close to your own position as you will not see any shadow on the model and the figure will appear flattened.

Squint at the subject as you draw-this will allow you a consistent comparison between tones throughout your whole field of vision. Draw the patches of observed shadow, and use endotropic and exotropic shadow (again with the gestural spirit) to qualify the forms and space.

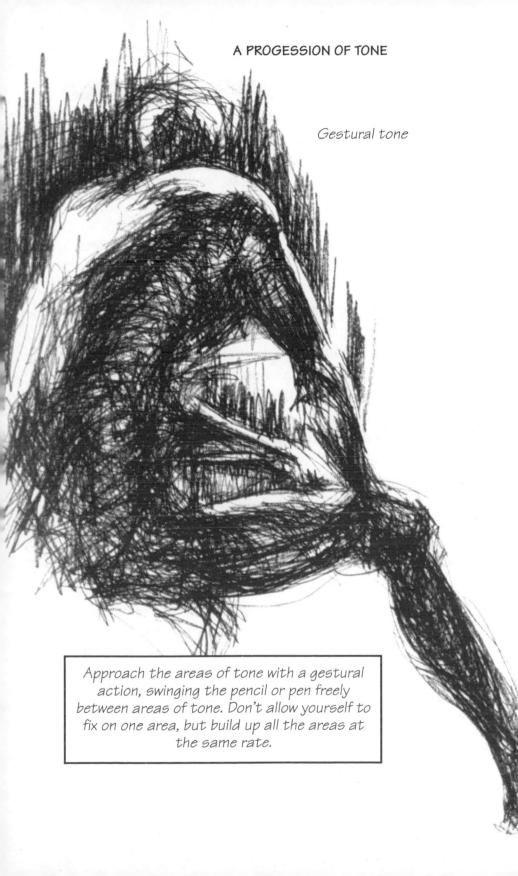

PROJECT 2 . SUBTRACTIVE TONE

One three-hour drawing

Materials: 22- x 30-in paper (white), charcoal or black pastel (not oilbased), plastic eraser, kneaded eraser

In this exercise, begin by covering the paper with charcoal or pastel, and then draw into the layer of tone with an eraser to record the lighter areas.

Completely blacken your drawing paper with your drawing material. Rub it lightly with newsprint to create an even tone. Draw with your

Treat the figure and surroundings with equal importance. This kind of drawing only works if the whole view is integrated. Consider the whole scene as a patchwork of the three tonal possibilities. Tone is your subject here; not model, nor table, nor floor, only tone. Try to forget everything that you know about what is in front of you.

plastic eraser, using vectors of analysis (see "Through the Window," Project I, page 33) to place the figure and environment lightly and loosely. Think about the composition at this stage as well. It should take you about fifteen minutes to map the figure.

Illuminate the figure with a strong directional light, positioning the light source so that it creates interesting conditions. You could use underlighting or some other unusual type.

If the room is very dark and the light source strong, you will have a dramatic and marked contrast, known as *chiaroscuro* (from the Italian, meaning light/dark). Squint in order to see the light and dark tones. For nuances in the shadows you can use a half-tone, which should be closer in value to your dark. In effect, you

are using three tones for this drawing, light, half-tone, and dark. While you are squinting at the scene, decide which parts fall into each tonal category and try to stick to this system.

Right: Subtractive tone

Proceed by rubbing out the lightest shapes in the scene. The actual method of rubbing can leave expressive marks (which can sometimes look like a woodcut), which you may wish to honor. Make sure that you give equal attention to all parts of the picture—figure and background. Then move on to the areas that fall into the mid-tone range.

There may be occasions in this drawing when you become confused between concerns for color and those of cast shadow. Remember that you are trying to depict the effect of light as it falls on forms within your visual field in order to give substance and space to the scene that you are portraying. You may need to compromise in some of your descriptions of color. If a color is dark within the scene and there is a discernible shadow on it, you may have to describe the lit area of that color with a half-tone and the shadow area with a dark tone. If the color is so dark that the shadow on it is hardly discernible, use your darkest tone for the whole area of that color.

As the drawing progresses, you may wish to play with the way in which light or dark areas run across more than one form, letting the tone consume forms. Should you wish to differentiate between two elements in the picture, you can use endotropic or exotropic shadow, or a line, to denote the edge.

PROJECT 3 ADDITIVE TONE

One two-hour drawing

Materials: 22- x 30-in paper, charcoal or black pastel, plastic eraser The approach in this project is to begin by establishing broad areas of tonal value, and then working into them to differentiate form and volume.

Pose and illuminate the model and surroundings. Squint at the scene through half-closed eyes and determine the pattern of dark tones across the whole subject. At this stage, also determine in your mind's eye the scale and composition of your drawing.

Quickly proceed to rough in the tonal areas—do not deliberate or hesitate. It is not necessary to measure, plot, or draw in the contours of the forms to bind the areas of tone together. Approach the drawing with a relaxed and intuitive approximation of the scale of the tonal areas. This part of the drawing should take you about twenty minutes.

Smudge your drawing with newsprint so that you have dark and mid-tones over the entire paper. There are a number of reasons for doing this. Firstly, it will push the dark tones back, so that they do not look like the last marks made on the paper. If they are not knocked back, they are likely to sit in front of the picture plane and fight against the illusion you are trying to create. In other words, they will read as deposits of dark pigment on the paper instead of shadows in space. Secondly, a mid-tone ground is created into which you can work highlights and on which you can reestablish the darker tones. Thirdly, it should make you less precious about reassessing and reworking your drawing. A drawing is seldom, if ever, right until it is finished.

Over the top of the smudged drawing, refind the scene in front of you with a line. This can be a gestural line, a continuous line, or vectors of analysis (for those who wish to be more deliberate).

Reassess and readdress the tonal balance. Use your eraser to create the light areas, and consider emphasizing or redrawing some of the darker ones. As with the previous drawing, consider using endotropic and exotropic shadows or highlights-with discretion-to distinguish the different features.

The line can be left as it is, or added to in order to describe parts of the scene in more detail. In either case, use the line advisedly. If you put outlines around all the features in the scene, objects will look like cardboard cutouts and the drawing will have no atmosphere. Let light or shadow break across the line, creating a drawing of atmosphere and light.

Remember that the first stage of this drawing is an approximation. As you develop the drawing, do not try to force what you are looking at to conform absolutely to what you put down to begin with. If you are consistent in your treatment of the different features in the scene, you should achieve a strong evocation of the incidence and effect of the light on the model and surroundings.

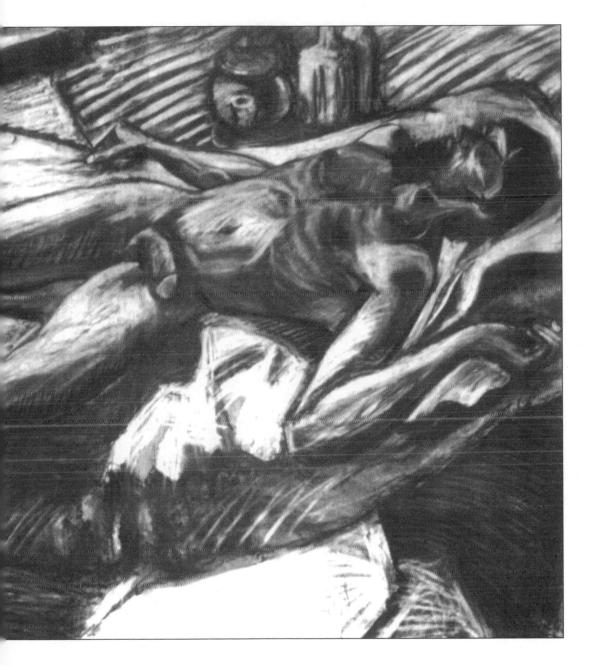

Additive tone

CHAPTER 4

BUILDING BLOCKS

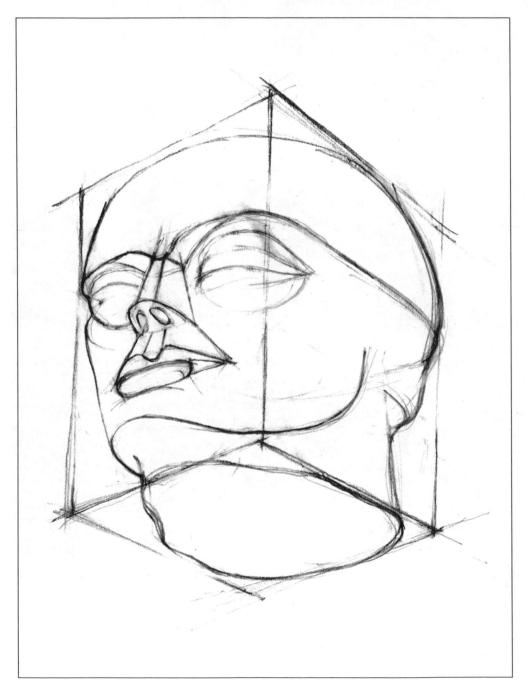

hen we use the word *form*, we mean the threedimensional object, or the illusion of it on a twodimensional surface. By *shape*, we mean any two-dimensional area-and only that. Shape is flat; it does not possess the third dimension-depth. This distinction may seem pedantic, but it is very important because the two are quite different.

From an early age, children develop an ability to perceive and manage shapes and forms in order to understand and use the things that are around them. They are given games that test and develop their awareness of form and shape. Two such games are particularly illuminating for the artist.

The puzzle that involves placing differently Shape formed blocks into matching slots develops a child's awareness of shapes. This aptitude is crucial for representing and understanding the objective world. In

"Through the Window" (pages 28-39) we touched briefly on one system–peephole perspective–for projecting a form onto a two-dimensional surface, and there are several other possibilities. Suffice it to say that much of drawing can be understood as a projection of a three-dimensional space onto a two-dimensional surface. The second toy that reflects on the theme of this chapter is the building block. Children encounter and use blocks in different ways at different stages. Initially,

Form

Buildina

with forms

they explore the physicality of the blocks-picking them up, dropping them, biting them, hitting two together, and so on. In this way, they assay and test their bodies and senses with the blocks. They then begin to organize the blocks in various ways, learning about the laws and forces in the natural world and about their own dexterity. This stage is characterized by the tower, which a child will build up and then cause to topple.

In the final stage, children are intent on building models of objects-trains, tractors, castles, people, and so on-based on their own observations and imaginations. They build the complex forms of the world in which they live with the simple constituents of a set of blocks, reducing the complexity of a steam train to a combination of a few cylindrical and rectangular forms.

FUNDAMENTAL SHAPES

There are three prime or inorganic shapes-the rectangle, the triangle, and the ellipse-through which we can understand an infinite number of organic possibilities. We can use these shapes to analyze and assess more complex shapes, and the relationships between shapes, in order to assemble more elaborate figures. In these instances, what we are analyzing is the flat figure, or the figure rendered flat.

FUNDAMENTAL FORMS

To understand three-dimensional objects we use form–either actual form or the illusion of form. There are three categories of fundamental form: the rectangular, including the cube; the ovoid, including the sphere; and the cone and its section, including the cylinder. We can use these forms in drawing to *crate*, or package, the complex forms that we see around us. Alternatively, we can re-create the complexities of the figure by using the forms as building blocks.

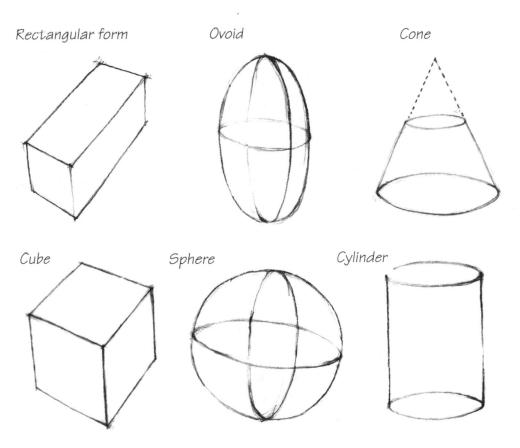

To "crate" the world, we use the rectangular form more often than the other two. Its relationships are constant, being built around the straight line and the right angle, and measurements are therefore easier to take. However, we can use any of the fundamental forms to assemble objects in our vision, depending on the drawing's context and purpose.

In sculpture, different cultures have restricted themselves mainly to just one of the three categories. The sculptures of the East are characterized by the use of the cone in describing the body. The head may still conform to the ovoid, but the rest of the figure is a series of cylinders. In the Occidental tradition, which emerged in Ancient Greece and reached its high point in the Italian Renaissance, the ovoid and sphere were used as standard building blocks. Although some African masks and sculptures are built with cubes and rectangular blocks and planes, quite a wide range of fundamental forms are used there.

The cartoon characters of Walt Disney are built from simple ovoid forms. They give the characters a cuter, cuddlier feel than the other forms, certainly; but the ovoid is also easier to animate because of its regularity. The ovoid allows the figure to be easily duplicated and moved in each cell. The character is reduced to simple, essential form-units that express its three-dimensional quality and movement.

The human figure can be seen as a puppet built from a series of simple forms combined into a system of complex relationships. In the artist's mannequin, simple wooden masses are hinged and connected to represent the human figure. The individual units illustrate the standard volumes that we need to attend to in the figure. Three immutable masses—the head, the thorax (or rib cage), and the pelvis—are articulated one to another. Not able to bend within themselves, they can only be orchestrated in relation to each other in three planes of movement. They can bend forward and back in what is known as the *sagital plane*; they can twist in the

horizontal plane; in addition, they can tilt in the *transverse plane*. The hinges connecting each mass to the next–the neck and the abdomen–compress and stretch to accommodate the movement of the head, thorax, and pelvis.

We can consider further volumes of the figure organized along the main bones-the upper and lower arms and the upper and lower legs. These, too, cannot bend or twist within their masses, but only in relation to each other. The hands and feet can each be considered an individual unit of form initially, but they can also be drawn by building them up from the individual units forming fingers and toes. Although the head can be considered as a single, discrete form, it is in fact composed of two interconnected forms-the mandible, or jawbone, and the cranium, or skull. Particularly when the head is seen in profile, it is important that these two forms are noted and represented.

PROJECT1

THE FIGURE AS A "BLOCK PUPPET"

Two fifteen-minute drawings

Materials: 22- x 30-in paper, charcoal or conté crayon Begin each drawing with a light mapping of the figure (gestural, continuous line, or vectors of analysis). Keep the drawing light but confident, as you are going to superimpose the second stage on top of the initial mapping.

Imagine you have only simple blocks based on the cube and rectangular form with which to construct the figure. On top of the initial mapping, place these blocks and sections to represent the figure in front of you (see illustrated overleaf). You can use a wedge for the feet, for example, as this is a section of a rectangular solid. Make sure that the blocks slot into each other.

Complete two drawings from two different angles.

Use a unique block for each section of the figure: head, thorax, pelvis, upper arms, lower arms, upper legs, lower legs, feet, hands, neck, and abdomen.

PROJECT 2 THE FIGURE AS A "CYLINDER PUPPET"

Two fifteen-minute drawings **Materials:** 22- x 30-in paper, charcoal or conté crayon The figure is built up using cylindrical units of the correct proportions.

Proceed as in the previous project, but using cylinders instead of blocks. Please note that the head would look peculiar as a cylinder, and is best considered as an ovoid form for this exercise.

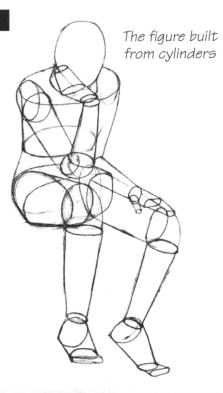

PROJECT 3

THE FIGURE AS AN "OVOID PUPPET"

Two fifteen-minute drawings

Materials: 22- x 30-in paper; conté crayon, 3B pencil, or ballpoint pen For the ovoid figure, use the continuous line (see "Hand, Eye, and Mind," Project 5, page 19). The line should swing around, describing interlocking ellipses that also represent the interlocking ovoid forms.

Do two drawings, spending fifteen minutes on each. Look for the major masses of the head, thorax, and pelvis, and also make a preliminary attempt to describe muscle, fat, sinew, and bone with the ellipse (see illustrated overleaf).

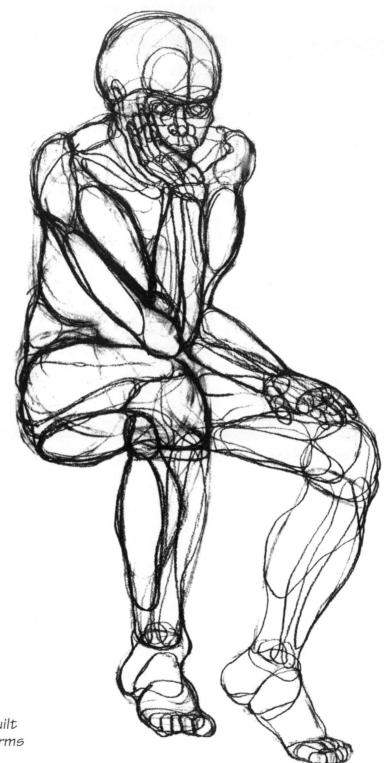

The figure built from ovoid forms

PROJECT 4 POSTURAL ANALYSIS AND FORM

Three fifteen-minute drawings **Materials:** 22- x 30-in paper, conté crayon or 3B pencil This exercise will best work if the model is standing upright, not foreshortened in any way.

Lightly place the figure with a gestural or continuous-line drawing. Over this initial drawing, draw and assess the masses of head, thorax, and pelvis by crating them. Assess the posture of the figure by determining the angles of the long arm and leg bones (see "Through the Window," Methods of Analysis, page 32) and the angles of the rectangles that can be formed around the three main masses. The lines formed across the base of the chin, the brow, and the top of the head should be parallel. The shoulders form the top of the thorax; a line drawn from shoulder to shoulder should be parallel to the lower edge of the

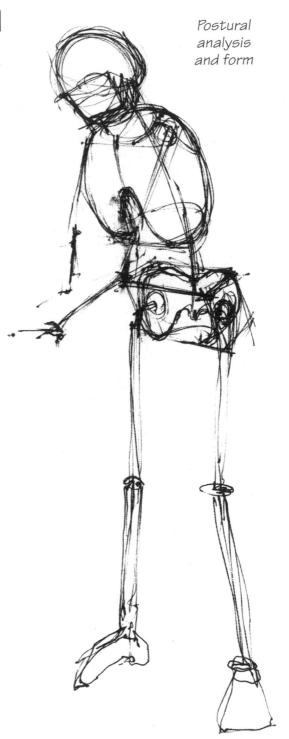

rib cage. The top of the pelvis is gained by drawing a vector between the two bones of the iliac crest, the two pieces of bone at the front, around the top bikini line. The bottom of the pelvic box is at the groin. Determine the axes through these boxes.

PROJECT 5

THE PLANAL FIGURE

One four-hour drawing

Materials: 22- x 30-in paper, 3B pencil or conté crayon In this project, the figure is analyzed in terms of a continuous series of changing planes.

Use vectors of analysis (see "Through the Window," Project I, page 33) to map out the figure. Draw the figure at a size that completely fills the paper, as it is mass, not space, that you are predominantly concerned with in this project. Determine the posture of the figure and lightly mark these accents and angles on the drawing.

Consider what the masses of the figure would look like crated. Lightly mark the side and front planes of the crates. Then, starting at the point where two forms meet, show the movement around each form as a series of planes (see opposite). Use these planes, or plates, to represent other complex forms in the figure. Proceed until you have described the whole figure in three dimensions as a progression of planes.

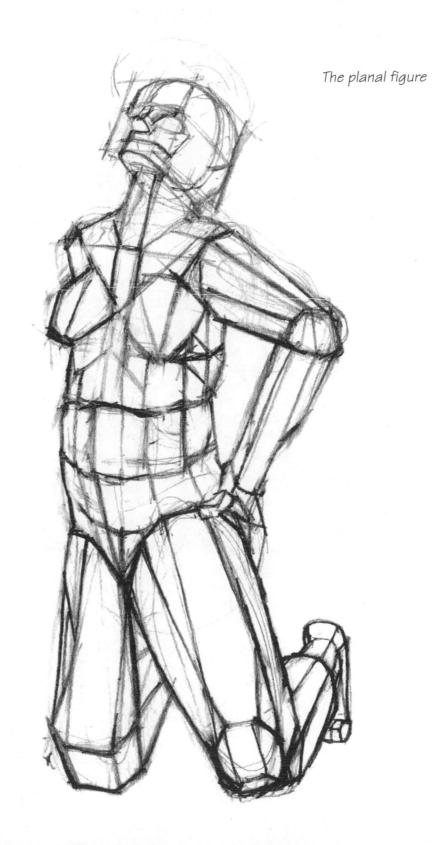

CHAPTER 5

INSIDE OUT, OUTSIDE IN

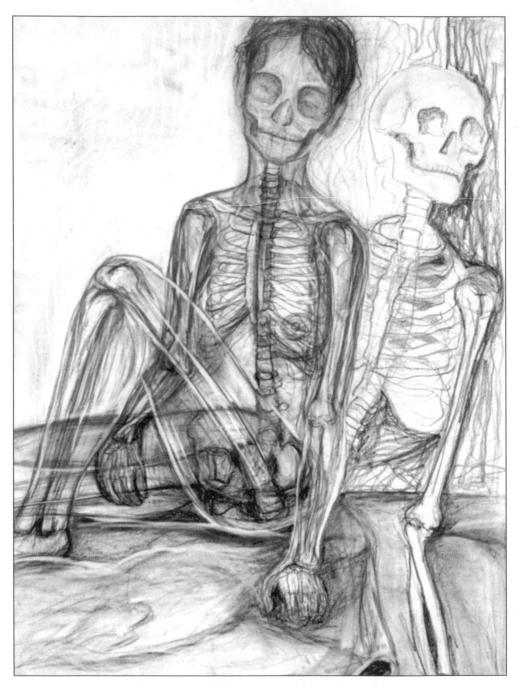

INSIDE OUT, OUTSIDE IN

imon Nicolaides advises that: "Anatomy in the hands of the artist is merely another instrument for making the figure articulate and clear. It is never to be thought of as an end in itself. Only a means to an end."

The figure is a complete entity and needs to be considered as such. It is nigh on impossible to distinguish between muscle, bone, fat, and flesh in the life figure in the way anatomy books are wont to do. The particularities of the individual model and the poses he or she takes up will always create unique situations, and you will need to use a good deal of detective work and invention to equate the information in an anatomy book with your own observations of the model.

The sculptors of Classical Greece, whose proclaimed aim was naturalism, continuously reinvented the anatomy of their figure sculptures. Michelangelo, Raphael, and other Renaissance artists likewise created their own musculature for their figures. In comic strips featuring the superheroes of today, anatomy is distorted and exaggerated to create a hyperreal musculature. Ovoid form is laid over ovoid to create bulging supermen and women. We need to invent and deploy some metaphor, beyond what we see, in all drawing if it is to carry our observations and thoughts about the figure and its anatomy.

An understanding and knowledge of anatomy is useful in the representation of the human figure. It will, however, take a great deal of study and drawing (the two are not independent activities in this instance) to reconcile and use knowledge of anatomy to enrich observed phenomena. This chapter is a first step, laying the basis for a reconciliation between observation and knowledge by looking at what can be ascertained from the outside, and building our knowledge of the figure on the inside.

INSIDE OUT, OUTSIDE IN

FROM THE OUTSIDE IN

Imagine a few oranges placed on a tabletop. One could draw them in a number of ways: concentrating on their silhouette, their texture, their form, or how they are lit, for example. If you were to throw a linen sheet over the tabletop and oranges, covering the oranges and tabletop in a continuous layer, you would still see that there were orange-like forms under the sheet. Ways of drawing this setup would be less obvious, although one way might be to draw the forms of the oranges and then progress to the sheet.

If a number of oranges were piled up on the tabletop and covered with a sheet, all you would know was that there was a large mound under the sheet. Only the oranges on the outside of the stack, those that come into contact with the sheet, would be individually discernible. To draw this setup you would need to start by thinking of the

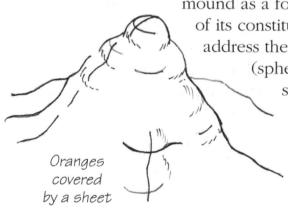

mound as a form in its own right (regardless of its constituent elements), and then address the individual orange forms (spheres) that press through the sheet.

Perhaps you can see where this is leading with regard to the human figure. The body
can be thought of as a number of major forms–upper arms, lower arms, thorax,

abdomen, and so on-each made up of minor forms-muscle, bone, sinew, and tendon-covered by the dermatic membrane. This is composed of cutaneous tissue, the skin, and

INSIDE OUT, OUTSIDE IN

subcutaneous tissue, the layer of fat beneath it. The weight and substance of the dermatic membrane, and whether it is tightly or loosely drawn over the forms, are additional factors that you need to think about when drawing the figure. Also, the dermatic membrane varies from person to person. In the case of a bodybuilder, the subcutaneous tissue is reduced to a minimum and the skin is drawn taut over the body, attached in all places to the muscle forms beneath and therefore revealing the cut of each muscle. For the rest of us, our fleshy exterior has thickness and weight. In places it is taut and attached to the muscle beneath and in other places it is slack and loose.

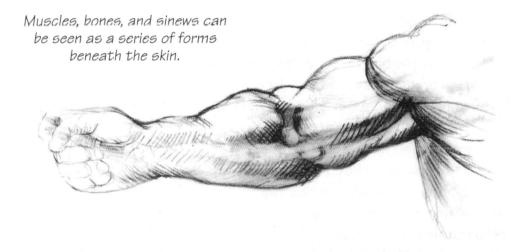

PROJECT 1 FROM THE OUTSIDE IN

One three-hour drawing

Materials: 22- x 30-in paper (black or white); pastel, conté crayon, or chalk (white or black can be used)

This project addresses forms of the human anatomy that can be observed at and through the dermatic membrane, in order to represent such forms by the way they come into contact with this membrane. This drawing is built in two stages. Consider the human figure in the same way that you did the covered oranges on the table, that is, as a series of forms covered by a membrane. In the first stage of the drawing, try to divine the major and minor forms of the figure's anatomy from your observations, and record them as a drawing. The aim in the second stage is to describe and use the surface covering the forms to qualify the relative positions of the forms and establish their three-dimensional nature. The first part of the drawing should take two-thirds of the total time.

Stage I

Pose the model so that you have a good view of most of the figure. On a fairly large scale, quickly and lightly map the figure, seeking generalized proportions and posture, using the fundamental forms as they apply to the basic units of the human body

as your elementary architecture (see Chapter 4, "Building Blocks," pages 54-65). Onto these forms, you are going to graft your observations and understanding of muscle, bone, and various tissues. Although you can use other forms to describe the musculature, the ovoid is the preferred unit. Renaissance artists such as Michelangelo have thought of the human figure as a gathering of ovoidal forms organized under a sculptural skin—ovoids overlapping and slotting into each other, built up on the architecture of the skeleton.

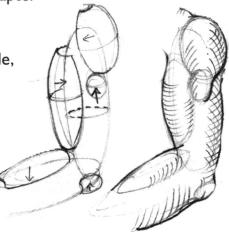

The ovoid is best for describing the musculature.

As with the oranges covered with a cloth, clues to the internal form and structure of the human body are provided at the points where they interact and mold its surface covering. Something causes

Try to use the ovoid to describe the forms that come into contact with the skin. If you are artful enough, you can show the hardness of bone, a flexed or flaccid muscle, slack skin, and fat.

a contour to bulge in a certain way, a shadow to be cast, an indentation to be made, a hollow to exist, and in this drawing you should be focusing on the causes of these effects. The effects themselves are only clues. For example, a hollow exists in a drawing only as that which is

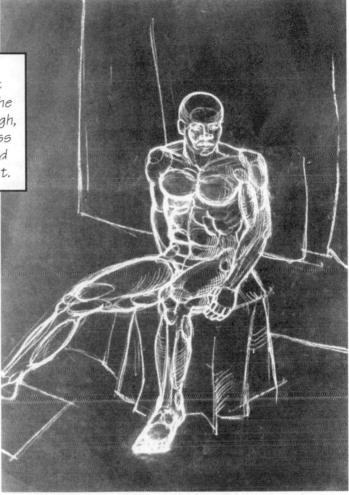

caused by two or more forms. In other words, to draw a depression you need to draw the cause of the depression, not the depression itself. This is so obvious, yet time and again students will not acknowledge that the hollow is only a feature of two forms.

Once you have constructed the major forms of the body, lightly and gesturally begin to rough in the forms you can detect under the flesh using overlapping ellipses (the silhouette of the ovoid). Make sure that the forms inform the silhouette and contours of the figure and are not compromised by a predetermined outline.

The figure is composed of ovoidal units that slot into and lie on top of each other. When beginners use the ellipse, they draw it as a shape, fitting one ellipse up against another, instead of overlapping them. This will flatten the forms in the drawing. Also, the internal forms of the figure are built on different scales and in different orientations to the major forms. Avoid building the figure through only one axis and orientation, and with one scale, otherwise a "Michelin" man–a series of ballooned forms stacked one on another–will appear. Throughout this exercise you are involved with form, not tone; try to deduce the forms under the surface.

Once you have drawn the ellipses, move to the contour, using it to define the edges of the form and to show where one form is in front of another. Use a heavier line for this. If you totally enclose a muscle form, it will flatten and read as distinct from the rest of the figure. You need to keep the forms open so that in the flow between forms you can imply skin through a continuity of surface.

Stage 2

Although the contour helps to create the look of three dimensions, you can further enhance the form and see how the skin is laid over muscle and bone by using a mark that moves across the surface.

This description of the surface of the form comes from an understanding of the form's cross section. Imagine slicing a loaf of bread. The slices reveal the loaf's cross section. The cuts are made parallel to each other on a horizontal axis, and the loaf becomes mis-shapen if the slices are not cut in this way. In a drawing, your analysis must be made in the plane that is

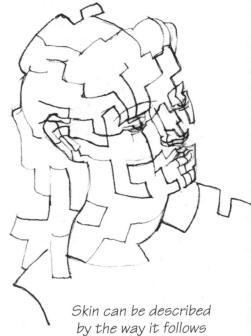

y the way it follows the forms.

either horizontal or perpendicular to the major form. You can also transfer from the horizontal to the vertical plane. Henry Moore (1898-1987) used this assessment of form in his drawings.

Continue your drawing using this analysis, describing the surfaces of the ovoids and the skin stretched over them. This will develop your understanding of these forms and the way in which they modulate the surface of the body.

There are also other ways of elaborating on this description of human anatomy. For example, you can use tone to model the figure. Light each ovoid form centrally (see Chapter 3, "A Progession of Tone," pages 40-53) and let tone slide and run across the forms on the surface of the figure like a continuous ripple.

You can also combine cross-sectional analysis with tonal modulations, developing the tone with a technique called *crosshatching*—a pattern of lines that take their directions from the surface of the form. Crosshatching is sometimes referred to as *bracelet shading* because the bracelet encompasses the form and also sits on the horizontal plane. Examine Michelangelo's drawings to see wonderful examples of both. (See page 125 for a more detailed introduction to crosshatching.)

FROM THE INSIDE OUT

Human anatomy is complex. Bones are not regular; ligaments squeeze and pull in all directions at the meeting point of two bones; muscles and tendons run in all directions, wrapping through and over each other as they connect to the bone. And on top of all this, there is flesh. Yet, in spite of this complexity, human anatomy is based on the simple logic of balance and motion. Human form is governed by and fashioned to accommodate the laws of mechanics and dynamics; we are built the way we are because of the activities that we perform in our everyday lives.

Gravity acts on the human frame. Our limbs, head, thorax, and pelvis are articulated to each other in a way that allows both for

our movements and for the effects of gravity. In motion and at rest, one part of the body will always move to compensate for a shift in weight caused by the movement or position of another part.

Bones can be regarded as the structural members of our dynamic human architecture. Ligaments are the springs that bind bones together. Muscles are the motivators, pushing and pulling one bone in relation to another in order to create movement. Where muscles connect to the

skeleton, they flatten out and attach like so many rubber bands. These connections are the tendons, or sinews. Muscles express the law of motion, "for every action there is an equal and opposite reaction," and are therefore paired. If one muscle pulls two bones open, another must be able to draw them closed.

With all the drawings, try to evolve an understanding of what the muscles act on-what mechanisms they activate. Look for the muscles that are tensed in particular actions and poses. If you include this type of information in your drawings, you will find that anatomy is transformed from the dryly diagrammatic into the life of a drawing.

The human skeleton and musculature

Muscles are scaled appropriately to the length and mass of the units they need to move. For instance, the muscle that attaches a limb to the main skeletal frame is larger than those that move the digits at the end of the limb. Popeye is a freak, possessing forearms that are disproportionately larger than his atrophied upper arm–excusable in a cartoon character, but not in an anatomically accurate depiction of the human figure.

To understand anatomy really well, you need knowledge of how the body moves, and you need to be able to place what you observe or learn about the figure within the framework of this movement.

PROJECT 2 FROM THE INSIDE OUT

One five-hour drawing Materials: 22- x 30-in or 30- x 44-in paper, conté crayon or 4B pencil

If you are feeling bold you can use $30- \times 44$ -in paper for this drawing, otherwise stick to $22- \times 30$ -in paper. You will need reference material on both the skeleton and the musculature. A real skeleton would be convenient if you have access to one. Otherwise, use an anatomical chart, anatomy books, or a model skeleton. The anatomical charts found in gyms are useful as they explain which muscles are used for different movements.

Ask the model to assume the same pose as in Project I (page 69). (If you want to save on model fees, or are not able to secure a model, you can transcribe the contours of the figure from your drawing for Project I.) If you have a skeleton, position it next to the model and in the same position.

Begin by plotting the model on your paper, analyzing posture and proportion. Then, using your reference material, draw the skeleton within the contours of the figure, assessing the positions of different parts of the skeleton by observing the points where bones come into contact with skin. On top of this drawing, develop the musculature, using observation and common sense to organize the muscles as they come into play in this pose. However, it would be a shame to bury the skeleton

completely, so try to leave some of the skeleton visible. You could also draw

some of the flesh in places.

Throughout the evolution of this drawing, you should constantly compare your findings with those in the previous project. They are, after all, two different approaches to the same problem, and by comparing the

Drawing from the inside out

aspects of anatomy that you can observe with those that you can reference, you can attack the subject on two fronts. You can develop this approach further by doing paired drawings of details of the figure, learning and applying the muscle names as you work. You can also repeat the exercise for different poses. This bringing together of what you know and can learn with what you can discover through seeing, provides a good introduction not only to anatomy but to other inquiries as well.

CHAPTER 6

MARKING TIME

In the previous chapters we have concentrated exclusively on space and form and their representation. We ignored all indicators of time in order to create a situation in which all relationships were spatial and constant. It was necessary to do so in order to clarify the concepts and projects of those chapters.

An experience is, however, shaped in both space and time. An image without time is therefore impossible, although we may contrive the illusion of it in order to match the finite, static condition of a drawing. The "instant point" (a moment without time) may be used as an aesthetic notion, but in reality a fraction of time bounds any experience, no matter how small (for example, the time of many photographs is about ½ of a second).

If drawings really are to be life drawings, rather than merely drawings of a figure, you need to discover how time can be contained in them. This can be addressed in terms of either the image itself (movement and expression), or the action of drawing (action and expression).

SINGLE IMAGES

With the aid of an electronic motorwind, a professional photographer can fire away a number of shots of an action, and then select the frame that captures the action in the most dramatic way. In the same way, the artist can select the moment in a sequence of actions that best conveys the whole movement-the *exemplary image*.

Alternatively, the artist can distill the whole sequence into one image, taking features from each of the instant images that a camera may record, placing and integrating them into a single image to give a synopsis of the sequence–the *synoptic image*.

MOVEMENT

Movement and expression can also be conveyed through the deviant and the unstable. We establish and can recognize positions of rest and normality. We can tell whether a body in a particular position can remain balanced. If balance is not established, we feel the body to be in motion–anticipating the sequence of movements needed to propel the

> body and overcome the pull of gravity. The ground anchors the body, so the figure's relationship to the ground also gives clues to its movement. In movement–and

e's A stable structure

especially extreme movement-form appears to dissolve. Obviously it is difficult to establish the boundaries of a form when it is in motion, as we rely on fixing its edge in a fixed space. Therefore, the

> broken or erased outline can be used as an indicator of movement. Multiple outlines, or the gestural outline, can also be used to indicate the moving figure.

An unstable structure

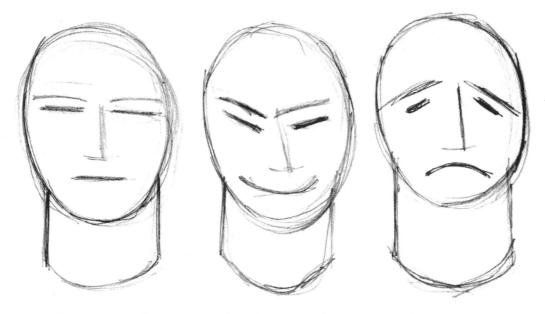

Emotion can be recognized in deviations from a neutral expression.

EXPRESSION

If the face at rest is taken as normal, or neutral, then an emotion can be expressed, and recognized, through any deviation from this. Our own recognition or memory of a situation or context will also facilitate our reading of the events or emotions being depicted. Some artists have codified and exaggerated movements of the body and face in order to create heightened emotion. Such emotion is melodramatic, appearing as the acting out of a feeling rather than the result of a feeling.

MULTIPLE IMAGES

An image or narrative can be portrayed as a collection of "instants," either by depicting images at regular intervals during the action, thereby creating a sequence of actions, or by darting in and out of the sequence, picking out moments from which the course of events can be unravelled. In either case, the spacing of images at regular intervals in time is understood by the viewer,

who can reconstruct the event in order to evoke the movement.

To break up a movement into a sequence of actions, you can divide the drawing into discrete cells of action, like a storyboard or comic strip, or you can use the space and objects in the setting surrounding the model to divide the drawing into units of activity.

Various acts within an action or event can be included in a drawing without thought for their chronological order, or different views or moments in the action can be combined or overlapped to create a unified action.

PROJECT 1

THE EXEMPLARY IMAGE

One thirty-minute drawing **Materials:** 22- x 30-in paper; charcoal, black pastel, conté crayon, or charcoal pencil

Ask the model to enact a simple action, such as rising off a seat, putting on clothes, or waking up. Then ask him or her to hold the action at a particularly dramatic moment.

Draw-with an appropriate drawing language-for thirty minutes, concentrating on the pose as an instant in the complete action. The environment is less important with a small movement because moving forms are contrasted with still forms, whereas when the whole body moves, the moving form must be calibrated against a static space.

This can be repeated for an expression of emotion, such as surprise or horror, which you can consider as an action of either the whole body or just of the face.

PROJECT 2 FIVE POINTS OF TIME, ONE SPACE

One two-and-a-half-hour drawing Materials: 22- x 30-in paper, charcoal or black pastel

You are going to draw five selected, separate moments in a movement set against a constant environment. Ask the model to move and select five points at which you want him or her to freeze. Make sure that all five points of the movement fit into one view. Use line or continuous line for this project. Draw the figure at the start of the sequence together with the surroundings, taking about

TIL.

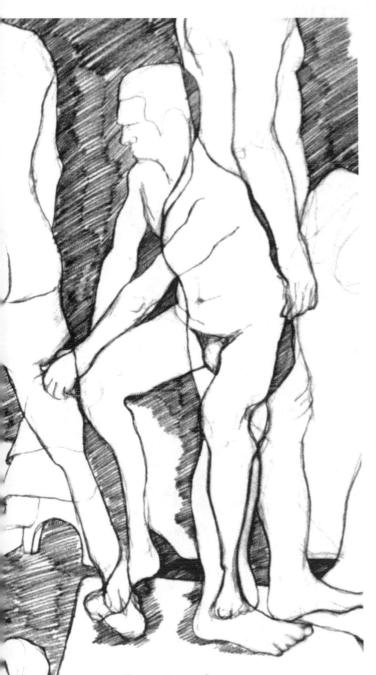

Five points of time, one space

half an hour. Then proceed to the second position. Draw this in the correct scale and position in space in relation to the first stage of the drawing. If this pose overlaps the first, you can erase part or all of the previous drawing, leaving just its faint impression.

Continue in the same way for the other chosen moments, keeping to the same scale and within the same space. This drawing also becomes an exercise in measurement and proportion. If the model moves a long way between each position, and there isn't much overlapping, you can repeat the exercise with smaller movements. If the model sneezes, for instance, some parts of his or her body will be still while other parts move.

PROJECT 3 THREE CELLS OF ACTION

Three twenty-minute drawings **Materials:** 22- x 30-in paper; charcoal, black pastel, conté crayon, or charcoal pencil

In this project you are going to make a sequence of drawings of an action. Ask the model to make an action (it can be the same as in Project 2). Stop the action at three moments, making a separate drawing of each. Again use line or continuous line. On this occasion the environment is not important, but the figure needs to maintain a constant scale.

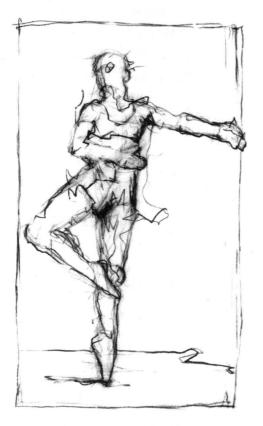

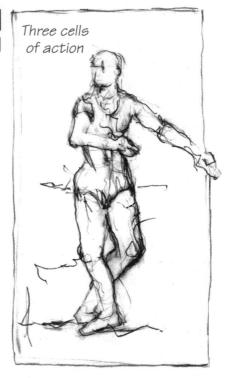

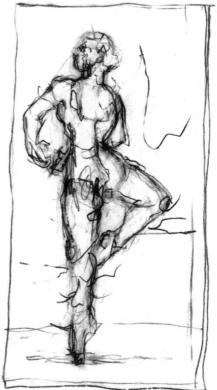

PROJECT 4 THE SIMULTANEOUS IMAGE

One four-hour drawing **Materials:** 22- x 30-in paper, black pastel or charcoal

In this drawing you will move around the still subject, gathering up different views and presenting them together as one image. Draw with a line.

Over three hours take up five different viewpoints and draw from them. The scale of the figure may be very different in each view. Draw the entire view in all five stations, overlapping one view over another. Once you have completed all five views, activate the drawing with tone. Use

If the image becomes very complex or confusing, you can erase parts of the previous view.

exotropic or endotropic shadow (see Chapter 3, "A Progression of Tone," pages 40-53) to pick out the edges of forms and also to develop abstract rhythms over the surface of the drawing. You can fill in the shapes left by overlapping views to clarify the image or to develop it aesthetically. This tonal work should take about an hour.

THE ACTION OF DRAWING

We have considered the moving subject and some possibilities for its depiction. We can also move in relation to the subject, taking different views of the scene and drawing these. However, life, or its expression, can also be reflected in our own perceptual activity and the temporal aspects of our drawing action. The way in which we negotiate a drawing, apart from what we are representing, can reflect our attitude to and understanding of our world. The early marks that are the scaffolding on which the final drawing is built can be left in evidence in the finished work. Like an archaeologist, the viewer can read in these buried marks a trail of the artist's endeavors, thoughts, and feelings.

PROJECT 5 NAVIGATING A DRAWING

One three-hour drawing **Materials:** 22- x 30-in paper, charcoal, plastic eraser

This drawing is made through a series of alternating decisions and revisions. Draw the model on a scale that more or less fills the paper.

Make the drawing with a constantly moving hand, moving the drawing tool into contact with the paper and then lifting it off, leaving a broken trail of marks that follow the scanning eye as it fixes and then breaks from its subject, only to pick it up again at another spot. This type of line is called a *scansion*.

The marks are made with certainty and then questioned (at this point the hand moves away from the paper). At a particular point (about twenty minutes into the drawing), rub the drawing back with a hand, cloth, or piece of paper, leaving a smudged base on which to build new decisions. Work over the top of the first drawing with the same broken scansion, but now introduce an eraser—not as a tool of correction but to work in highlights as drawing actions. These need not conform to a directional light, but can abstract tonal rhythms for the sake of the drawing itself.

Carry on building up the drawing and breaking it down until it is complete. Earlier decisions will lie under later marks, creating an abstract space where the last actions are suspended in front of earlier ones. This allows viewers to read in the drawing the time spent thinking and doing, and draws them into the act of drawing itself.

Right: Navigating a drawing

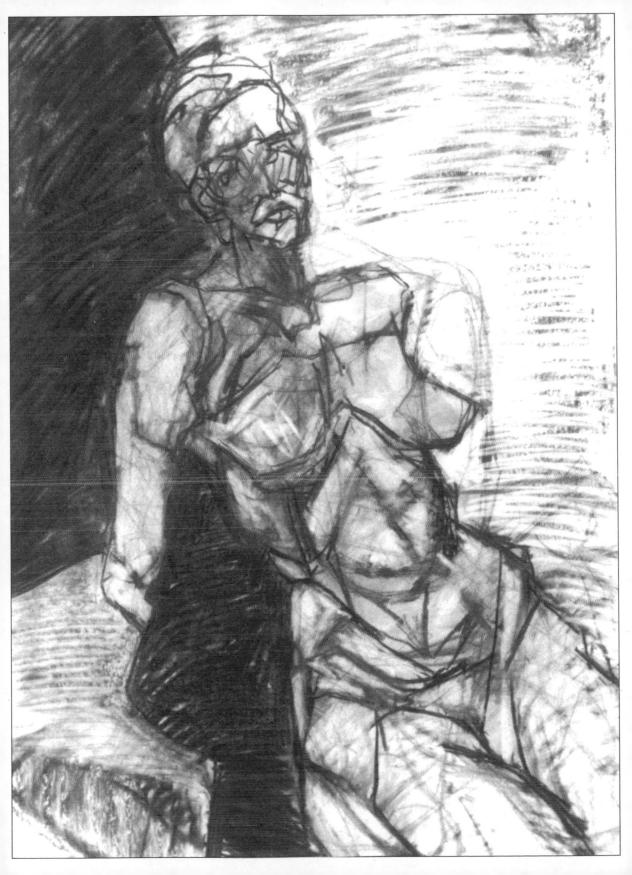

CONCLUSION

eonardo da Vinci wrote in his notebooks: "Life is long. In rivers, the water that you touch is the last of what has passed and the first of that which comes, so with time present." A drawing dips into this river, picking out an aesthetic present that is part of the coursing stream. In order to know the stream, you must touch it. But not only do you touch the stream; it touches back. It is important to reflect in your drawings on the intertwining of yourself and your world.

Merleau Ponty wrote: "Before the essence as before the fact, all we must do is situate ourselves within the being we are dealing with instead of dealing with it from the outside–or, what amounts to the same thing, what we have to do is put it back into the fabric of our lives," (*The Visible and the Invisible*, 1964). To place what we draw into "the fabric of our lives" is an imperative for life drawing. You cannot be uninvolved, and in your involvement lies the seed of your drawing.

We have covered a great deal in the small space of this section but there is still much that lies beyond. We have dealt predominantly with the representation of the figure and environment in a perspective space, but there are also other spatial systems. Some quite amazing drawings of the figure have been made using schematic or diagrammatic approaches. Projections other than perspectival ones can also be used in representing a human being in the world, as evidenced in many great works from the East. All of this remains to be explored or used to help you develop representations of your own observations and opinions, actions and stories, thoughts and feelings.

STILL-LIFE DRAWING

INTRODUCTION

here are many ways in which we can understand and express our ideas, observations, and feelings through drawing, and it is important that you embark on this drawing course without any preconceptions. Many students, particularly beginners, start out with very narrow opinions about art and drawing, adopting a fixed attitude as to what a drawing should be and how it should appear. In particular, they think that a drawing should be an exact copy of the reality it is taken from. Yet this is an impossible task, and when students try to achieve this idea of copying reality, they ultimately fail.

When you stand in front of a still life and try to draw, you can easily become overwhelmed by the subject because you do not know how to approach it. But if you break down and simplify the subject in front of you, the process of drawing becomes more manageable and accessible, particularly if you are a beginner. As an example, in one of the projects that follow you will approach the still life by looking only at its textures, and finding ways to create the illusion of texture through drawing. In another project you will observe light and shadows on the still life, and concentrate on describing just this aspect of the subject.

The different ways of looking at and understanding what you see are as important as the physical act of making a drawing. Each of the following chapters presents a particular way of looking at still life-through light, shape, texture, form, space, and movement-and then introduces techniques that you can use to describe that way of looking. It is important that you start with Chapter 1 and work through the subsequent chapters in sequence, as projects later in the section often refer back to earlier projects and chapters.

INTRODUCTION

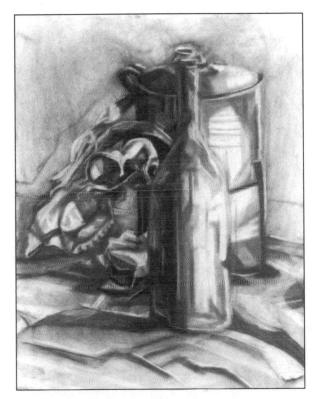

Still life seen as form, light, and space

Until relatively recently, still life was cast aside by theorists and was not recognized as a subject of any real importance. Yet, since the times of ancient Greece, artists have used still life in many forms as a means of recording everyday life. It is the stuff that reflects our historical and cultural activity and the evidence of our domestic lives. Insignificant objects can be given significance and any object can be given symbolic meaning. The consistent

attention and fascination of artists towards still life has proved its worth and brought it critical attention and approval, elevating it to its rightful place in the history of art. In each chapter that follows, a historical context is given for the approach being tackled, and specific works and artists are suggested for study that will help you with your own drawing.

By the end of this section you should have gained experience in a wide range of drawing styles that will enable you to express your ideas and observations. You may find that you enjoy and respond to some projects very positively, whereas you find other projects difficult to get to grips with, but this is all part of finding out where your strengths and interests lie.

CHAPTER 1

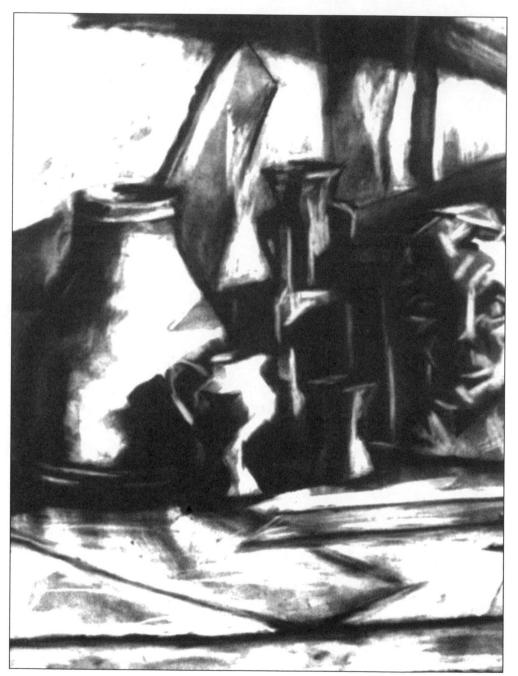

hen we look at the world, we often take what we see for granted. The purpose of this chapter is to encourage you to reexamine your everyday visual experiences and interpret them afresh by introducing a way of seeing based on ideas about space and tone. At the end of the chapter, you should be able to construct a drawing, as many artists have done before, using the techniques of negative space and chiaroscuro (extremes of light and dark) and the basics of proportion.

Drawings are all based on observation: what we see and how we understand, formulate, and interpret this. However, when you are making a drawing, bear in mind that you are not trying to reproduce "the truth" of what you see. Your aim should be to make an interpretation or expression from your observations and knowledge of the subject. You cannot possibly include everything about the subject in a drawing; you have to be selective and discerning by taking a particular approach each time. By gaining a basic but broad range of experience with different approaches, you will be able to develop your own work further.

NEGATIVE SPACE

Negative space is the space around objects. It links the objects together and helps us to see the composition as a whole. As such, it is the underlying structure that forms the composition. We usually look at and recognize objects, but are seldom aware of the spaces between them. However, if you draw objects as individual items without considering the spaces between them, they tend to have no relationship to one another and will float in a void.

Negative space places the objects in a context and sets up relationships between them. An example of a work in which the use of negative space is important is *The Battle of San Romano* by Paolo Uccello (c.1396-1475), in which the shapes between the horses' legs, for example, are as considered as the actual legs themselves. This use of negative space helps to guide the eye through the composition. Edgar Degas (1834-1917) was also a master of negative composition, especially in his paintings and drawings of racehorses. Also worth looking at is Vincent van Gogh's (1853-90) *Sunflowers*; notice the shapes he has created between the flowers.

CHIAROSCURO

By using a strong light to illuminate a still life, you can create very dark shadows and bright, light areas. You can then add tone to the drawing to express this extreme example of light and dark, which is known as *chiaroscuro*. There are many good examples of artists who have used chiaroscuro in their work, but possibly the artist who is most closely associated with the technique is Carravaggio (1571-1610). He used tone in an organized, formal way (for modelling forms or differentiating between objects or planes in space), in contrast to Rembrandt (1606-69), who used the extremes of light and dark to create dramatic, atmospheric effects. This latter approach to tone is the method that you will use in this chapter. The more formal aspects of tone are covered in later chapters.

MEASUREMENT AND PROPORTION

In a still life, the positions and proportions of objects remain constant throughout the drawing; this enables you to judge whether you have drawn them accurately (except, of course, when you want to distort the shape, form, or size of objects deliberately). Although measuring is important for most drawings, do not worry about being absolutely accurate. Be as accurate as necessary for the drawing. The still life is the starting point for your drawing, a reference to help you, but you are not reproducing it exactly. From time to time, ask yourself whether the proportions of the objects look right. If not, correct them using the still life to help you.

PROJECT 1

NEGATIVE SPACE AND CHIAROSCURO

One six-hour drawing (including setup)

Materials: still-life objects, white sheet or paper for background, spotlight or directional lamp, window-mount, 22- x 30-in paper, charcoal, compressed charcoal, plastic eraser

Selecting still-life objects

Your choice of objects is important. It is very easy to select things that are not appropriate for this exercise, while by choosing the right objects you can avoid all kinds of unnecessary problems and side issues. Do not use objects that have any decoration on them, because at this point patterns and decoration will create confusion. Also, do not choose any transparent objects such as bottles or glasses. Wine bottles that have been painted with white or black emulsion paint to make them opaque are very good.

You will need about half a dozen objects with simple forms: for example, a vase, a brick, a jug, a casserole dish, a painted bottle, a stoneware pot, and so on. Make sure that the objects are different sizes, forms, and tones. For instance, you could choose a small, dark, rectangular object, a tall, thin, white, cylindrical object, and a fat, squat, spherical object. So even before you start to draw, your subject matter will consist of an array of simple objects that already possess different characteristics.

Creating the setting

Push a table flush against a wall and cover it with white paper or a white sheet. If the wall is not white or a plain, light color, cover the area directly above and behind the table with white paper or a white sheet as well. It is necessary to push the table up against the wall for two reasons. First, this limits the depth of field, or the distance from the front to the back of the area you are drawing, and eliminates any unnecessary objects from the background that might appear if the table was in the middle of the room. Second, and more importantly, an artificial horizon line is created where the top of the table meets the wall. This line is crucial because it is your starting point for the negative-space drawing, and you will be assessing the objects in the picture plane against it.

Arranging the still life

Having collected your objects, you need to consider how to arrange them for the drawing. Ad hoc arrangements sometimes work perfectly well, but for this exercise it is best to think about your arrangement before you proceed. Most importantly, avoid a symmetrical arrangement—one with the tall objects at each end and the rest gradually diminishing in size towards the center. Another unsuitable arrangement would be with all the tall objects at one end, gradually diminishing down to the smallest objects at the other end. Nor do you want to place the objects in a straight line across the table. You need to make a small but interesting depth of field by overlapping some objects in front of each other. The objects should not stand in isolation; one or two standing on their own is all right, but not all six. Finally, the dark objects should not be grouped together at one end of the composition and the light objects at the other.

The first time that you attempt this project, place yourself directly in front of the group if possible. Try out a number of different arrangements until you are satisfied with one that appears to be balanced and rhythmical without being too ordered. Once the group is set up, make a small, quick, outline drawing from your proposed drawing position. Look at your sketch and decide if the composition works; if not, make any adjustments that you feel would improve it.

Using a window-mount

To select your composition, hold up the window-mount towards the still-life group and look through it. If you are right-handed, use your left

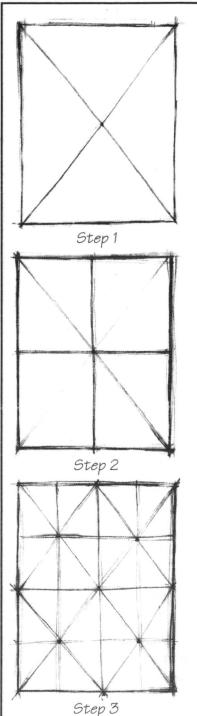

HOW TO MAKE A WINDOW-MOUNT

A window-mount is a very useful device for framing and organizing a composition. You can buy plastic mounts with a grid printed on one side, or you can make one quickly out of an 8½- x 11-in sheet of card stock or stiff paper.

To make one yourself, take an 8½- x 11-in sheet of card stock or stiff paper. Draw a line from one corner to the diagonally opposite corner. Repeat this with the other two corners. This locates the center of the sheet (Step 1).

From the center, draw a horizontal line and a vertical line. You now have four rectangles and a diagonal line running across them (Step 2).

Subdivide the rectangles again so that each is made up of four triangles. You now have the center of each rectangle. Draw a horizontal line and a vertical line through the center point of each of these four smaller rectangles (Step 3).

You should now have a central rectangle that has the same proportions as your 22- x 30-in sheet of paper. Cut out this

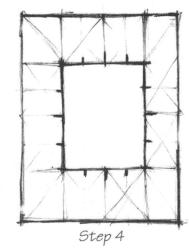

rectangle and you have a window-mount with four measuring marks along the top, bottom, and sides of the edges of the window (Step 4).

POSITIONING THE EASEL

Position your easel in front of the setup, about 5-6 ft (1.5-2m) away. It should be placed at right angles to the still-life group so that your drawing board does not obscure your view. Ideally, if you are right-handed you should have your left side towards the still life, and vice versa for left-handed people. When you are happy with your position, draw around the feet of the easel so that if it moves accidentally, you can place it back in the same position. Attach 22- x 30-in paper to your drawing board with masking tape.

You should stand for this type of drawing, so place your drawing board on the easel with your eye level approximately two-thirds of the way up the paper. Distortions always occur while you draw, and if you sit you will not be in a position to spot them. If you stand, you can move back from

If you don't have access to an easel, prop up your drawing board against something like the back of a chair. your drawing regularly to view it, and you will be able to see-and correct-distortions as they occur.

hand to hold the mount, and vice versa if you are left-handed. Always try to look at your subject from exactly the same position. Some students prefer to attach the window-mount to the top

edge of their drawing board.

Choose a composition that you find interesting. Do not have any objects going off the edge of the picture. In other words, only have complete objects in your composition.

The first mark

You are going to draw the negative space. Think back to when you placed the table against the wall, creating a horizon line for the drawing. It is this line that you use to enter the drawing and assess the objects. Looking through the window-mount, see where the horizon line meets the inside edge of the mount on the left-hand side. Is it a quarter of the way up the side, or halfway up, or somewhere in between? When you have decided, place your charcoal in the corresponding position on the left side of your paper and begin to draw the horizon line. It is

important at this point to find the angle of the line. Do not assume that it is horizontal from your viewpoint. To find the angle, compare the horizon line to the straight edge of the window in your windowmount. How does it compare? Try to re-create this angle on your paper as you draw the horizon line.

Draw this line with pressure until it meets the first object. Don't make it too light, as if you are afraid of it. Draw up and over the object, carefully assessing its silhouette and proportions. Look carefully as it is important that you observe the individual character of each object, noticing, for example, the lip around the top of a bottleneck. As the line proceeds over the top of the object and down the other side, it might hit another object. Your line must then change direction and follow the silhouette of that second object. Otherwise, continue down the side of the first object until it comes to the horizon line again. Follow the horizon line until it meets the next object. Continue with this procedure until you reach the other side of your paper. In effect,

> Negative space drawn correctly (Step 1a, below left) and incorrectly (Step 1b, below right)

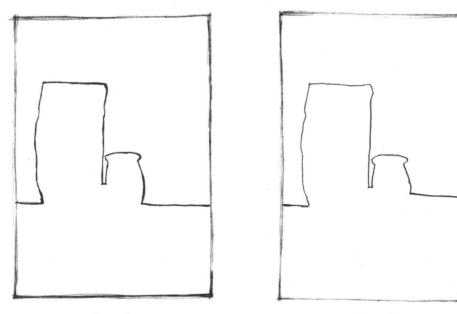

Step 1a

Step 1b

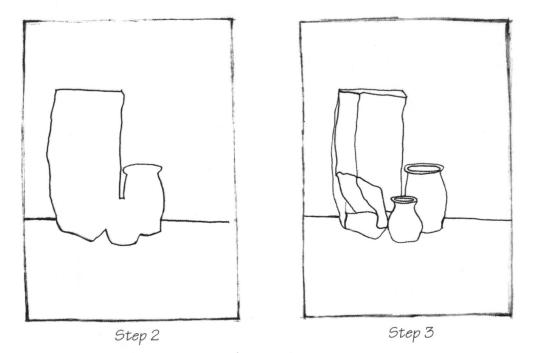

you have drawn the top half of the objects in silhouette with one line that splits the paper in two (Step 1a).

Once you have done this, assess whether the objects look in proportion. A basic mistake made by some students is that they don't keep the horizon line at a consistent angle across the paper and the composition starts to become disjointed and distorted as a result (Step 1b).

For the next stage, place the charcoal on the point where you started the drawing, and retrace the first line until it meets the first object again. This time, follow around the lower silhouette of the objects. As with the top line, observe the objects carefully, measuring their relative proportions by sight. Continue this line until you reach the right-hand edge of the paper. This will give you three definite shapes: the shape of the wall in the background–negative space; the shape of the objects; and the shape of the tabletop–also negative space (Step 2).

Once you have completed this, you can fill in what is referred to as

the *object space*, or the space occupied by the objects, rather than the space around them. In other words, you now draw the objects themselves (Step 3). It could be, at this point, that your drawing is slightly distorted or out of proportion. Don't worry as this happens to most of us. Just persevere with the drawing and make the necessary adjustments.

Chiaroscuro

You now have the composition drawn out. Next, you need to set up a direct light source that provides contrasting tones—light lights and dark darks—across the group. A spotlight or a directional lamp with a strong bulb are best. Try to cut out any other light source in the room (draw the curtains and turn off the overhead light) so that there is only one light source, which will make the lighting on the still life quite extreme and dramatic. Position the light to one side so that it casts shadows across the objects from either right or left.

To emphasize the atmospheric, chiaroscuro effect that you are

WORKING WITH THREE TONES

It can be difficult to distinguish between what is dark and what is not because we are presented with a lot of tonal transitions. The best way to sort this out is to make a scale consisting of three tones: black, gray, and the white of the paper for the lightest tone. Apply this scale to your observations by classifying each area of tone in the still life as one of these three tones (either very dark, a mid-tone, or very light). If you think, for example, that something is nearly black, adopt it as being black. When the drawing has progressed sufficiently, you can introduce greater subtlety to the three tonal areas.

aiming to capture, squint your eyes as you look at the subject. This will obscure much of the detail and help you to see the subject as areas of tone. If you look at the group with your eyes fully open, they will adjust to the shadows and begin to pick out small details, which is not what you want. So, squinting your eyes, look at the group through the windowmount. Then, over the top of your original drawing, begin to draw the outlines of the shapes of the darkest areas.

A problem that tends to arise for students is that they want to remain truthful to the

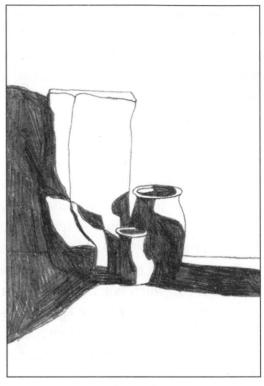

Step 4

shape of the objects. This is definitely not what you should be seeking. Tones should be seen as areas that fall across objects, and the edges of objects may merge with shadows and become one area of tone. Don't worry about this loss of definition; objects will still be discernable because you are rendering them as the light affects them, and everyone is familiar (although perhaps unconsciously) with light and how it functions.

Once you have drawn in the outlines of the darkest areas, fill them in using compressed charcoal to produce a black and white drawing (Step 4).

The next stage is to create the gray areas. This is easy and enjoyable. Lightly smudge the charcoal all over the drawing with the flat of your hand, eliminating all the areas of white paper (Step 5). This creates mid-tones and an atmospheric effect. At the same time,

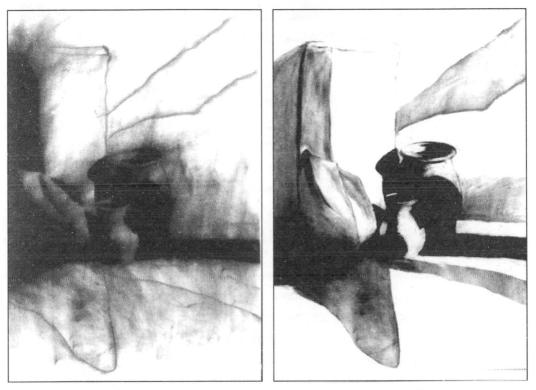

Step 5

Step 6

the objects will recede into an illusory space. At this point you may need to reestablish the darker areas as the smudging will weaken them.

The final stage is to bring the white areas back. Do this by squinting at the subject in order to observe the lightest areas. Then use a plastic eraser to establish the light areas in your drawing (Step 6).

Once you have completed these three tonal stages, you can become more subtle about the tonal changes. Observe the group with your eyes fully open so that you can see the subtler changes in tone that exist. When you have finished, you should have a dramatic, atmospheric, chiaroscuro drawing after the manner of Rembrandt.

Do a number of these drawings using a variety of simple compositions in order to build up your confidence.

PROJECT 2

NEGATIVE SPACE AND CHIAROSCURO

One six-hour drawing

Materials: still-life objects (see previous project), white sheet or paper for background, large sheet of black paper, spotlight or directional lamp, window-mount, 22- x 30-in paper, charcoal, compressed charcoal, plastic eraser

This project uses the same techniques as the previous one (see page 95), but your drawing skills will be extended by enhancing the group of objects and making the setup more complex.

Place a table against the wall and cover it, and the wall behind if necessary, with a white sheet or piece of paper The next step is to make the tabletop and background more complex. Take a large piece of black paper, tear it into strips, and stick the strips down on the backdrop and the tabletop, thinking about the composition as you do so. Then place the objects on this setup, but this time include more objects and create a greater depth of field. Some objects should be near the front of the table and can even overlap it. The light should be positioned in front and to one side of the table so that shadows are cast back across it at an angle.

Choose your composition carefully through the window-mount. When you are happy with it, begin drawing as before, from the lefthand edge of the paper, following the horizon line and finding the objects above it. Then do the same for everything below the horizon line. Return to your starting point again and come back along the top line, picking up the places where the black paper establishes the vertical plane of the wall behind the table. Then do the same along the bottom line, establishing the horizontal plane of the tabletop and picking up objects in that plane.

You need to measure the objects more accurately than you did in the previous project, and locate them more carefully in relation to each other, but there are two things that will help you: measuring guides and

vectors of analysis. If you have measuring guides or marks on the sides, top, and bottom of your window-mount, dividing it into halves and quarters, you will be able to locate each object's height and width in relation to these marks, as if there was a grid across your viewing area.

Chiaroscuro

When you have established the composition, you can begin to think about tone. Position the light at the front and to one side, with the light falling diagonally across the setup, so that the shadows imply planal recession across the tabletop and a change of plane, or direction, on the wall. Think of the tabletop as one plane (horizontal) and the wall behind as another plane (vertical). The black shadows travel back across the table towards the wall,

VECTORS OF ANALYSIS

A helpful observational technique, which can be used in conjunction with measuring guides on a windowmount, is to use what are known as vectors of analysis. A vector is a direction. Take the direction of a line, for example on the side of an object, and extend it. Such a line will often pick up on a line on another object in another part of the composition. This creates a relationship and a point of contact between the two objects.

and in some cases up the wall. When you add these shadows to your drawing, they will indicate receding space and a large depth of field.

Continue as before, drawing in the outlines of the darkest tones, remembering to squint your eyes to simplify the tones. Draw all the dark areas first. Students are often confused at this stage by the black paper. The areas of black paper in shadow will be black, but where it is lit, these areas will appear gray. Tone depends on the amount of light falling on that area: white surfaces can become dark tonal areas if they are in dark shadow, and black surfaces become a mid-gray where they are strongly lit. What you have to remember is that you are looking at the effects of light.

Continue as in the previous project, developing the dark, midtoned, and light areas, until you have a very strong, atmospheric, spatial drawing.

CHAPTER 2

TEXTURE

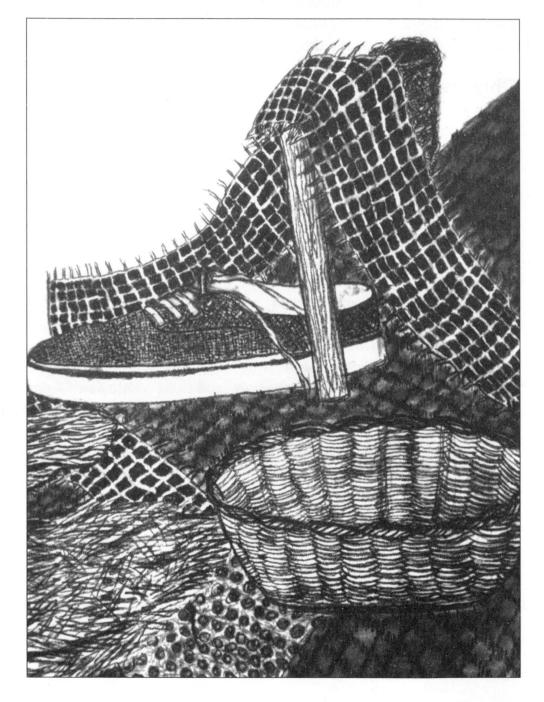

S pace, form, light, and atmosphere in a subject are not the only concerns that occupy artists. The challenge, conscious or not, of creating a sense of touch through visual illusion, whatever the subject matter, has also always excited artists. From grandiose objects made of gold or silver to the everyday earthenware pot, or from a peach to a cabbage, the depiction of texture has been a liberating area of work for artists. It has allowed them to experiment with their medium and to show off their abilities. Moreover, the implied suggestion of texture and surface qualities has never aligned itself with politics, academic ideas, or movements. It is what it is.

In the past, texture was as important to artists in the classical tradition as it was to those working in a more romantic or naturalistic way. Whatever school or background they came from, these artists all imbued their objects with the idea of surface qualities, although in different degrees of intensity. While some artists slavishly labor over the minutest textural details, others just imply these qualities with sublime simplicity by using a few statements or marks. Whatever approach is taken, the illusion of texture can be exciting both for the artist to create and for the viewer to perceive.

Texture is a very important element in our visual understanding of the world and it is appropriate in drawing at any level. It can be executed as a labor of love or put in as a mere suggestion, but however it is presented it is understood by all. We know and understand immediately what the artist is trying to convey.

There are many examples of work concerned with texture, not only in still life but in most other subject areas, too. Look at stilllife drawings that convey texture, but also look at art using other subject matter, such as landscapes and interiors, and using other mediums, too. Because paint is a medium that particularly lends itself to this approach, there are many more paintings than drawings available that describe texture.

PROJECT 1 MARK-MAKING

One two-hour drawing

Materials: 22- x 30-in paper, charcoal, compressed charcoal, plastic eraser The aim here is to depict your sense of touch through your visual sense.

First of all, you must become familiar with your drawing equipment, which in this case is charcoal and an eraser. In order to discover the ways in which these drawing tools can be used for describing texture, fill a sheet of paper with a vast range of different types of marks using the charcoal and eraser. In doing this you will be starting to build up a vocabulary of mark-making that you can refer to later, when drawing textural objects. Try not to be obvious with the way you make marks. Be inventive and try using your eraser over the marks to push them or reduce them.

Be aware of the different ways in which you can hold the charcoal to make marks. Try using the side of the charcoal, pulling it down the paper to make a sharp line. Then try dragging it across the paper sideways. If you need to get a sharp, thin edge, snap the charcoal in two. Marks can be intuitive, like scribbles, to describe an organic type of texture, or they can be regular and systematic, creating a sense of order and regularity that can depict man-made textures.

Right: Examples of mark-making

Try making marks in the following ways: straight, harsh marks; fluid marks; stabbing marks; caressing marks; thick marks; thin marks; circular marks; triangular marks; light marks; dark marks; unconscious marks; conscious marks. Don't just stick to these suggestions; add some of your own ways and types of marks. You will be amazed at what you can achieve within the limitations of charcoal and an eraser. Save this sheet as reference for future drawings.

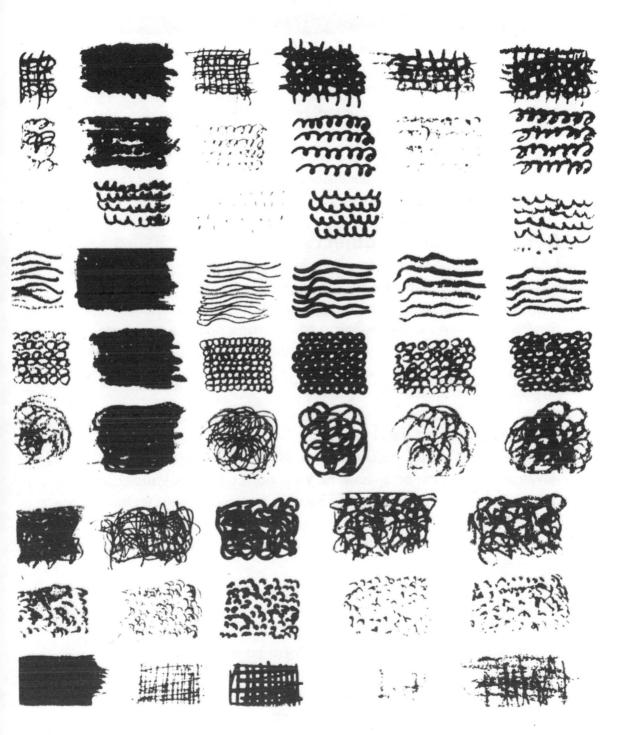

PROJECT 2

STUDIES OF TEXTURAL OBJECTS

Approximately one-half hour per object

Materials: textural objects and surfaces, 22- x 30-in paper, charcoal, compressed charcoal, plastic eraser

Before engaging in a concentrated and complex drawing of texture, you need to research the idea to understand what it is you are about to draw and what you are trying to achieve.

Selecting textural objects

Collect a number of objects that have varying textural qualities. You will need objects that are rough, smooth, hard, soft, reflective, dull, furry, man-made, natural—anything with an interesting texture. Seaweed, a worn piece of wood, a rough stone or brick, a sponge, string or rope, a mop, coarse fabric, a dishcloth, a straw hat, a basket, shells, bread, a bandage, cotton, a teddy bear, leather, and paper are just a few possibilities.

Drawing a textural object

Choose one of these objects to draw. At this point, you want to develop a feeling for, or a sense of, your object. Handle your chosen object with your eyes closed and be very aware of how it feels, as it is this sense of touch that you are going to draw. Try to understand how the object is constructed. Is it man-made or organic? Is it regular or irregular?

Now set up the background (see "Space and Light," Project I, page 95), placing the object on a white tabletop with your easel positioned nearby. Take a piece of charcoal and quickly draw the outline of the object, giving the general idea of the form or shape. Make your drawing as large as you reasonably can, filling the paper.

The next step is to understand and analyze the texture of the object. You are not going to draw this object in minute detail.

The intention is to understand the structure of the object and how the structure contributes to its texture. At the same time, think about how you can simulate the texture through marks made with the charcoal-making visual marks that tell us what that object is made of, marks that are a metaphor for that texture. For instance, if you are drawing a block of wood, you do not need to copy every grain that you can see on it; you should try to *imply* the grain.

There is no mystery to this way of drawing, and the approach can be quite graphic. If you cannot think how to imply the grain of wood, think about the simple way in which wood grain would be indicated in a cartoon or comic book, and use this as a starting point. A block of wood could first be drawn to show its form—i.e., that it is a threedimensional object. It can then be turned into a wooden block by implying the grain of the wood. Where the grain goes over the edge of the block, the change in direction of the grain is followed. This gives the illusion of the texture of

wood; the change in direction also gives an understanding of the form of the object.

> Textural study of a block of wood

TEXTURE

Above and below: Textural studies of objects

Once you have an understanding of a particular texture and a way of implying it, you can draw that texture without necessarily looking at it anymore because you have created a metaphor, or language, for

it and all you have to do is implement it. Remember, however, that the process can be very quick (if you are drawing cotton, for instance), or it can be very concentrated and lengthy (if you are drawing something like a wicker basket), depending on the

subject. Look at the drawings of Leonardo da Vinci (1452-1519), which

include both very beautiful close observations of nature (flowers, roots, and so on), and interesting textural studies of running water. Look, too, at the studies and drawings of Max Ernst (1891-1976), who was a master at using texture. Some of the object drawings of Fernand Léger (1881-1955) are also worth studying.

Do several drawings of different textural objects. After a few drawings, you should be feeling reasonably confident about your achievements.

PROJECT 3

A few minutes for each drawing **Materials:** textural surfaces, thin paper such as newsprint, charcoal, compressed charcoal

Frottage creates an impression, in charcoal, of the surface over which the charcoal is rubbed. For example, if you try frottage using a wooden floorboard, you will get an impression of the surface of the wood. Use thin paper (try newsprint, which is a cheap paper available from good art shops) and make rubbings of as many different textured surfaces as you can find, both indoors and outdoors.

Examples of frottage

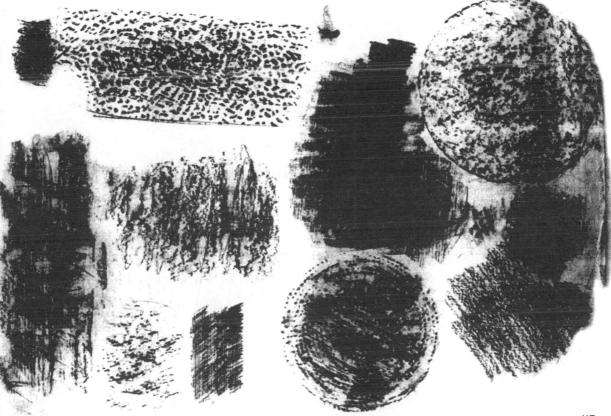

Stable surfaces are best for this project. For example, you can try frottage on a variety of walls, a variety of floors, pavements, grating, fences, drain covers, and so on. Experiment with many different surfaces (soft and hard) and see what results you get.

Frottage should help you with your own ideas about mark-making and will help you to build up your vocabulary of textural marks.

PROJECT 4 TEXTURAL STILL LIFE

One six-hour drawing, including setup

Materials: textural objects (see Project 2, page 110), textured surface or fabric, 22- x 30-in paper, window-mount, charcoal, compressed charcoal, plastic eraser

You are now going to embark on a textural still-life drawing, but first you need to set up a suitable arrangement. By now, you will probably have collected a certain number of objects, but as you become more familiar with the idea of texture you will probably have other ideas about what you want to draw. So now might be a good time to collect a few more objects.

Setting up a textural still life

Push a table flush against the wall (see "Space and Light," Project I, page 95), and place something over the top that covers the whole surface to give an underlying texture on which to place the objects. A cotton bedspread is good because it has a loose texture, yet it also has a structure. Place your objects on this, laying some of them side by side and scattering others on top of each other. Remember that

Right: Textural still life

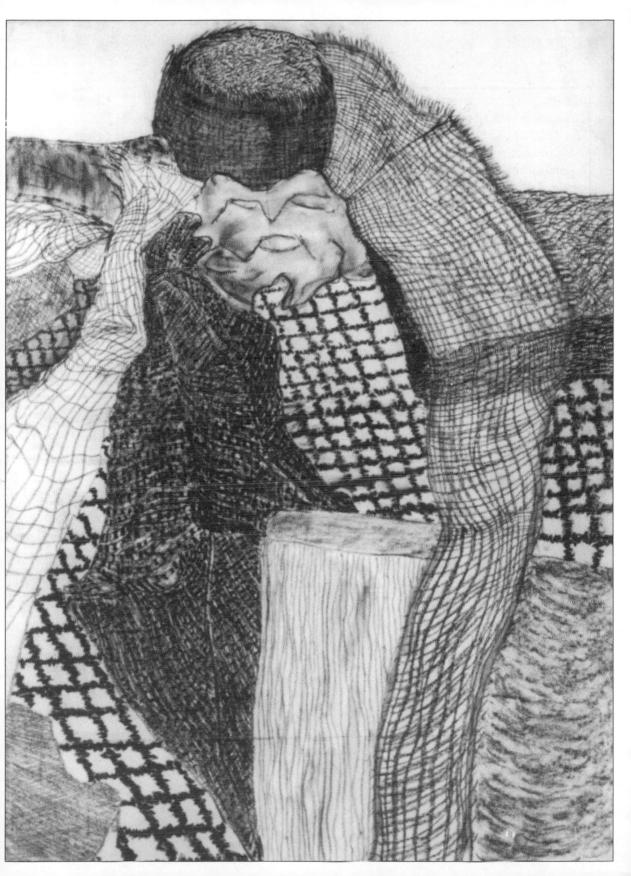

Don't draw one object in isolation and then move on to another object in a different part of the setup. Instead, build up your drawing gradually by working on one area, and then moving to a contrasting texture next to it until you have completed your drawing. adjacent objects should contrast with each other in texture and tone if possible, so try not to put similar textures next to each other or the drawing will become confusing.

Starting to draw

Use the window-mount to select your composition. As this is a complex and concentrated drawing, do not attempt to draw the whole arrangement. Choose a section of the group that offers you a simple yet exciting

contrast of textures. Be prepared to move objects around until you find a satisfactory composition.

Start by finding the outline of the objects and draw them as they relate to each other. You can use negative space and horizontal and vertical lines (see "Space and Light," Project 1, page 95) to help with the measurement and placement of objects in relation to each other. This will help you construct the basic composition for the drawing. When you have completed this stage, begin to draw the textures.

Remember to refer back to your previous textural drawings and frottage for ideas. Also, have a spare piece of paper at hand to experiment with different ways of drawing textures as you go along. The negative texture—the surface on which the objects are lying—is just as important as the textures of the objects themselves.

CHAPTER 3

FUNDAMENTAL FORM

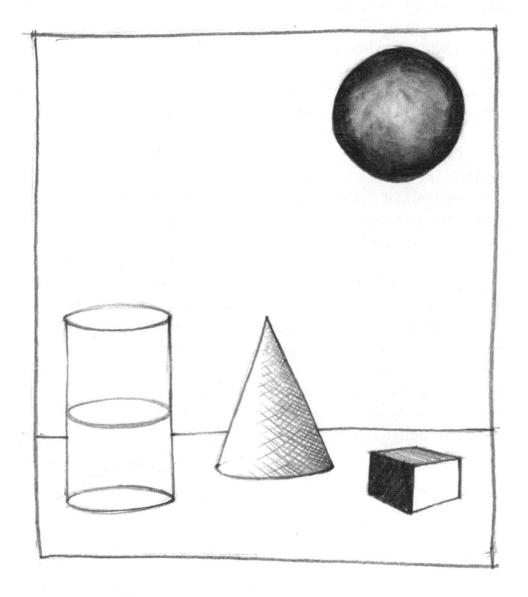

I n this chapter we will look at the illusion of three dimensions (form) on a two-dimensional surface (a flat piece of paper). First, however, it is essential to understand what is meant by the term *form*. Many people confuse the idea of form with the idea of shape; people often refer to shape when they really mean form. Shape is flat and two-dimensional and is bound by a perimeter, whereas form has volume and is threedimensional. In early Byzantine paintings, artists would top-light the heads of saints and paint the figures with limited or no space behind them. This created a sense of form as relief, like a relief carving. Approaches to describing the three-dimensional nature of things gradually developed from the relief into the depiction of fully three-dimensional forms in more naturalistic or constructed spaces.

When we draw from observation, we are creating the illusion of form. This can be achieved in many ways, but, like all aspects of drawing, it is only a part of the whole subject of still life. In fact, without particularly focusing on form, we have already touched on it in the previous two chapters. In Chapter 1, the use of chiaroscuro provided an understanding of objects existing in space and consequently suggested a three-dimensional world. In Chapter 2 we looked at the way in which the texture of an object can help to show its form.

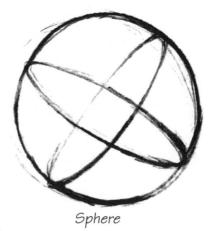

DRAWING WITH FUNDAMENTAL FORMS

There are countless numbers of different organic (natural) and geometric shapes and forms, but the drawing methods in the following projects make use of four fundamental forms: the cube, the sphere, the cone, and the cylinder.

How do we go about creating the illusion of form through drawing? The usual way is by observing and analyzing the subject in terms of the underlying fundamental form or forms. You can then draw the basic form of the object as a cube, sphere, cylinder, or cone, or a combination of any of these, modifying or emphasizing it where necessary. Some objects are quite simple to categorize, whereas others offer a choice and you will have to decide which will work best. This method of working enables you to break down the complex visual world into simple units that you can then embellish as necessary.

Once you have decided which fundamental form your object is based on, you can use one of a number of drawing techniques to demonstrate your understanding of that form.

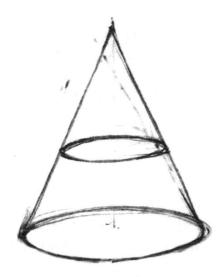

Cone

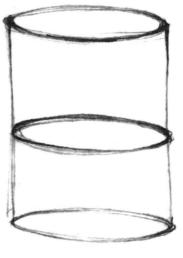

Cylinder

Before starting, you may find it helpful to practice drawing ellipses and the four fundamental forms from different angles (without using perspective). For instance, try drawing a cube from above, below, side view, and so on.

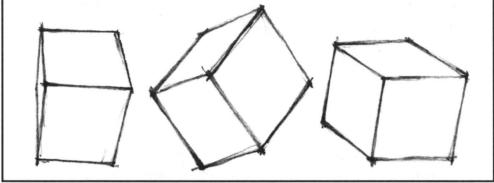

PROJECT 1

THREE TECHNIQUES FOR DEMONSTRATING FORM

Three three-hour drawings

Materials: still-life objects, window-mount, four sheets of 22- x 30-in paper, two to three sheets of paper for practicing, 2B and 3B pencils, plastic eraser

This project looks at three simple ways to denote fundamental form: crosssectional analysis, modelling with tone, and crosshatching.

Set up a table against a wall and create a plain backdrop. Then select a number of objects. At this stage, do not choose any items with very complicated or difficult forms, but also do not choose anything too simple. For example, do not use a straightforward cube or cylinder, but select objects that are variations on these forms. The objects that you chose for the projects in "Space and Light" (pages 92-105) will probably do very well, but you could select different things. Construct a still-life group, bearing in mind the points raised in that chapter about the placement of objects.

Cross-sectional analysis

Set up your easel with drawing board and paper. Hold up your window-mount towards the still-life group and select your composition. Using pencil, proceed to draw the negative space and the object space (see "Space and Light," Project 1, page 95), filling the 22- x 30-in sheet. You will end up with a drawing that consists of shape, not form. Now analyze and draw the objects by breaking them down into their fundamental forms.

To emphasize the forms, draw with line around and through each object—a technique known as *cross-sectional analysis*. This will give the illusion of three dimensions. Imagine that the objects you are drawing are transparent and that you are drawing the line onto the actual objects and can see it following the form around each object. Once

you have drawn all the objects in this way, you can add subtle details about the form to each object.

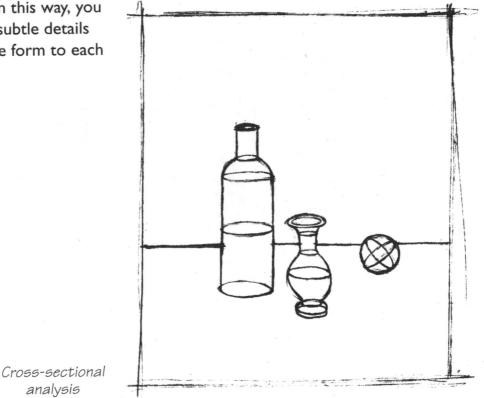

Modelling form with tone

Modelling form using tone

The human eye does not see a line around an object, but what we do see are areas of tone. Line is constructed by us in drawing: when drawing the outline of an object, we are not drawing a line that we see; we are inventing a line to denote the edge of something. When modelling with tone, we create the illusion of volume by using gradations of tone around the form. Before trying to model form using tone, try creating four different tones with pencil and eraser on a spare piece of paper. Make the darkest tone black and the lightest the white of the paper, and then make two different gray tones. As an exercise, try drawing the fundamental forms using tone.

Next, set yourself up with a new sheet of 22- x 30-in paper. Hold your window-mount up towards the still life and select your composition. Using pencil, draw the negative space and the object space, making sure to fill your sheet of paper. The next step is to model the forms with tone, with a direct light source-either real or imaginary-falling on them.

When drawing using chiaroscuro, you were drawing light and shade, or areas of different tones, without regard to the edges of objects. When using tone to model form, however, you do need to draw the edges of objects, drawing what you know to exist and using tone to depict the object as three-dimensional. The emphasis, when you are modelling with tone, should be on giving the illusion of form. This is as opposed to chiaroscuro, where the emphasis is on drawing light and shade, the form of the object being secondary to the tone.

Next, using another sheet of 22- \times 30-in paper, make another drawing of the same composition using just tone and no outlines.

Crosshatching

Take a new sheet of 22 - x 30-in paper and make another drawing of the setup using negative space and cross-sectional analysis. (You can use the same composition or a new one.) In this drawing, you are going to use crosshatching rather than tonal modelling to describe the forms.

Modelling form with crosshatching

Crosshatching consists of a series of crisscross lines that can be used to emphasize the form through tonal variation. In some of his etchings Pablo Picasso (1881-1973) used crosshatching, but he let the crisscross lines evolve almost into a scribble. Both regular and scribbly crosshatching work on the principle of creating different tones through the density of the crosshatching.

The difference between crosshatching and modelling with tone is that modelling with tone is based more closely on observation and is more often used to create gradual transitions in tone. This is because we can actually see tonal variations. Crosshatching, on the other hand, is a purely invented mark; it is not something we see when looking at objects.

Because crosshatching is artificial and constructed, it does not necessarily rely on a directional light source. However, it does rely on a certain amount of observation and an understanding of form. Also, it can be constructed in a way that is not consistent with any particular light source (imagined or real). For example, within a still-life drawing each object could be treated as if lit by a different light source from a different direction. And despite this, the whole drawing can still function as an illusion of space and form.

Additionally, modelling with tone can be used in a similar way to crosshatching (that is, in a more artificial and invented way), and crosshatching can be used observationally.

PROJECT 2 METAMORPHOSIS

Six one-hour drawings **Materials:** two objects, 22- x 30-in cartridge paper, 2B and 3B pencils, plastic eraser

Using one of the techniques from the previous project, make a series of drawings in which one object gradually metamorphoses into another.

For this project you need to select two different forms. One must be a geometric, man-made object and the second a natural object with an organic form, but there must be some harmony and connection between the two. In other words, do not choose objects with

Remember to break the objects down into their fundamental forms to give yourself a much clearer understanding of the objects. opposing forms. As an example, you could choose a garlic press and a daffodil. Although very different, these two objects both have a kind of stem with a type of head attached to it, and one could evolve into the other through a series of drawings.

Take a sheet of 22- x 30-in paper and divide it into six equal squares. Decide which technique you are going to use-cross-sectional analysis, modelling with tone, or crosshatching-and draw one of your objects in the top left-hand corner. Then draw the other object in the bottom right-hand corner using the same

technique. Then proceed to do a series of four more drawings, using your chosen technique and working from the top left corner to the bottom right, gradually transforming one object into the other.

Try this project two more times, using each of the other techniques described in the previous project. You can use the same objects or choose different ones.

Right: Here, modelling with tone and crosshatching has been used to transform a hammerhead (1) into a piece of ginger (6).

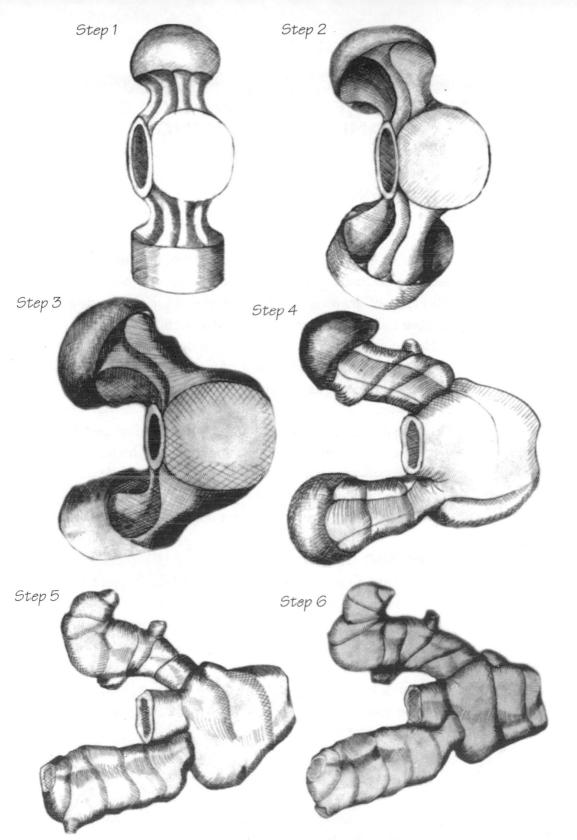

PROJECT 3

PARALLEL PROJECTION AND EXPLODED DIAGRAMMATIC DRAWINGS

One three-hour drawing and one six-hour drawing **Materials:** one object, two sheets of 22- x 30-in cartridge paper, 2B and 3B pencils, plastic eraser

This project consists of two drawings—a parallel projection drawing and an exploded diagrammatic drawing—that show how an object is constructed. This type of drawing is usually reserved for instructions on how to assemble technical objects and for instructional diagrams in car manuals. However, if you can develop an understanding of this working method, it will improve your grasp of form. And although these approaches are not obvious means of expression, it is possible to use them in that way.

You need to choose an object with certain attributes. It must be fairly simple, constructed from a number of pieces, and you must be able to take it apart, which probably means that it will be man-made and functional. An electric plug is used as an example here, but you can choose anything that appeals to you as long as it fits the criteria above.

Parallel projection drawing

Using fundamental form and cross-sectional analysis (see Project I, page 120), draw the object from a three-quarter view (meaning that you can see two sides and the top plane) using a parallel projection; that is, you are *not* drawing it in perspective. All lines that recede into the distance should remain the same distance apart (i.e., parallel). Make the drawing quite large, filling your 22- \times 30-in paper, because it is easier to recognize your mistakes at this scale. This stage of the drawing will help your initial understanding of the object.

Right: Parallel projection drawing of an electric plug

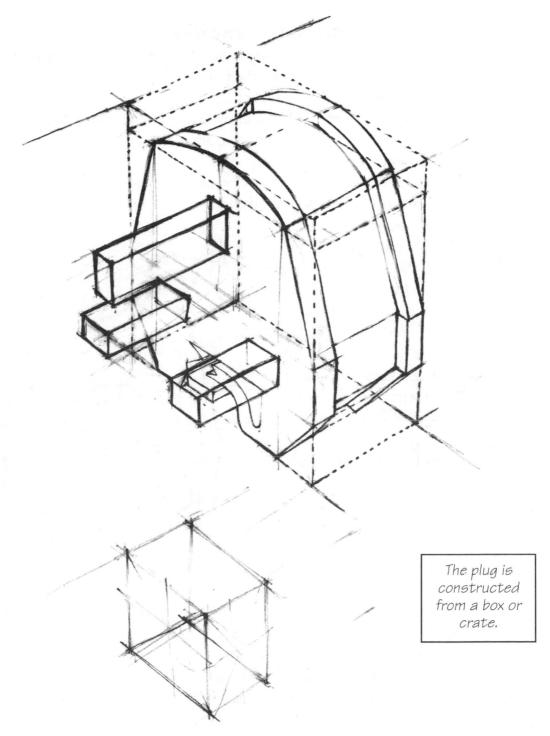

Exploded diagrammatic drawing

In this drawing the approach is to disassemble the object visually by using a parallel projection, so that the finished drawing shows the dismantled components of the object.

In the case of the plug, it is again drawn within a crate or box, but this time the crate is projected forward, altering its dimensions. It is important to keep the crate in proportion to your object on the front elevation: imagine what type of crate your object would fit into and draw it accordingly. If you are drawing a tall, thin

object don't draw a small, squat crate; draw a tall crate but, as mentioned above, make the crate longer than the object. This will help you to position each component so that it looks like an integral part of the object, and to see how the pieces relate to the object as a whole when they are disassembled and projected forward.

Now take your object apart so that you can study each component individually and set it in the framework of the overall drawing. If you are drawing a plug, first take the back part and draw it at the back of the crate, using the crate as a guideline. Also draw the internal parts (Step 1).

The next step is to project forward within the framework, using the guidelines of the crate, and draw the three brass fingers and the fuse casing (Step 2). For the final step,

Step 3

using the same projection, place the top of the plug at the other end of the crate, again using the crate as a guide to its correct position (Step 3).

Try this approach with a number of drawings of similar objects.

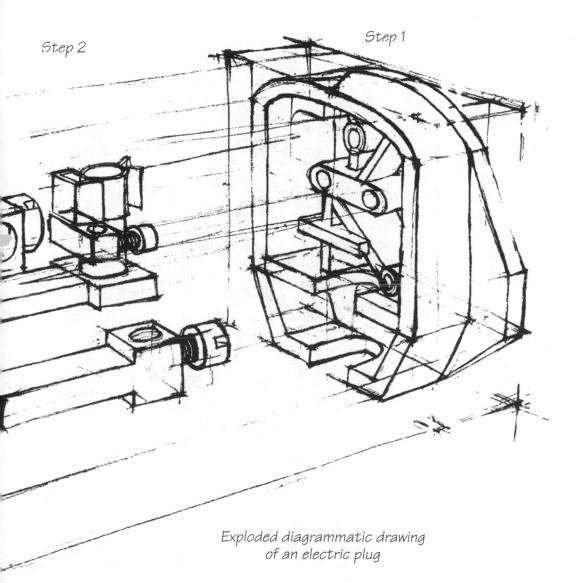

CHAPTER 4

DRAPERY

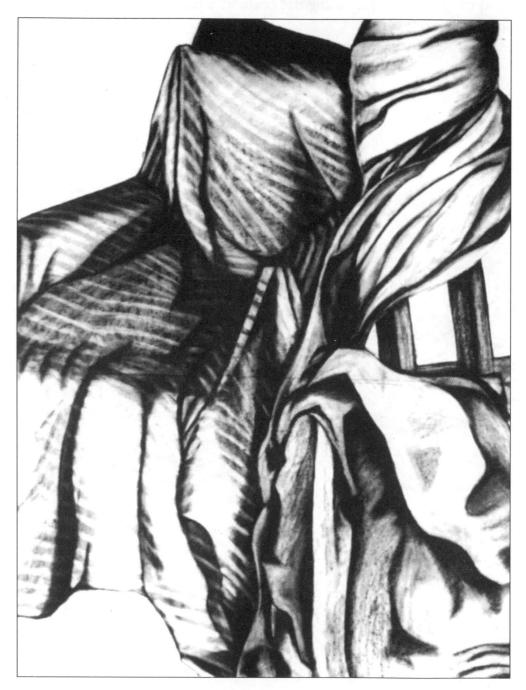

The term *drapery* refers to the artistic arrangement of clothing or material in painting, sculpture, and drawing. Drapery has been used as still-life subject matter in drawing for centuries. In the past, artists' apprentices would spend hours producing drawings of drapery as part of their training. It became such an essential part of art, particularly for commissioned portraits of statesmen or wealthy merchants, that some artists began to specialize in it. The master would paint the portrait and then employ the drapery artist to finish the background and finery. Of the many examples of drapery studies that exist, those by Leonardo da Vinci, in particular, are worth looking at. However, bear in mind that although important, drapery and clothing were usually secondary to the main subject and supported the anecdotal content of the work.

Another traditional use of drapery is in *trompe l'oeil*-the creation of an illusion of real drapery in a real setting. For example, a curtain would be painted onto a wall with a landscape painted beyond it, and at first glance they would appear to be a real curtain and a real landscape. Drapery is used in this case as a transitional device for moving from reality to illusion.

Drapery has often been used by artists as a compositional device, to create the underlying structure of a painting. In fact, in some cases its compositional function was so blatant that it bore no relation to naturalism but was purely a pictorial construct. Nicolas Poussin (c.1593-1665) and El Greco (1541-1614) both used drapery as a device, but each in a different way. Poussin manipulated drapery to help the compositional flow in his paintings and guide the eye across the picture, creating movement across the picture plane while at the same time echoing the lines of moving figures. In contrast, El Greco painted drapery very expressively, so that it flows through the picture space with a sense of monumentality and purpose. Yet drapery in El Greco's paintings still has the desired effect of guiding and encouraging the eye through and across the picture space.

The following projects focus on clothing and drapery because they are useful subject matter on which to practice creating the illusion of form and texture. You will be combining methods of drawing covered in previous chapters.

PROJECT 1 TROMPE L'OEIL

One five-hour drawing

Materials: an article of clothing or drapery, a very large sheet of drawing paper, spotlight or directional lamp, a range of graphite sticks and pencils or charcoal and compressed charcoal, plastic eraser

Choosing drapery

Because this drawing deals with tone, you need to select the drapery item carefully. Choose something like a black or white shirt or coat. Also give some consideration to the texture of the garment, as you can use this to enhance the drawing. For instance, a shirt might have a lace collar and cuffs. A black leather jacket would make a very good subject as the dense tone of the leather, the creases, and zips all make for an interesting drawing. If lack of space is a problem, you could use a small item such as a scarf or towel.

Setting up the still life

As with previous drawings, the still-life arrangement is very important. If you have chosen a shirt, coat, or something similar, place it on a hanger and hang it flat against the wall from a nail or hook. If you have chosen something like a scarf or towel, hang it directly on a hook or nail. It is also important that the background is neutral in tone (that is, white or a plain color) and that there is no patterned wallpaper. It will not help the illusion if your garment hangs too flat against the wall as

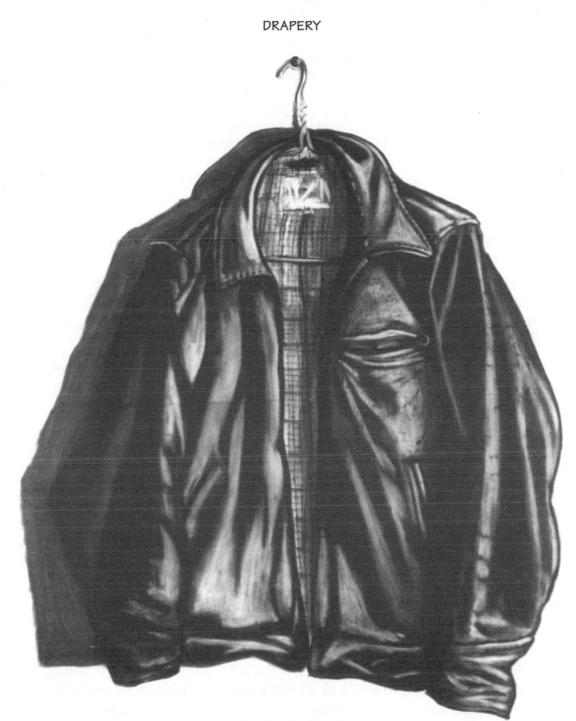

Trompe l'oeil jacket

USING EXTRA-LARGE DRAWING PAPER

If your garment needs to be drawn on a sheet of paper bigger than 22×30 in, you may be able to buy a very large sheet of drawing paper $(30 \times 44$ in or bigger); if not, you can join two or more $22 \cdot \times 30$ -in sheets together. When you do this, place the ends of the two sheets together without any gap or overlap, and secure with a strip of masking tape. The side with masking tape will be the back of the drawing.

there will be little contrast in tone between one part and another, so make sure that it hangs in a way that creates folds.

Your next consideration is lighting. You need to side-light the drapery with a strong light to create a strong shadow on the wall to one side. A spotlight or a directional lamp with a powerful bulb both work well.

The size of the garment will determine how large your paper is and therefore whether you can use an easel and drawing board. Your paper must be a little bigger than your garment so that you can draw it approximately life-size, together with the shadow that is cast on the wall. If your drawing paper is too large to use with your board, attach the paper to the wall next to your subject. Otherwise, set up your easel and drawing board as for previous projects.

Study the subject so that you see it like a bas-relief, and begin to draw. At first, concentrate on the overall composition, drawing the outline of the garment. Remember that the scale you are using is approximately life-size; and don't forget to include the hanger and the nail or hook that your drapery item is hanging from, and any shadow that is created by them. Make the drawing fill the paper but do not touch the edges, and draw the cast shadow as it is an integral part of creating the illusion. Then, using line, begin to draw the folds of the material. This will give you a basic appreciation of how the form falls and will help you understand the fluting of the folds. The next step is to model the form using tone and texture.

Tone

The aim of this project is to do a tonal drawing using observation as a starting point, but developing the drawing by using what you know to be there. In "Space and Light," when using chiaroscuro, you observed light and shade on objects and focused on drawing these areas of tone rather than trying to draw the object; in other words, you allowed the object to evolve through the drawing of tone. This is how you should approach an initial understanding of the form of the garment. Draw the tonal areas that fall across the drapery and the shadows that it casts on the wall.

The second stage is analytical rather than observational. Stand back and assess what you have achieved with the first process, and what is lacking that prevents the illusion from working. The next step is to develop a visual language for showing form. This is much simpler than it sounds because you will use the same method—modelling with tone—as in "Fundamental Form" (pages 117-125). Don't continue to draw the tones exactly as you see them; instead, try to use a system of tonal modulations to express form and space. For example, when describing a fold in the material, make the nearest point light and gradually darken the tone as the cloth recedes away from you. If part of the setup is in dark shadow—so dark that you cannot see any detail—observe that area more closely and draw what you know to be there, not just what you see.

Texture

Finally, think about the texture of the garment and how this can be implied. This not only gives a sense of what the garment is made of, but will also help in the final modelling of the form. When the drawing is finished, if you take down the garment and put up your drawing in the same place, your trompe l'oeil illusion should be reasonably convincing.

PROJECT 2 DRAPED FORM

One five-hour drawing

Materials: a large object or piece of furniture; one to two large, plaincolored sheets; spotlight or directional lamp; window-mount; $30- \times 44$ -in or $22- \times 30$ -in paper; pencils or graphite sticks if using $22- \times 30$ -in paper, charcoal or compressed charcoal if using $30- \times 44$ -in paper; plastic eraser The aim of this project is to describe the forms that occur in material draped over an object, using tonal modelling.

Choose an object and cover it with the sheet or sheets. The object should have obvious form so that you can get an understanding of what is underneath the sheet, but it should have enough interest not to make a boring composition (not something as simple as a table). You could use a chair, for example, with a back and arms. When you have chosen the object, place it 2-3 ft (1.5-2m) in front of a plain wall. You will be using the line between the floor and the wall as a horizon line (see "Space and Light," Project I, page 95). Drape the sheets loosely over the object, making sure that they reach down to the floor. There should be some indication of the form of the object underneath the covering, without too much detail. Light the draped object from the front.

For this project, it is best to work on $30- \times 44$ -in paper if you have the space. If you are working on this paper and you do not have a large enough drawing board, attach the paper directly to the wall.

Select your composition using a window-mount. The draped object should be drawn in its environment—including the floor, walls, and so on—as this will help your understanding of space. First, draw the composition using the horizon line and negative space (see "Space and Light," Project I, page 95). Then, observing the draped form carefully, try to describe the folds of the cloth by drawing with line.

Right: Draped form

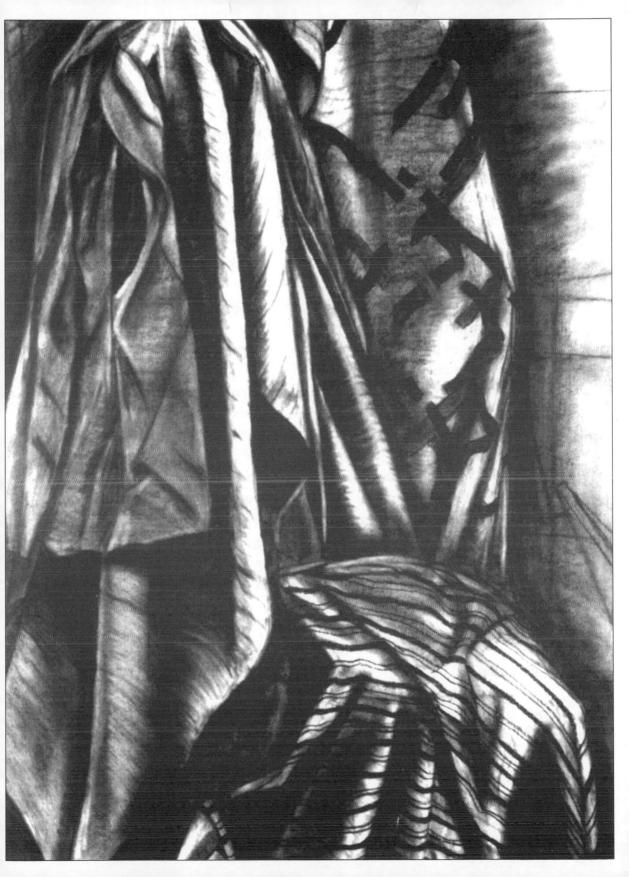

The next stage is to describe the tones in the subject. You will notice that when the form is lit from the front, the draped object appears somewhat monumental. This is because the surfaces facing you and those on top of the subject are lighter, while surfaces receding away from you get darker (unlike side-lighting, where one side is lit and the other is in shadow, and cast shadows fall from one side to the other). You need to demonstrate this tonally to create the illusion of form. Bear in mind, however, that shadows are cast by front-lighting, and that there might be some folds of drapery casting shadow or contained within shadow. Remember also that you will be using a darker tonal scale for the darker areas than the tonal scale you would use for the more brightly lit areas.

On a scrap of paper make some studies of an area where the cloth is fluted. Do one study of folds that are directly lit by the light source, and you will notice that the tonal range extends from white to black. Then make a study of an area of cloth that is in shadow. You will notice that here the full range of tone is not available, and that you have to describe the form using a lower-key, or darker, tonal range. From this you should realize that in some areas it will be necessary to use very gradual tonal transitions, and in other areas you may need to use contrasting tones to show the shadow of a fold falling on a lighter area.

Next, make small studies to start developing a visual language or system to show the form of the cloth, using a system of tonal modulations to express form and space. For example, when drawing a fold in the material, start with the point nearest to you, facing the light, and gradually darken the tone as the cloth recedes away from you. If some areas are lost in shadow, draw what you know is there, not just what you see.

When you understand this from your studies, start drawing the tonal areas of your main drawing. You don't need to refer very much to the actual draped object in front of you. You should end up with a strong, monumental drawing, showing the weight of fundamental forms, as in an El Greco painting.

PROJECT 3 WRAPPED FORM

One five-hour drawing

Materials: a large, tall object or piece of furniture; two or more large, plain-colored sheets; window-mount; 30- x 44-in or 22- x 30-in paper; pencils or graphite sticks if using 22- x 30-in paper, charcoal or compressed charcoal if using 30- x 44-in paper; plastic eraser; spotlight or directional lamp

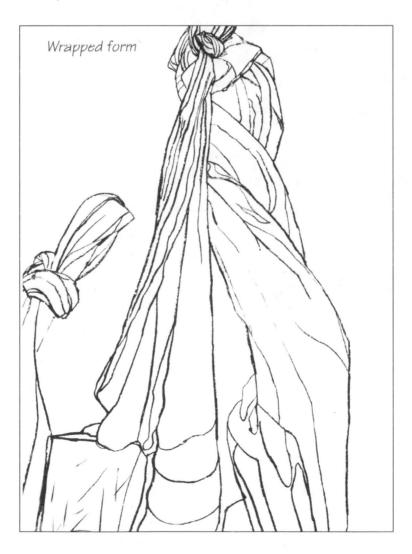

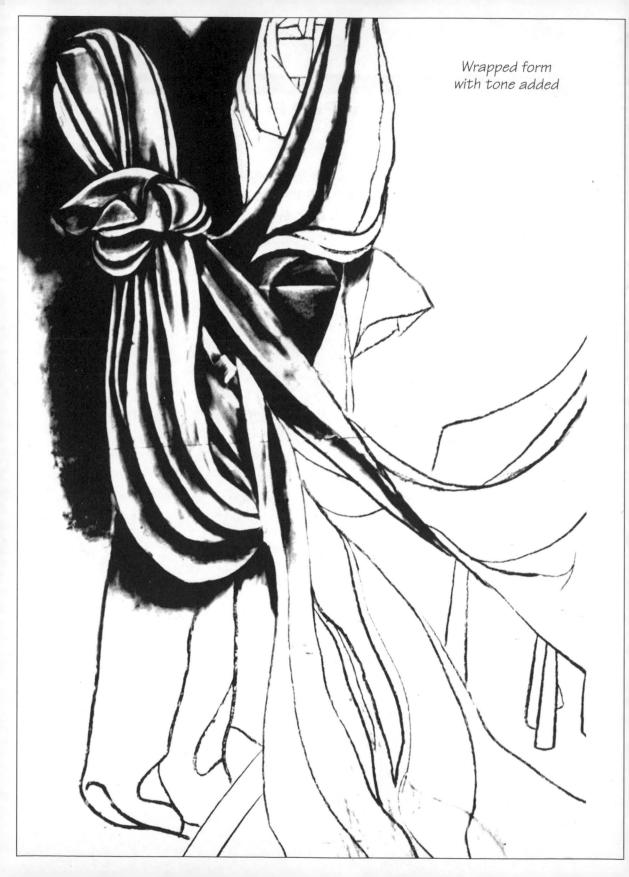

DRAPERY

For this drawing use a tall, standing form such as a coatrack, stepladder, or easel and wrap the sheets around it. If you use an easle, angle it forward to give a sense of direction and movement (as occurs in Poussin's drapery).

Place the object 2-3 ft (1.5-2m) in front of a plain wall. Instead of draping the sheets over the object, twist and wrap or tie them around it. You can make large knots with a sheet, and also leave areas of the object underneath exposed. Tie and twist the sheets around the object with a closely bunched-up effect to give a sense of movement and tension to the composition through the way the drapes are manipulated. The twisted and wrapped sheets will follow the form of the object underneath more closely than in the previous project, where the sheet was loosely draped. Light the wrapped object from the form or side.

Select your composition using a window-mount. The object should be drawn in its environment, including the floor and walls. Draw your selected composition, taking the horizon line—the line between the wall and the floor—as your starting point and drawing the negative space (see "Space and Light," Project 1, page 95).

The drawing should demonstrate the illusion of the drapery moving around the form of the object with the emphasis on line, but don't neglect tone as a device to aid form and movement. Now, still only using line, begin to draw the linear effect of the drapery as it wraps the object. Like Poussin, you should try to establish the rhythm that the line creates, and to do this you need to strengthen and weaken the line at certain points by making it thicker (to strengthen) or thinner (to weaken).

Usually, the line becomes stronger at the point nearest to you and weaker as it disappears around a form, away from you. Your drawing should be more linear than tonal, although you should use some tone. For example, if there is a large area of cloth with large folds in it, you would need to describe that area tonally. Also use tone to help delineate an edge or emphasize a line.

CHAPTER 5

OBJECTS IN SPACE

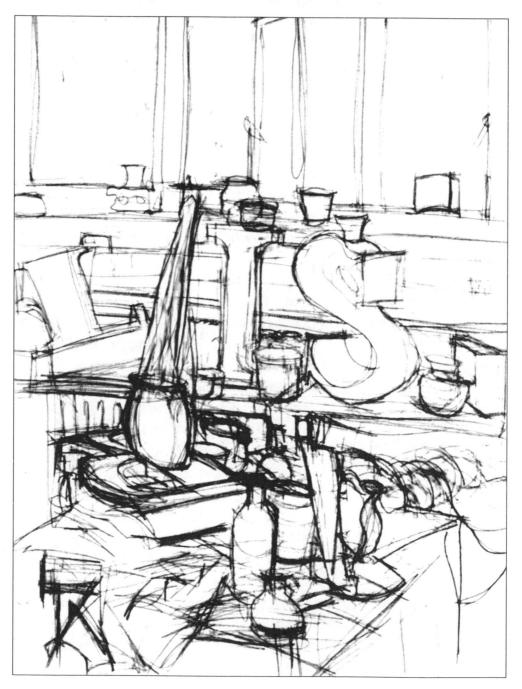

Previous projects have concentrated on the illusion of space on the picture plane, but with a relatively shallow depth of field. In the drawings in this chapter, you will be creating the illusion of a deeper space. To show this greater depth, Projects 1 and 2 involve setting up a still life in a room and placing the objects at different distances away from your position within the foreground, middle ground, and background. The drawings will then focus on the idea of space.

Artists working with still life as their main subject have usually used a very shallow space, or depth of field. This puts greater emphasis on the chosen still-life objects, in turn allowing ideas about the subject matter to come across more clearly. In anecdotal, historical, or religious pictures, on the other hand, still-life objects are usually set in a deep space or depth of field. In these paintings, the objects are subordinate to the primary purpose or content of the picture; and they often appear scattered about the scene, although they were usually strategically placed to enhance the space and composition and add symbolic or anecdotal meaning to the pictures. There are many examples of this use of still life. The Spanish painter Diego Velázquez (1599-1660) loved to use ordinary everyday objects as his subject matter and to depict them in a very naturalistic manner. For his work to be accepted, however, he usually had to place them within a religious context. His handling of still-life subject matter, nevertheless, shows that his interest lay in the portrayal of the ordinary.

Before the twentieth century, only a few artists used still life as a primary subject matter and set it in an environment with a deep depth of field. Van Gogh's *Bedroom at Arles* is a good example. This painting shows the full length of his sparsely furnished bedroom. The objects, the setting, and the way in which the artist has treated them creates a very personal and reflective comment, and provides a powerful example of how objects and their environment can be manipulated to make a

very poignant statement. J. M. W. Turner (1775-1851) used atmosphere in his interiors of Petworth to create a sense of space, although it is arguable whether these are studies of still life or interiors. It was only with the arrival of the twentieth century that the idea of space and the understanding of objects in space were looked at in a different light.

One of the new ways of understanding the potential of objects is found in the ideas of Surrealism, a movement that included artists such as Max Ernst (1891-1976), René Magritte (1898-1967), and Salvador Dalí (1904-89), and the paintings and drawings of the Italian Metaphysical artists, including Giorgio de Chirico (1888-1978) and Carlo Carra (1881-1966). These two groups of artists began to use objects in a new context, juxtaposing them in ways in which they would not normally be observed, and placing them within a deep space, such as a landscape or a twisted interior. Their pictures evoked a type of dream world.

Although all of the following projects make use of spatial compositional ideas (organizing the objects in a receding space), each provides a different approach. As you work through each one, try to make the still life the major focus, while rending and connecting objects in a relatively deep space.

PROJECT 1

CONTINUOUS-LINE DRAWING

One three- to four-hour drawing

Materials: still-life objects, plain-colored sheets, window-mount, 22- x 30-in paper, 3B and 4B pencils, plastic eraser, pencil sharpener The aim of this project is to make a gestural drawing with a greater depth of field than in previous projects. Look at the gestural drawings of interiors by Alberto Giacometti (1901-66) as examples.

Setup for Project 1

The best place to do this project is in a long room. Set up a table in the middle of the room; at the far end you will need something like shelves, a desk, or a set of drawers-something that is slightly higher than the table-on which you can put objects. Set up your drawing board at the opposite end of the room to the desk or shelves.

Arrange the drapery over the table so that it creates links back through space. It should be arranged so that it lies along the length of the table, going away from your drawing position, rather than lying across the table. Then, when you draw the drapery, it will travel into the picture space rather than across it. The drapery doesn't have to cover the tabletop completely. Arrange it so that part hangs over the front edge of the table. The drapery then acts as a visual device in the drawing by leading the eye back through the picture space.

Placing the objects

You can now place the objects strategically within the space. Look at the length of the room and in your mind's eye divide this into three areas-foreground, middle ground, and background-and group the objects at different points within these three areas. Place some objects on the front edge of the table closest to your drawing position; avoid placing them in a straight line, but overlap them slightly. Set up some more objects in the middle ground (roughly from the center of the table to the back). Place the middle-ground objects to one side of the objects in the foreground so that you can see them from your drawing position. For the background, put some objects on the piece of furniture beyond the table. You should have created a rough, asymmetrical zigzag of objects going back through space. Once the objects are in place, manipulate the drapery by ruffling it and bunching it up around some of them.

Now select your composition. You can use a window-mount, but remember that the composition should include the whole depth of the room and the far wall and ceiling, if possible. You may need to hold the mount close to your face to include all of this.

Don't worry at this stage about accurate proportions and angles (such as the side of the table, or the line where the ceiling meets the wall), as they can be corrected later. Using the continuous line, you want to get the feel of where the objects are located in the space.

Starting to draw

You are going to start with a continuous-line drawing. This means that you do not take the pencil off the paper at all until you have drawn everything in the composition. No matter how much you are tempted, do not deliberately lift your pencil off the paper, as to do so will break the momentum of the line. However, if the pencil does come off, restart the drawing at the place where you stopped.

Right: Still life set in a deep space

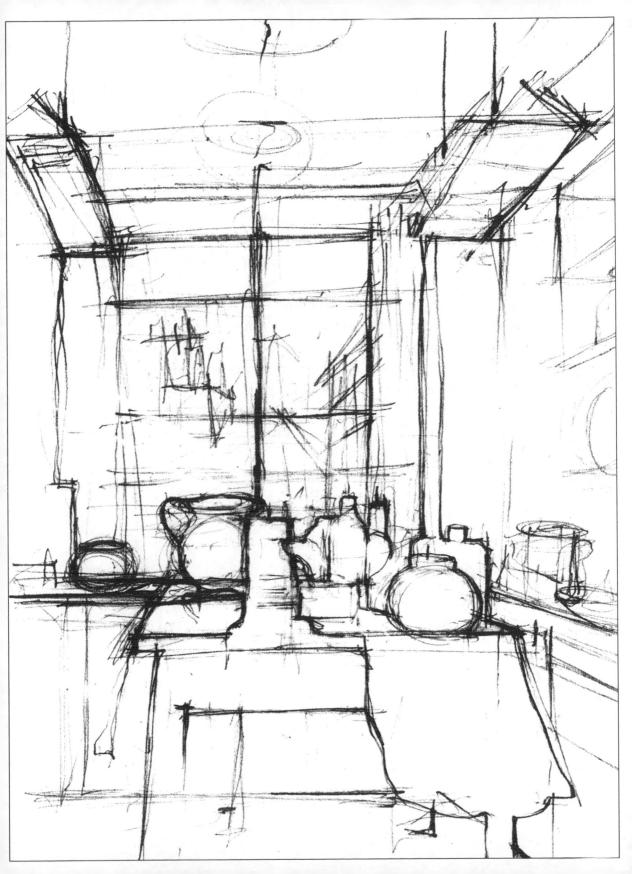

A line can be brought forward within the picture space by making it darker, and it can be moved back within the picture space if it is made lighter. Place your pencil on the paper, starting at the point where you think the edge of the nearest object is. This could be the edge of the table or a drape that hangs over the edge. Use this line as the entry point into your drawing. You could think of your pencil as a fly in a room that leaves a line behind it

as it flies from one object to another and back again. The line should move back and then forwards in space, picking up sides, edges, tops, and bottoms of objects, but without drawing a complete object.

Your final drawing may contain completed objects, but these will have been achieved at different stages. In other words, do not arrive at one object, draw it completely and then move on to the next object, draw that, move on, and so on. The purpose of the line is to activate an understanding of the whole space. Allow the line to pick up the negative space as it moves through the drawing, and let it find a corner of the room, windows, cupboards, and so on as well as the objects.

> To link objects at different points in the composition, the line travels back in space over the objects.

The line you are drawing with is a free line-it is a line of discovery. Spend about half an hour on this stage. You should end up with a very scrawly drawing. Now you can correct and establish with line, where necessary, the perspectival angles of tables, cupboards, drapery, and so on.

The next stage is to consolidate the links in space between the objects and to emphasize them. The line you are going to use now is very like the horizon line used in the early projects of this section (see "Space and Light," page 92), but instead of moving *across* the picture plane it travels *back into* the picture space (see diagram opposite).

With this rotated horizon line, pick up the nearest object and follow it, travelling over the objects that overlap, across the page, back into the space. Pick any point from the area in which you are working and link them at different points going back into the composition. These links should suggest themselves to you as you work. Do several of these rotated horizon lines, emphasizing the objects and the depth of field. Continue to develop the drawing by putting lines in, taking them out, and putting others back in, until you feel you have expressed fully the idea of the objects in space. This is best displayed in the illustration on page 149.

ASSESSING ANGLES

A quick way to assess an angle is by holding up your pencil, either horizontally or vertically, to the edge of an object, such as a table, and judging the angle made by the edge. Is it less or greater than 45 degrees? When you do so, be sure to shut one eye and, most importantly, hold your pencil as if it is on a vertical sheet of glass. You are trying to transfer the threedimensional onto a two-dimensional surface, so don't twist your pencil into the space.

PROJECT 2

TONE AND ATMOSPHERE-A REDUCTION TONE DRAWING

One five-hour drawing

Materials: still-life objects, several plain-colored sheets or drapes, spotlight or directional lamp, 22- x 30-in paper, charcoal, plastic eraser The aim of this drawing is to show atmospheric depth within the picture plane by using line and tone.

Use the same setup as in the previous project or arrange a similar one. Light the setup by directing a strong light towards the group from the front or from one side and turn off any other lights in the room to create a dramatic atmosphere. Cover your paper all over with charcoal. The surface should be completely black with no areas of white peeping through, so apply the charcoal very heavily. The technique you will use is known as a *reductive tone drawing* because you take away tone rather than add it. This will help you to understand the way a direct light performs with still life and to separate the concepts of object and light in drawing.

Choose your composition through a window-mount, making sure that you include some of the foreground, middle ground, background, ceiling, and walls.

To begin, use the eraser to draw with a continuous line, as in the previous project, exploring and discovering the objects in space (Step I, see opposite). The eraser will create a white line on the black charcoal surface, and will give you a free and open start. Things may look a little smudged and scrappy, but don't worry as the drawing will come later.

Once you have established the composition, begin to observe the light. Squint your eyes to simplify the areas of light and dark. Using

Right: Tone and atmosphere, Step 1

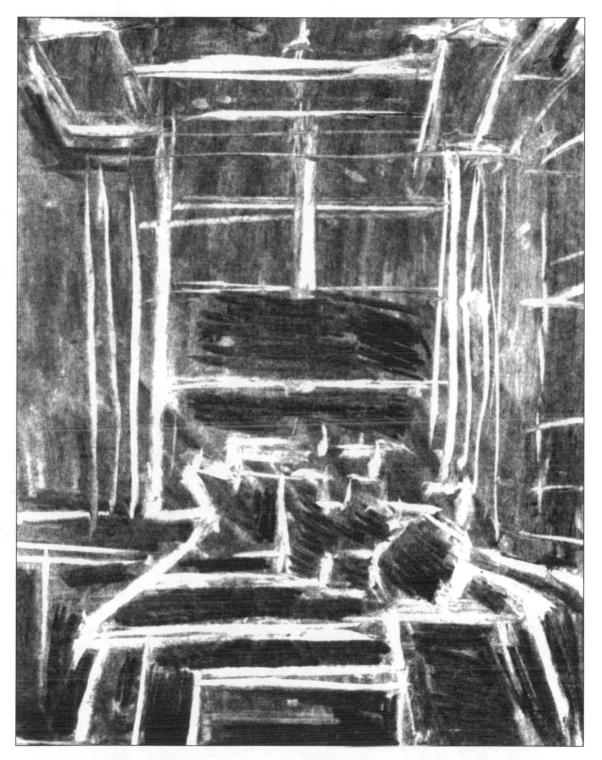

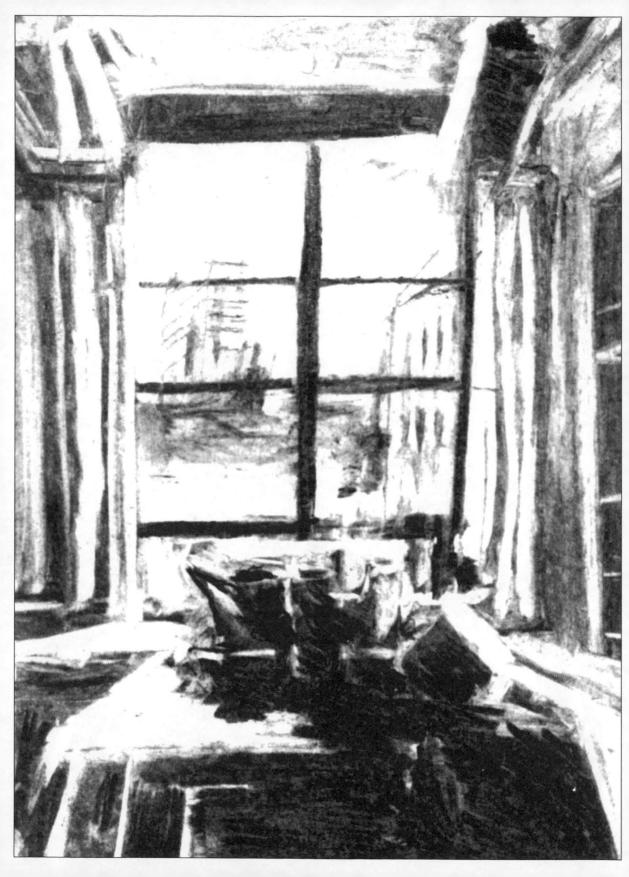

the eraser, rub out all the lightest areas. Look at areas of tone rather than objects, which means that in some places objects and background may fuse together as one shape.

At this point you should have a white and grayish drawing. The next step is to reestablish the black areas. Keep your eyes squinted as this will eliminate detail. You can keep repeating this process by bringing back the light through erasing and putting in the dark by applying the charcoal. In Turner's interiors of Petworth there is hardly any definition; light and atmosphere alone describe a deep interior space. Work your drawing until you have achieved this sense of atmospheric space (Step 2, opposite).

PROJECT 3 METAPHYSICAL DRAWING

One five-hour drawing

Materials: 22- x 30-in paper, sketchbook, pencils or graphite sticks, plastic eraser

Before starting this project, look at the work of De Chirico and also the Surrealists, whose paintings are constructed from the imagination and are symbolic of a personal time and place or event.

Think of objects and places that have some special meaning for you, in either your conscious or subconscious memory. It could be a distant memory of a place, or perhaps an insignificant object that often enters your thoughts. Or you could choose objects that reflect different times or stages in your own life. Collect these ideas, which you will use as notes and references from which to construct the drawing, by making small sketches in a sketchbook. When you have gathered a number of ideas and references and you feel your research

Left: Tone and atmosphere, Step 2

for this drawing is complete, it is then just a matter of putting the drawing together.

First, consider the environment in which you are going to place your chosen objects. It needs to be an implied deep space, but it could be imagined or observed. Again, look at De Chirico and the Surrealists for inspiration. Draw this environment using line. Then place your objects in this space so that they occupy their position convincingly in the illusion you are creating. The space does not have to be in proportion or in perspective; it can be entirely imagined. Strange things might occur with the scale, but this is all right as the objects will be read symbolically. For example, you might have a giant pair of scissors leaning against a wall in the background, and in the foreground a very small peach. These two objects juxtaposed in an alien context could create the idea of threat. Draw the objects using line as you did the surrounding environment.

For the final stage, adopt a constructed method of working using tone (see "Fundamental Form," Project I, page 120) and implied texture. You can use an implied directional light source, which will add the idea of shadows becoming an important part of the reading of a picture. Or you can construct each individual element in the picture using tone to model the form without cast shadows. Remember that implied texture can play an important part in the meaning and reading of this drawing.

If you have enjoyed this way of working, try juxtaposing different objects in different environments. After a time, you will find that you are using objects and placing them in environments that are very particular to your personal memories, dreams, and feelings, evoked by the subconscious. You will begin to create a visual resonance that is not only particular to you, but which also holds meanings of other sorts for the viewer.

CHAPTER 6

THE MOVING VIEW

B efore the beginning of the twentieth century, artists depicted their subject matter from one viewpoint. Whether the subject was taken from nature or was a contrived historical or religious scene, the viewer was given a fixed position from which to read the event. It was not until the advent of Cubism at the beginning of the twentieth century that artists began to question the static view of the world that had previously been presented in drawing and painting. After all, we move and objects can be moved, so why should we always work from and present a fixed position?

Before embarking on the projects in this chapter, look at the early Cubist works of Pablo Picasso (1881-1973) and Georges Braque (1882-1963), two artists who tried to understand and present the world from a number of different viewpoints within one picture. For example, a Cubist painting of a cup might show it depicted from a side view, from underneath, and from above–not presenting the cup as we see it, but trying to present what we know is there.

One difficulty with this way of working lies in the need to convey the idea that an object exists in space, in context with other objects, because the illusion of form would undermine the sense of different viewpoints. To overcome this, the Cubists used a particular system of shading that created the illusion of planal recession (many different planes, usually in a shallow depth of field, making up the picture). Their system used shading on the inside of the plane in conjunction with shading on the outside of the plane in order to make the edge of the plane appear to come forward.

In the work of the Cubists, we get a sense of space almost being twisted on the picture plane, as if it were fractured. We pick up fragments of objects seen from various angles rather than one consistent view. This approach enables us to examine the world of three dimensions on a two-dimensional plane in an analytical rather than an observational way.

PROJECT 1

SUPERIMPOSED ELEVATIONS CREATING PLANAL RECESSION (ONE OBJECT)

One one-hour drawing

Materials: still-life object, 22- x 30-in paper, pencil, plastic eraser In this project, studies of an object from several different viewpoints are superimposed on top of each other, which will give an insight into ways of approaching the more complex drawings in Projects 2 and 3.

Choose an object that is not symmetrical—one that has a handle or spout or something similar. A plate would not be suitable, but a teapot would work well. The first stage is to draw your object from three different viewpoints, referred to as side, top, and bottom elevations.

Side elevation: Look at your object from the side and draw it using

line, describing the shape of the object. Don't try to describe or imply the form of the object; instead, use outline to create the silhouette.

Top elevation: Next, look at the object from above and make a line drawing superimposed on top of the side elevation drawing. Use the same proportions as the side elevation.

Bottom elevation: Look also at the object from the bottom, superimposing the drawing over the previous two.

Superimposed elevations, Step 1

Again, use the same proportions. You will now have three line drawings from three different viewpoints superimposed on top of each other (Step I, previous page).

The second stage is to add shading to create the illusion of planal recession: different planes (like flat sheets of card) overlapping each other and appearing to go back into a shallow space (Step 2, above). In places you will need to depict one edge in front of another.

THE MOVING VIEW

ADVANCING AND RECEDING PLANES

To make an edge of a plane come forward, shade a small area behind that edge. This will allow you to create and organize the spatial recession.

PROJECT 2

SUPERIMPOSED ELEVATIONS CREATING PLANAL RECESSION (MANY OBJECTS)

One four- to five-hour drawing

Materials: four to five still-life objects (teapots, cups, jugs, bottles, kettles, etc.); 22- x 30-in paper; 3H, 2H, and HB pencils; plastic eraser You are going to use the same system as in the previous project, but this time include more objects. Before starting, look at some examples of the early Cubist work of Braque and Picasso.

Position a table against the wall to create an artificial horizon line and arrange the objects on it (see "Space and Light," Project 1, page 95). Then begin to draw in line, using the negative space, and complete the objects using line only. This will help you establish the composition and the relationships between objects.

The next step is to analyze each object from different elevations, as in the previous project. In the drawing you have just done, you drew one object in different elevations. What you must do now is to render

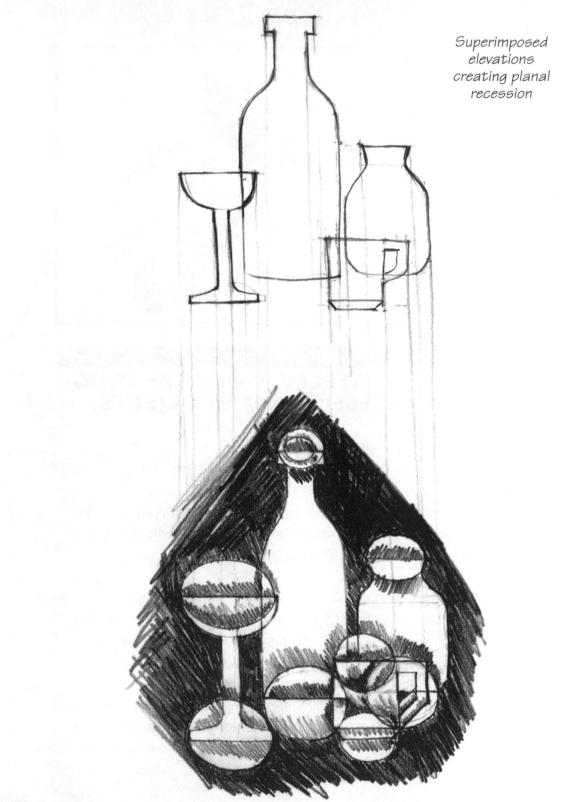

multiple objects in all three elevations-top, side, and bottom-even though they might need to be superimposed on each other.

Once you have drawn all the objects from all three positions, you can begin to simplify the composition in an abstract sense. Try to balance the composition by rubbing out some parts and linking shapes and lines together. It is advisable to keep some elements of the original objects recognizable. Then add shading on the inside and outside of planes, using the same principles as in Project 1, to create a spatial illusion of overlapping and receding planes.

PROJECT 3

MOVING YOUR VIEWPOINT

One four- to five-hour drawing

Materials: still-life objects; window-mount; 30- x 44-in or 22- x 30-in paper; pencils (4H-2B) if using 22- x 30-in paper, charcoal if using 30- x 44-in paper; plastic eraser

The drawings in the previous two projects were based on technical observations (taken from views of the sides, tops, and bottoms of the objects). The aim of this project is to produce a drawing abstracted from three or four superimposed drawings of a still-life arrangement.

It is best to do this drawing on $30- \times 44$ -in paper if you have a large enough drawing board. If you cannot get a $30- \times 44$ -in drawing board, use 22- x 30-in paper and pencils. If you are able to use $30- \times 44$ -in paper (or two 22- x 30-in sheets joined together) use charcoal.

THE MOVING VIEW

Setting up the still life

Choose about ten objects with different forms, heights, and characters; for example, jugs, bottles, vases, figurines, sink-plunger, funnel, and so on. One of your objects must be symmetrical (such as a wine bottle). For this project you must be able to move all around the table on which the objects are placed. If this will be impossible, place the objects on a board (which you will rotate) on the table.

First, place the symmetrical object in the center of the group. This is your anchor object: it will remain static and in the same position in all the drawings, and you will be able to take your bearings from it in the later stages if you feel completely lost. Then scatter the other objects randomly around the central object. Remember to consider the composition from each direction.

Beginning to draw

Choose your composition by holding a window-mount up to the group, and make sure that the anchor object is in the center of the composition. Using the window-mount, start by doing a simple line drawing of the still life. Use the edge of the table as the horizon line and starting point and proceed to draw using the negative space (see "Space and Light," Project I, page 95). Draw the group with a simple yet sharp, clear line, with the anchor object in the center of your drawing. Spend about fifteen to twenty minutes on this drawing.

Second and third positions

The next stage is to draw the still-life group from the second position. If you think of your first position as twelve o'clock, the second position is at three o'clock. If you can't move around the table to the three o'clock position, carefully turn the board on which your objects are placed a full quarter, taking care not to disturb the objects. Draw the still life from this direction over the top of the first drawing, again using a clear, simple line. You should not need to draw the central object as it should still be located in the same position. You can use the window-mount again for this drawing if it is helpful to do so. Try to keep the proportions of the objects roughly the same as they were in the first drawing. This process can be daunting at first, but you must keep pushing yourself. It will become fun later.

Now repeat the process from the six o'clock position. The drawing will become very complex at this stage and you will probably feel agitated and confused. Don't worry about this, as out of the chaos you will create order later on. If you feel that you now have enough information you can start the final, abstraction stages of the drawing. If not, draw the setup again from the nine o'clock position.

Abstraction

Begin to work on the drawing without reference to the still life. This is where the fun starts, because you can control and direct the development of the drawing. You should adopt a quite free and open attitude toward creating the abstract drawing.

Spend some time looking at your drawing and think about how you need to proceed in order to create a harmonic, rhythmical, balanced drawing. Think about how lines could be linked to make connecting rhythms and harmonies. Identify the lines that you feel are not working and take them out with an eraser, but leave the ghost of them in.

You should begin to see echoes and rhythms in the drawing-these could be lines or shapes that repeat or echo each other to create the idea of movement and space-and emphasize them.

You could play with the composition by joining shapes together and then using shading inside and outside the edges of shapes to create planal recession.

Make sure that the arrangement is not too symmetrical and that the objects are arranged at different distances from the anchor object.

CONCLUSION

Here aving worked through the different drawing methods and approaches used in this section's projects, you should now know more about yourself as an artist and about where your strengths and interests lie. It is a mistake to think that you have to master all of these ways of working before you can progress further. Rather, you should now be asking yourself which areas and approaches were the most rewarding for you. You might have been successful with most of the projects, but which way or ways of working excited you most? And which way of working would allow you to develop your ideas further?

Once you have made these decisions, you have a whole working base to proceed from. However, do not totally put aside areas of drawing that you didn't immediately find interesting, as they will probably emerge again at a later stage in your development, and at that point you may begin to take an interest in them.

Good luck, and remember that there is no such thing as a bad drawing–just an unfinished one.

ABSTRACT DRAWING

INTRODUCTION

In 1910, when Wassily Kandinsky (1866-1944) painted the first abstract picture, his intention was to move from the perceptual to the spiritual. Abstract artists ever since have been interested in moving beyond merely representing a thing or event, to find ways of expressing a transcendental essence.

There is no recipe or formula for the creative act. Prescriptions and absolute method are counterproductive in teaching and learning about art. Drawing is made through observation, action, and thought. It is not a "craft" removed from experience and ideas. Like speech, it is learned and used in order to articulate thoughts and feelings. However, drawing is not philosophy, nor the illustration of philosophy. It is the "idea" itself and it is expressed in the form it is because it cannot be expressed in any other way. Drawing is not rational, like math or logic, but it does have a rationale–a reason why it is made.

Some people use the term *abstract* to gainsay all art that they find inaccessible. More often than not, this means art in which they cannot assess the skill that was used to match the drawing to an observed reality. This need for a "reality check" drastically limits the opportunities for art. In the present volume, *abstract* is taken to mean nonobjective or nonrepresentational art: art whose meaning is not reliant on creating recognizable images.

Abstract art can be considered as evolving from three different roots. They are not mutually exclusive, but it is useful for the purposes of this book to deal with them independently of each other.

The metalingual or reflexive root Artists in this category evolve their expression through considerations of the visual language– questions and expressions evolved in and about the nature of

Abstract drawing gives visual form to a nonvisual idea.

picture-making itself. The reflexive abstract is dealt with in Chapters 1, 2, and 3.

The representational reduction, or observed root This type of abstract work finds its generating root in observed phenomena; that is, the artist will choose to highlight the formal aspects or abstract tenor of the object viewed, not the object itself, finding in the complexity of the visual array before him or her an opportunity to highlight particular aesthetic features. This is done by editing out elements from the full complexity of what is observed. The observed or visual abstract is dealt with in Chapter 4.

Nonvisual equivalents, or the associative root Into this category fall works of art that find their source in trying to give visual form to things inherently nonvisual–emotions, sensations, and nonvisual aspects of experience such as music, time, movement (pure movement, not a "thing" moving), and irony. The associative abstract is dealt with in Chapters 5 and 6.

CHAPTER 1

FLAT AS A PANCAKE

hrow a stone into a pond and it creates eddies, lines of force around the point at which it entered the water. These ripples travel outwards, affecting the surface of the water until they reach the pond's limits. These limits, the banks, in turn halt and influence the ripples. The territory of a drawing–its shape, size, and surface–is known as the *format*. Place a mark within the format and the mark creates its own invisible ripples–perceptual and aesthetic forces that issue from the mark to influence the terrain in which it operates.

The format of a drawing is both the substance that supports the drawing and the overall shape of the drawing area. It may be made of rock, paper, or air, and it can be circular, square, triangular, or some other shape. It can also be a three-dimensional form, such as the curved surface of a Greek vase or a Baroque dome. Every format has its own formal concerns–concerns not directly connected with the illusion of representation but rather with drawing in the abstract; that is, as design and composition.

This chapter is concerned with drawings that read as one with the surface of the support-in other words, with a flattened pictorial space-thus abandoning the idea of a picture as a window through which a world can be seen. The support becomes a place for actions and decisions. On a playing card, say the jack of hearts, one is aware of the image on the card not as an illusion that lies behind the picture plane, but as being one with the surface of the card. A target, a flag, wallpaper, written text, and musical notation also operate in this way.

Some artists choose to make their images coincide with the surface of the picture in order to give the images a different kind of presence. Their images are not invitations to dream, fantasize, and escape, but to be aware of, confront, and engage with actively. Abstract artists often make assertions about the "reality of the work," its purpose, and its means of production; asserting the physical fact of the work itself. With a flattened picture space, the image and the fact of the work coincide.

HARMONICS AND HARMONY

We are concerned in this chapter with building, within and in response to the format, compositions that have aesthetic value, or beauty. It is difficult to evolve strict rules for beauty, although many artists and writers have tried. If there is such a thing as objective beauty, it is tempered by each individual's subjective response to the notion.

The evaluation of aesthetic harmony is born out of both innate and gained experiences and values. Strict, rigidly determined laws in which these aesthetic ideals might be determined are so elaborate and complex that they are nigh on impossible to regularize into one complete system. However, many artists have sought to evolve theories of aesthetic harmony and explore this in their work, seeking for a pure aesthetic in art as there is a purity within mathematics and nature. This aesthetic can be

From earliest times, artwork has been made to be valued not only as an illusion but as a fact, or object. Artists were commissioned to make works from valuable pigments such as lapis lazuli and substances such as gold and silver. These were used so that the pictures would be seen and valued in the same way as precious jewels, as well as for their imagery. thought of as a developed sense of the necessary in the relationships between the parts of a picture and its whole.

Robert Girard, in *Colour and Composition* (1974), writes: "In any living form the essential structural lines which appear to separate or unite the secondary parts of the form are known as 'harmonics.' Harmonics correspond to lines of intent and vital energy." Harmonics–or lines of partition–"are the essential structural lines which

best adapt themselves to the functional and aesthetic character of a form while at the same time revealing its mode of formation and growth." For instance, the veins in a leaf are organized in the way they are so that the sap is distributed efficiently to all

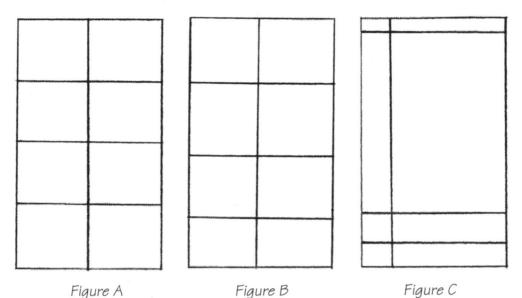

parts of the leaf. Not only is it a magnificent design for its function, but it is also perceived as such. The design looks appropriate and necessary and therefore reads visually; it is seen as harmonious.

If we can see this harmony, we must have an inbuilt sense of the necessary. The American aesthetician Maitland Graves, in his *Design Judgement Test* (1946), used the figures above to test the aesthetic sensibilities of students.

Figure A, being symmetrical, is balanced. The grid is even; all the squares are the same size and as a consequence divide the format evenly. Figure B looks as though it should be symmetrical, like A, but it is not. The differences are so small that the figure reads as though the divisions are not made intentionally, and it therefore looks inept. Figure C looks as though it is meant. The changes from the regularity of A look purposeful. The symmetry of A, although obviously ordered (one or all sides of a drawing reflecting each other), becalms the aesthetic forces, whereas it can be seen from C that asymmetry can still contain balance, harmony, and visual tension.

HARMONICS OF THE RECTANGLE

Although a format may be any shape, size, and form, in drawing, the format most regularly used is the flat-sheeted rectangle. In the projects that follow, you will be looking for lines with which to partition the format–structural lines that explore the aesthetic potential of the rectangle. As with the veins of a leaf, the lines that you are looking for create areas of different sizes and shapes across the surface. As in the case of a jigsaw puzzle, every section is important in forming the complete image. There is no distinction between positive shapes (shapes that represent objects) and negative shapes (those formed by the space around the positive shapes).

The principal lines of division in the rectangle fall into four categories: the diagonals, the medians (lines that divide the rectangle in half vertically and horizontally), other lines parallel to the sides, and concentric rectangles.

Although you will need to feel your way in these projects, weighing your decisions according to your own aesthetic values, artists of the past have evolved and regularly used certain geometric principles for ordering forms and images.

THE GOLDEN SECTION

One geometric theme for harmonious proportions that has had much favor since antiquity is the Golden Mean or Section. The proportions of the Golden Section are 1:1.618, and give rise to a division whereby the smaller part of the rectangle is to the larger part as the larger part is to the whole. These proportions can be used to divide or construct, and are thought to possess a harmony naturally satisfying to the human eye and spirit. The Golden Section is held to be present everywhere in nature, although this may be somewhat contrived.

A simple demonstration of the Golden Section can be made by dividing a line, using a ruler and compass.

1. Divide the line AB in half. This can be done with a compass. Open the compass points to a distance wider than you judge half the line to be.

2. From A draw an arc above and below the line. Repeat from B. Draw a line joining the points where the arcs intersect above and below the line, which will give you the center of the line AB.

3. At point B, draw a line at right angles to AB. With the point of the compass on B, draw an arc from the midpoint of AB to the perpendicular line. The arc meets the perpendicular line at C. Connect A and C, which gives you a right-angled triangle.

4. Place the point of the compass on C and set it to B. Draw an arc that intercepts AC at D. Now place the compass point on A and set the compass to D. Draw an arc that crosses AB at E.

The line AB is now divided into Golden Section proportions: BE is to AE as AE is to AB.

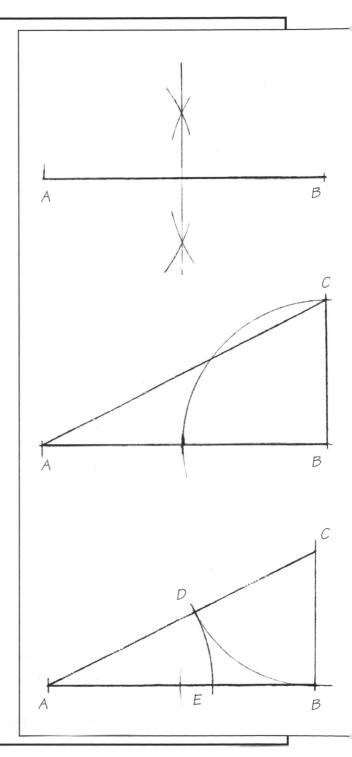

PROJECT 1

STRAIGHT-LINE DIVISIONS OF A RECTANGLE

One one-hour session

Materials: 22- x 30-in paper, black pastel or charcoal, plastic eraser

Draw four different rectangular formats. Make sure that they sit within the boundaries of the paper so that the edges of the paper do not complicate and interfere with the decisions you need to make within your formats. Partition each format using straight lines, weighing up the aesthetic value of each section against the others. You can use the Golden Section proportions-length to width-to create the formats. Or you can use it to divide one or both sides of the rectangle as part of the partitioning.

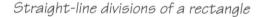

FLAT AS A PANCAKE

PROJECT 2

GEOMETRIC DIVISIONS OF A RECTANGLE WITH TONE ADDED

One two-and-a-half-hour session **Materials:** 22- x 30-in paper, black pastel or charcoal, kneadable and plastic erasers

Again, create four rectangular formats on the paper. Divide each into dramatic This is not just a balancing act, but also an attempt to create and resolve aesthetic tensions.

divisions. You can include the circle and the arc, but remember that these shapes act on the surface and therefore need to be thought of as segments of the rectangular whole. When you have done this, smudge the drawings with your hand to create an even tone over the picture. Use your eraser to make some segments light and use

Geometric divisions of a rectangle with tone added

FLAT AS A PANCAKE

the pastel or charcoal to make others dark. Think of the tonal progression from light to dark as an opportunity to give weight to different areas. Although there is no mass, the partitioning lines can be thought of as having tonal weight. You can also modulate tone across individual segments, moving from light to dark across the area.

PROJECT 3 THE RECTILINEAR GRID

One one-hour drawing **Materials:** 22- x 30-in paper, drawing material of your choice

Create a rectangular format within the limits of the sheet of paper. Within this format compose a rectilinear grid; that is,

a grid composed of lines that are parallel to the sides of the format. These can be drawn with a ruler or freehand. You can add interest by varying the weight of the lines and the spacing between them.

PROJECT 4

WARPING THE GRID

One one-and-a-half-hour drawing **Materials:** 22- x 30-in paper, pencil, pen and ink, typing correction fluid

Draw a regular rectilinear grid with pencil. Now think of disturbing the complacency of the grid by warping some part of the line character. Imagine the stone disturbing the surface of a still pond, or a magnet influencing a surface of iron filings.

The grid can be considered as a matrix, a calibrated space (like the staves of musical notation) on which different shapes act (like notes).

Warping the grid

When you have completed this, proceed in ink. You can develop tone in the areas set up by the grid, creating a warped checkerboard or something more irregular.

PROJECT 5

A GRID WITH SHAPE CHARACTERS

One one-hour drawing **Materials:** 22- x 30-in paper, pencil, ink and wash, plastic eraser

Create a regular rectilinear grid in pencil. Within this, using ink, develop and compose with different shape characters that act across the surface. Do not overlap the shape characters or try to create depth. The spaces between the characters are as important as the ink-and-wash grid, but consider the activity of the grid in relation to the characters.

A grid with shape characters

PROJECT 6

COMPOSITION WITH LETTER SHAPES

One two-hour drawing

Materials: three sheets of 1 - x + 7-in paper, pencil, plastic eraser, pen, brush, ink

The purpose of this project is to develop a design through the selection and manipulation of a motif—a distinct theme or phrase on which a composition turns, or to which it returns repeatedly.

For this project select a letter, or letters, of the alphabet on which to base your composition. With pencil, create a format. Place your chosen letter shape within the format, turning, enlarging, reducing, or otherwise influencing the characteristics of the shape as you do so. Then add shapes where necessary in the composition, but remember that you are dealing with the surface, so do not overlap shapes. With undiluted ink, fill in the shapes to make a strong black-and-white composition.

Divisions of the format are used in Minimalist art. Minimalism sought to reduce painting to the Modernist goal of essential features. Art was pared down to a "minimum," abolishing representational imagery and illusionistic pictorial space in favor of a complete, unified, and abstract image.

CHAPTER 2

MAKING SPACE

n the previous chapter we sought "the ideal" at the surface of the picture by exploring the harmonics, or aesthetically satisfying divisions, of the format. In this chapter we will break the surface of the picture plane and explore its illusory depth. We will look at the structures at the surface and the elements beyond it, and explore the connections between surface and depth in compositions that use shape.

In the projects—as in the work of the Russian Constructivists such as Aleksandr Rodchenko (1891-1956) and Kasimir Malevich (1878-1935) in the early twentieth century—the elements of your compositions should be limited to shapes. By *shape* we mean the two-dimensional figure itself—a plane like the picture plane—not the three-dimensional figure, actual or illusory. The Constructivists limited composition in this way because to do so honored its origin in the flat collage elements of Synthetic Cubism; it reflected the sheetlike nature of new materials, such as steel and glass; it allowed them to create lightness by deemphasizing volume; and, because shape is the constituent of the plan and elevation, it was akin to the detailed drawings for buildings. It therefore allowed them to insinuate construction.

The Constructivists were concerned with creating ideals or abstracts for the future. Although this chapter is concerned with creating drawings for their pictorial sense–that is, drawings that are concerned with and comment on picture-making itself–it is worth noting how reflexive art has extensions into the world. Although our concern is with a pictorial musicality, limiting oncself to shape may cause further resonances.

To pursue the music analogy, music organizes its elements in time, drawing its elements in space. Music is read in linear progression because it unravels in time; a drawing is presented complete, but although it is not read in the same way as a piece of music, the artist can still orchestrate the way it is read by others by creating aesthetic pathways in the organization of its elements. Factors that you can use to orchestrate the abstract

tenor of a drawing include rhythm, order and balance, movement and direction, point and counterpoint, and echo.

RHYTHM

Rhythm is an important factor in a drawing; it is the root from which expression emerges. The aesthetic rhythms of art, music, and poetry have similarities. The rhythmical phrasing in a drawing can be considered as time laid out as a measured space. As with music and poetry, rhythmical meter can be developed through experience and an inner sense. Rhythm can be picked out by phrasing all kinds of pictorial elements-marks, shapes, lines, and forms. It can be read at the surface of the picture (the harmonics of the format) or in illusory space. For example, in a photograph of a formal garden, one can analyze the phrasing of particular tonal shapes on the photographic paper (the surface), or marvel at the way in which the topiary (the shapes of particular bushes) is laid out in the space of the garden.

ORDER AND BALANCE

The notions of order and balance need to be addressed in a drawing. Balance is achieved by playing the tensions and rhythms in one area against those in another, but this need not be immediate or straightforward. Symmetry, although providing obvious order (all sides being reflected in each other), tends to becalm a drawing and this can destroy its impact. However, it is possible to balance a drawing asymmetrically and still achieve an order that has both visual tension and harmony, that is, one that looks appropriate.

MOVEMENT AND DIRECTION

A finished drawing is presented in full. It is seen at first as an object, but once the viewer is engaged he or she reads it in a similar way to reading music, although not in a prescribed progression. The reading of a drawing is reliant on two things: the habits of the viewer and the arrangement of pictorial elements. The habits of the viewer when looking at a drawing may be linked to the habits and occasions of

the viewer's other readings-particularly the reading of written text. In Western culture this is from left to right, and in the Orient it is from bottom to top. The arrangement of pictorial elements themselves can imply a direction or movement, which the viewer senses through the directed or orchestrated arrangement of rhythmical elements. This in turn can create either anxiety or calm, depending on the way the elements have been arranged.

POINT AND COUNTERPOINT

The world is read through differences–light against dark, heavy against light, thick against thin, soft against hard. When contrasting elements are set side by side in a drawing, a new and dramatic aesthetic connection can emerge.

ECHO

If a theme established in one section of a picture is reflected in another, this creates an echo. The echo may be actual and complete—the same elements being used and repeated with the same phrasing in two parts of the picture—or it can be implied, the pictorial elements differing but the phrasing being the same. An element in one section of a picture may demand a compensating element in another for order.

SPACE

Pictorial space is the space of the surface area; *illusory space* is the depth. In the following projects, illusory space is developed through the relationship of shapes to each other, and not through a perspectival construction or a literal depiction.

SCALE

Scale can be used to create an illusion of space. Unless there are other indicators of position that take precedence, such as overlaps, or relationships to a ground plane, larger shapes will appear nearer than smaller shapes. Scale is built through counterpoint—one needs

to compare a shape to another one to see how large it is. For example, the epic scale of the movie *Star Wars* is declared in its opening frame. Coming from the top of the screen (and thus from over the audience's heads) a spacecraft enters the frame. It is moving very fast, indicated by the length of time it takes to reach the vanishing point. It is also large, for at the moment it enters the screen and for a while, the audience sees a good deal of it. But it is nothing compared to the Death Star, another craft which takes a much longer time to pass overhead. It is the relative scale of the two crafts that sets up a relationship of power and weight in the vastness of outer space.

Tone, texture, and weight of line can also be used to make a shape advance or retreat, or seem heavy or light, as dark shapes appear heavier than light ones.

OVERLAP

Overlap is the other method that can be used to give a sense of space. If one shape sits in front of another and obscures part of it,

In Figure A below, we see half a disk but read the other half as obscured by the oblong. Thus we read the two shapes as a circle and an oblong or rectangle (as shown in B). We might have been seeing the two shapes in C, but our eyes seek the simplest and most familiar meaning.

The coincidence of the flat edge of the half disk and the top edge of the rectangle (as shown in C) is also optically inopportune, because if the edges of adjacent shapes touch, the illusory space is flattened.

we read it as being in front of the overlapped shape.

The displaced, or obscured, edge demarcating or marking a discontinuous surface is a major indicator of space. When doing the projects you should avoid organizing shapes so that they touch. Overlap shapes or keep them scparate, because otherwise the picture will sit on the surface. Regard the edges of the format in the same way. Consider the edge of the format as a window frame. Shapes can be overlapped by the frame or contained within it, but do not let shapes just touch it.

You can use opaque or transparent overlap. Opaque overlap emphatically places one shape behind another. In a transparent overlap, the two shapes are like pieces of

acetate that affect each other, but are more ambiguous about which piece is behind which.

PROJECT 1

SKETCHES FOR A COMPOSITION USING GEOMETRIC SHAPES

One three-hour drawing

Materials: three sheets of 22- x 30-in paper; HB, 2B, and 5B pencils; plastic eraser; pen and ink

The elements to be used in this project are geometric or inorganic shapes. Inorganic shapes are human constructs-fundamental and intelligible. There are three basic geometric shapes-the rectangle

Basic geometric shapes

(including the square), the triangle, and the ellipse (including the circle). More complex geometric shapes can be evolved using combinations and sections of these shapes, such as the pentagon, hexagon, dodecahedron, stars, and so on.

Although the shapes can allude to forms, being the projection of three-dimensional forms onto a two-dimensional surface, and although we can make schematic representations of objects in the world using combinations of shapes, we are not interested in descriptive or imitative shapes in this project. Also, do not try to render shapes as forms (this is the subject of the next chapter).

On the three pieces of paper, draw a number of formats. These should not be larger than 10 in (25 cm) in any dimension, and can be circular, oblong, or square. Then, with fluidity and courage, start to draw shapes with pencil within the formats, considering the tensions and connections between the shapes and the format (illustrated opposite). Proceed intuitively in trying to build a complete and dramatic composition. At this stage, you will be drawing with line. Do not be afraid to use your eraser to revise your composition.

When you have settled on a composition, proceed in pen and ink, going over the pencil drawing. Think, as you work, of the weight of line around the shapes. You may also want to use tone, which can be either solid or developed with crosshatching (see page 125).

Right: Sketches using geometric shapes

PROJECT 2 LARGE DRAWING WITH GEOMETRIC SHAPES

One four-hour drawing

Materials: one, four, six, or eight sheets of 22- x 30-in paper; black pastel; plastic eraser

If you have the room and are not scared of getting messy, draw on a large scale. To do this, align the sheets of 22- \times 30-in paper up to each other and run masking tape along the join.

A drawing using geometric shapes

Pick a sketch from the previous project, and draw a large format in the same proportions as the small one. Map out your chosen sketch on the large scale with line. You can apply tone to shapes—not to give the illusion of form but to show that the shape is a particular tone. You can also use tone to create contrast along edges. This tone, when used inside the shape, is called an *endotropic shadow*. When it is used outside the form it is called an *endotropic shadow*. Invent textures and patterns for shapes where appropriate. You may wish to smudge all or part of the drawing and then work light back into it with an eraser. This is a more effective way to create light areas than by leaving the paper white, because these light areas will work better with the other elements in the drawing.

PROJECT 3

SKETCHES FOR A DRAWING WITH ORGANIC AND INORGANIC SHAPES

One two-hour drawing

Materials: three sheets of 22- x 30-in paper, pencil, charcoal, ballpoint pen

In this project you can adopt organic or inorganic shapes, or both. By mixing different types of shapes you will open up other possibilities for these drawings and some possibilities that you can pick up on later in the book.

A sketch using organic and inorganic forms

Organic shapes are those that are not geometric. They have a sinuous, unmediated outline. The amoeba is a typical organic shape. Organic shapes can be identified with instinct and intuition, while the inorganic (or geometric) shapes are identified with the rational and the intellectual.

Create a number of formats on the paper. Then start to doodle different compositions. If it helps, pretend you are doodling on a telephone pad. In these sketches you are again working with the vocabulary and grammar of picture-making, with shapes and with creating space through overlap. Once you have worked out a number of compositions, proceed to the next project.

PROJECT 4

LARGE DRAWING WITH ORGANIC AND INORGANIC SHAPES

One five-hour drawing **Materials:** numerous sheets of 22- x 30-in paper, black pastel, kneadable and plastic erasers

For this project, choose a sketch from the previous project and transfer it to a larger scale. Even better, you could work with a combination of sketches, creating a complex composition by extending the formats of the original sketches in order to join them up with other sketches, and resolving the spaces between them. Not only will this add richness to the composition, but also you will learn much more at this stage from a fairly involved composition. Continue the drawing as in Project 2 (page 192). CHAPTER 3

FINDING FORM

In the previous chapter, you used what perceptualists call *occlusion*, or hidden-line elimination, to create depth. In other words, you overlapped the shape elements of your compositions, hiding sections of more distant shapes to give the illusion of space. The lines around shapes are also depth cues, marking the limit of a surface when projected onto the picture plane. You will be using the outline again in this chapter, but you will also need to use other depth cues to portray the dimension of depth in individual figures.

This chapter builds on and directly uses the ideas of the previous two chapters. It is also concerned with creating a harmonious arrangement of elements at the surface and in space. However, although the impetus for the projects is still based on the notion of an aesthetic ideal, they also begin to anticipate the themes of the next chapters, in that observed phenomena can be used as the source, and the results of the projects will inevitably offer up associations. It must be emphasized that you should not set out in this chapter to analyze observed phenomena for their abstract tenor, nor work up intentional and direct associations from or with nonvisual topics. What is added to the endeavors of the previous chapters are volume and weight: in other words, form.

Form has already been defined as the three-dimensional object itself or its illusion. In drawing and painting, which are both essentially two-dimensional, when we refer to form we mean the illusion of form. What are the devices, strategies, and cues that allow us to create a three-dimensional figure on a two-dimensional surface? Let us consider two categories: those with a continuous surface and those with planal facets.

FORMS WITH A CONTINUOUS SURFACE

If we take a flat rectangle and bend it so that the middle comes towards us and the two perpendicular edges turn away, the rectangular silhouette is transformed to show this bend. The top

and bottom lines are represented as curved in a perspectival representation. The second figure is still a flat shape with curved edges, but our eye and brain seek to make sense of the deviation

Shape recognition

two perpendicular sides together. A cone can be elaborated in a similar manner. The curved bottom surface of the cone suggests its three-dimensionality. Thus, a silhouette can also provide cues to three-dimensionality.

from the norm, the rectangle or

square being the easiest image to recognize. If your viewpoint is above the rectangular figure, you will see the curves as more pronounced in the middle than at the sides. A cylinder can be derived from the bent sheet by bringing the

The adjacent shape may allow you to recognize a head and mentally construct its three-dimensionality. It could also be the shape of a swimming-pool, but our thoughts race to construct it as something we recognize easily.

Cross-sectional analysis works to describe visible and invisible surface of form (as below)

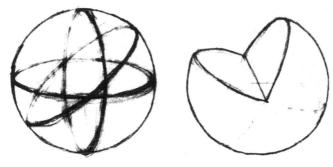

However, we are not concerned here with figuration or with constructing the three-dimensional in this way.

The threedimensionality of the sphere cannot be deduced from its

silhouette alone because its silhouette is the same as that of a disk. Further cues are needed. You can describe the cross section of the form, that is, the surface or plane that is left when the form has been cut into. The front edge of the cross-sectional plane also describes the movement of a line around the curved surface. The

cross-sectional analysis and its derivative, the *surface analysis*, can be used to describe the threedimensionality of a figure, whether it be a fundamental form, or a more complex figure.

The cross section should follow either

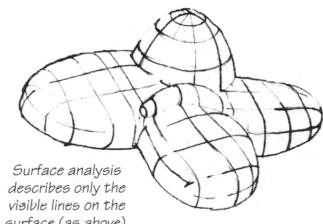

visible lines only the visible lines on the surface (as above).

the form's horizontal or vertical axis. The horizontal cross section, like the contour lines on a map, connects all points on the same level, describing a plane horizontal to the ground of the object. The vertical cross section can be considered similarly. Another way of considering surface analysis is to think of the form as being bound with string. A description of the string wrapped around a form will give the form.

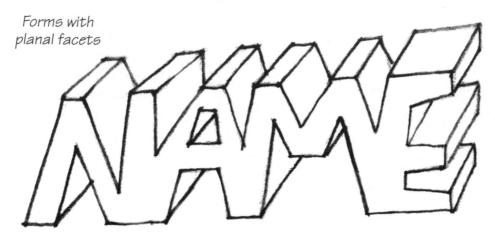

FORMS WITH PLANAL FACETS

Forms can be created by developing them from the shape. In the "tagging" of graffiti artists, and in many schoolbooks, the simple letter shapes of names are produced by drawing what are known in projection systems as *orthogonals* back from the corners of the letter shapes, developing planal flaps on the original shape. The orthogonal is the line that appears to move back into the picture plane.

We can create planal forms by drawing lines back from the corners of the shape at an angle to the edge of the generating shape, and joining these lines with lines that may be parallel to the lines of the generating shape or bear some other relationship to it. The lines that form the edges may be parallel, as in an isometric projection (with parallel orthogonals), or they may be nonparallel, as in an oblique projection. The generating shape may also be turned from its horizontal axis and the verticals kept vertical as in an axonometric projection.

THREE FUNDAMENTAL FORMS

There are three forms that you should give special attention to. From these three basic form units, you can derive, or at least understand how to derive, more complex figures.

The rectangular-based solid is represented here in different projection systems: in an isometric projection with parallel

orthogonals (A); in a one-point perspective (B), with orthogonals converging towards a vanishing point; and in a two-point perspective (C), with the front face twisted into the picture

silhouette are the circle and

Rectangular-based solid

plane and the orthogonals converging towards two vanishing points; an oblique projection is also possible, with the front face flat to the format and the orthogonals either converging, or diverging, or running parallel.

The cone and conic section seen at eye level (in perspective) can be seen as a triangle. However, the circular base is more fully elaborated by using either the ellipse (right) or the circle (far right) as its representation.

The cylinder is an extreme conic section, the sides being parallel, and like the cone it can have either an elliptical or a circular base and top.

The sphere and ovoid as seen in

Sphere

respectively. They are declared as forms by cross-sectional and surface analysis.

Ovoid

More complex forms can be built by using one or more of the fundamental forms in combination. Also, like a sculptor, you can cut into the fundamental forms and find forms that may be geometrically more complex. You can also use forms that are organic in nature–derived from organic shapes–by using surface or cross-sectional analysis to highlight the forms. Light can also be used to give indications of form.

GRAVITY AND WEIGHT

Although you do not need to indicate a ground plane in the following projects, the bottom edge of the rectangular format will act as a ground, drawing elements to it. To a greater or lesser extent the other edges do the same. Color–in drawing, the tonality, or lightness and darkness, of a form–can affect its perceived weight. A dark element will seem heavier than a tonally light one. Shape, too, affects the weight, a hard-edged fundamental shape or form appearing heavier than a sinuous, organic shape or form. Also, on the whole, the larger the element, the heavier it will seem.

TONE AS A QUALIFICATION OF FORM AND SHAPE

Tone can be applied to a form to indicate the tonality of a color and/or to give weight to the toned figure. There are also three ways in which tone can be used to indicate form and space: directional light and cast shadows, exotropic and endotropic shadows, and modelling.

Directional light When light from a particular direction falls on a form, it lights the part of the form that lies in its path, leaving

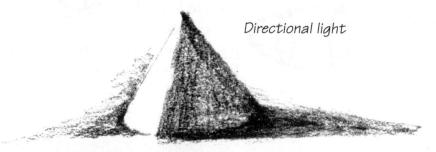

that which does not in shadow. It will also cast another shadow, which is a projection of that form, onto a plane or another form within its reach. The projected shadow is formed as a result of the direction of the light and its angle of incline, and of the form and texture of the surface on which it falls. These shadows can be calculated or, in your case, intuited.

> *Endotropic and exotropic shadows* Endotropic and exotropic shadows can be used to contrast the edges of pictorial elements. Exotropic shadow can also be used to create space. Pigment can be placed in the space around the form (the negative space) to create atmosphere. One reads the drawing

> > matter as lying in space, thus accentuating the picture depth.

Modelling Forms can be modelled with light and shadow. A

"modelling light" provides each form with its own light source. The light source is used to make the nearer part of the surface

appear to advance and the farther part retreat, like modelling in clay. The shadow presses back the parts of the form farthest from the eye. In the case of a sphere or cylinder, the form is more often than not top- and front-lit, causing the middle to come forward and the edges to recede.

Exotropic

shadow

Endotropic

shadow

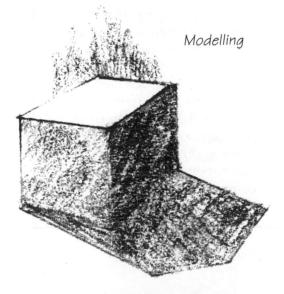

PROJECT 1

SKETCHES FOR A COMPOSITION WITH FUNDAMENTAL FORM

One three-hour session

Materials: a number of sheets of paper or newsprint, 2B and 3B pencils, plastic eraser

Draw a number of rectangular formats. In the first few, using line, work out various compositions using fundamental forms as discrete elements; do not try to combine fundamental forms to create new forms. Organize the forms so that they occupy a credible space and relationships to each other. Each form should occupy a definite space and spatial volume. To consider your forms as actual solid entities, you will need to ensure that they do not partially or completely

ESPACE LIMITE AND ESPACE MILIEU

The format frames the composition, and the way we read a composition depends on the way it is framed. If all the forms are complete-in no way cropped by the frame-we have a sense that the picture is the full world of the action. There are no further elements lying outside the picture. This is referred to as espace limité (limited space). When the edges of the format crop the forms, there is an insinuation that the action continues beyond the frame of the format. This is called espace milieu, and it suggests that the image continues into the surrounding world. You can consider these two notions of space as you evolve compositions in the following projects.

occupy the same space, or overlap. As you become more confident, start to create some forms from combinations of the basic forms.

Once you have completed eight or so sketches as line drawings, develop one of the sketches using surface analysis. In another sketch, use tonal modelling to develop the forms. There are no strict rules for doing this; use your own intuition and judgement to sense what works. With the modelled form, try to grade the tone so that it becomes lighter as it moves into the lighter area.

Use directional light to develop a third sketch. Imagine the light entering at a particular angle to the plane of the picture and the "ground." Try to anticipate what part of the form will actually be hit by the light. Remember that the form will cast shadows, and that these may hit other forms. The shadows will have particular shapes. Do not try to modulate the tone in this drawing, just use one light tone (the white of the paper) and one dark tone.

PROJECT 2 PEN-AND-WASH DRAWING

Three one-hour drawings

Materials: three sheets of 1 - x 17-in or watercolor paper, pencil, mapping pen, ink, wash (an ink-and-water solution—you may need to make two or three solutions of varying depths of color according to your drawing; a 50:50 solution gives a medium tone, but test a sample first), brush

Take the three worked sketches and develop them on individual 11- x 17-in sheets. In each of the drawings, draw out the composition lightly with pencil first to map all the particulars. In the first drawing, map out the surface analysis; in the other two drawings, outline the shapes that the tones of the original sketches occupy.

Complete the drawings with pen, ink, and wash (see illustrated overleaf). Use outline advisedly. There may be occasions when you want a heavy outline, or sometimes you may want a light one, or sometimes none at all. Use the wash to complete the tones. You can also use the wash for exotropic shadows where necessary.

Overleaf: Pen-and-wash drawing of a composition using fundamental forms

PROJECT 3

SKETCHES FOR COMPOSITIONS WITH ORGANIC AND GEOMETRIC FORMS

One two-hour session

Materials: 22- x 30-in paper, 2B pencil, plastic eraser

Follow the same procedures as for the sketches in Project I (page 204), but in these you can use organic and more complex geometric forms. You can also work planes into the picture at different angles, in, on, and through which the forms can play. When you have completed sketches that you are happy with, proceed to the next project.

Below and opposite: Sketches using organic and geometric forms

PROJECT 4

COMPOSITION WITH ORGANIC AND INORGANIC FORMS

One two-hour drawing

Materials: 22- x 30-in paper; 2B, 4B, and 6B pencils; kneadable eraser

Use the sketches from Project 3 (page 208) as a point of departure for a composition, but modify or deviate from them where and when you feel it necessary. Make the drawings with pencil, and use all the different means of qualifying the forms-surface analysis, exotropic and endotropic shadows, modelling, and directional light-in the one drawing. Explore the aesthetic properties of different weights and actions of marks in describing the outline of the surface analysis and in building up the tonal areas of the drawing.

CHAPTER 4

BEYOND THE LOOK

BEYOND THE LOOK

eonardo da Vinci (1452-1519) worked to understand systematically the forms, structure, and purpose of his world. He sought analogies where many saw only differences. He compared and drew connections in form, function, and size in the visual world. He evolved highly sophisticated morphologies (categories of forms). He observed that the vortex was the basis of the forms of some plants, of movement in water, of the destructive forces of nature and humans, and even a particular hairstyle. By recognizing the analogous in the abstract tenor of things–abstract tenor being the course of abstract meaning that holds through a thing, in its form, structure, function, and so on–he was able to hypothesize beyond what existed by abstracting from what he observed and applying it imaginatively.

To observe and understand the abstract or formal composition of a thing requires one to edit the details and complexities of the world. You need to seek the major structures, or "dominants," in an object, human figure, animal, or entire scene: lines, dots, tones, or other features that dominate and impose a structure on the thing observed. To abstract from the observed means to simplify the complexities of seeing, to seek the general in order to move from the specifics of representation to a nonspecific abstraction

ANALYZING THE OBSERVED

The Dutch artist Piet Mondrian (1872-1944) made a series of drawings of a tree. The first in the series was quite specific, detailing its branches and the exact form of its trunk. The image produced could be recognized as a particular tree. The next drawing in the series became a little sketchier and more schematic. The next more so. Details were left out, the naturalism of the first drawing giving way to something more abstract and more geometric. Horizontal and vertical accents were emphasized. In the final drawing, not only is the particular tree not recognizable, but the representation of the tree is so reduced that the tree itself is no longer recognizable.

BEYOND THE LOOK

In "dematerializing" the tree in this way, Mondrian turned the threedimensional image into a two-dimensional one. For him, the horizontal accents represented the "female principle," the vertical accents the "male principle." The idea of the reconciliation of the male and female principles was called the *universal eros* by Mondrian. The balancing of the contrariness of the world–such as male and female, vertical and horizontal–to make the multiple and complex whole through "dynamic equilibrium" was part of Mondrian's professed purpose.

This brief resumé shows that there was a purpose to Mondrian's abstractions. His apparent simplification has a high and complex intention, and the final works are among the great abstract images.

PROJECT 1

ABSTRACTING FROM A STILL LIFE

Two one-and-a-half-hour drawings

Materials: two sheets of 22- x 30-in paper, charcoal or black pastel (not oil pastel), plastic and kneadable erasers

This project takes a still life as the starting point for an abstract composition. Cut out a window from a piece of spare paper in the same format as your drawing paper but at a reduced scale (no larger than 8 in/20cm in the largest dimension). Set up a still-life arrangement and position your easel where you have a good view of the still life and the drawing paper. Frame your view with the window-mount, seeking an interesting composition. Draw the image within the window-mount. Draw only with line contour-do not bother with tone, texture, or color. Try to complete the drawing within one hour. Then smudge the drawing with cloth, paper, or your hand (Drawing Ia, page 214).

Now work back into the drawing using the vector, or straight line, as your sole mark. Even curved lines can be broken into a series of straightline facets. Lightly extend the vectors beyond the edges of the forms

BEYOND THE LOOK

Abstracting from a still life: above, Drawing 1a; below, Drawing 1b

BEYOND THE LOOK

Above and overleaf: Different final variations

(Drawing Ib, opposite). Spend half an hour on this stage. By then, you should have a web of intermeshing straight lines. Use this as a sketch for your final drawing.

The final drawing can be evolved in a number of ways. You can use the sketch as a starting point for a drawing that again makes divisions of the format. If you want to follow Mondrian's lead, use only horizontal and vertical divisions of the format, deriving a rectilinear grid from the observation of the still life. Although Mondrian was emphatically against the diagonal, you can also employ the diagonal in your divisions of the format. Whichever you choose, make sure that you use lines derived from the lines of description in the earlier drawing of the still life. A third alternative is to note the horizontals and verticals at the point where they meet, making smaller marks to accent the contact. With this option you are not dividing the format, but rather making a series of small, horizontal and vertical accents derived from the points of intersection in the first drawing.

ABSTRACT TRANSCRIPTIONS

In the previous project you were analyzing the "dominants" in an image at the surface of the picture. The dominants in this instance were the dynamic forces derived from the outlines of objects and their surroundings. Space and form are ignored in this type of abstraction; the lines become a map of forces on the surface of the picture.

BEYOND THE LOOK

The same approach can be used to analyze and perhaps make use of the compositional constructions of the Old Masters, in particular their group compositions, or any other representational and nonrepresentational work (although the latter already addresses the abstract). Analysis of the group compositions of artists such as Nicolas Poussin (c.1593-1665). Rembrandt (1606-69), Théodore Géricault (1791-1824), and Eugene Delacroix (1798-1863) offers ways of entering their work and an opportunity to transcribe and develop the surface composition. In a painting such as *The Battle of* San Romano by Paolo Uccello (c.1396-1475), one can concentrate on the rhythm made by the oranges and the circular decoration across the run of the picture, or analyze the dominant compositional lines-vital lines that run through and connect elements in the painting.

PROJECT 2

ANALYSIS OF THE DOMINANTS IN A GROUP COMPOSITION

One two-hour session

Materials: 22- x 30-in paper, postcards or photocopies of chosen picture, 3B pencil, charcoal

Obtain postcards, photocopies, or other reproductions of a painting depicting a group of figures or objects. You are going to draw on the reproductions, so make sure that you are willing and able to do so (books are not a good idea). On each of the reproductions, look for and draw an analysis of particular dominants, such as lines of

BEYOND THE LOOK

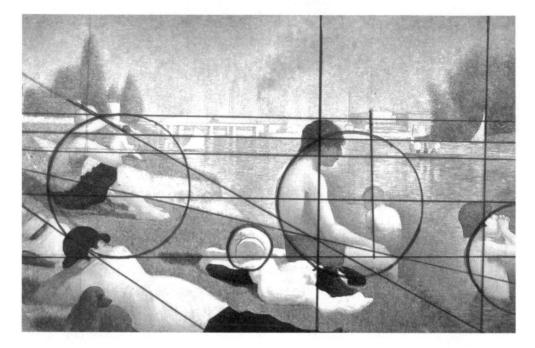

compositional force, areas of similar or contrasting tones or colors, decorative motifs, and so on.

On 22- x 30-in paper, produce a series of small sketches, in the same proportions as your reproduction, of the dominants within the composition. This analysis will show the way in which pictures hold together as a compositional structure at the surface. If you have a basic knowledge of perspective or other projection systems it may be worth having a go at analyzing the way in which the illusory space is constructed by examining the planes of recession or the other means by which depth is suggested. In pictures with buildings as a major feature, the lines of compositional force tied to the buildings give a clue to the construction of the illusory space and the particular projection system used. You can make a separate drawing of this, or draw over the other compositional analyses.

In a landscape, the contour of the land and the elements within it will offer a planal recession, and you can trace the silhouette of each plane in a separate sketch. In a composition with people or objects, it is important to note the position of the elements in relation to the illusory surface supporting them. In these sketches, first indicate the surface and then map the elements on it, analyzing their relative positions in space.

USING THE OBSERVED

You can make abstract drawings that allude to more than one view of a subject. In the 1950s, Ben Nicholson (1894-1982) made a number of abstract works that brought together different strands of his interests. They were neither abstract landscape nor still life, but alluded to both sources. The elements were reworked and rearranged from different observations. The following project explores one way of doing this.

Left: Analysis of the compositional dominants in Georges Seurat's Bathers, Asnières

PROJECT 3

COMPOSITION USING THE NEGATIVE SPACES DERIVED FROM TWO REPRESENTATIONAL IMAGES

One three-hour session

Materials: 22- x 30-in paper, a number of sheets of newsprint, conté chalk, pastel or charcoal, plastic eraser

Select two images to use as reference material. Different subject matter would be best. You can use photographs, paintings, or drawings of objects, landscapes, or the figure. On newsprint, analyze and draw the areas of the pictures *not* occupied by objects—the negative space—in outline only. These act as shape molds around the positive silhouettes of the objects and carry a hint of the objects represented without clearly detailing them. This stage should take about one hour. Then use the negative shapes as a starting point for a composition. Draw the shapes, now positive, altering their orientation, scale, and perhaps shape where you feel it necessary. You can also use tone, texture, and pattern as and when you feel it is required.

ABSTRACTING FROM OBSERVED FORMS

Sculptors such as Constantin Brancusi (1876-1957), Naum Gabo (1890-1977), Henry Moore (1898-1987), and Barbara Hepworth (1903-75) sought to make connections between the forms of different types of objects. At the start of this chapter we looked at the way in which Leonardo sought morphological connections by finding archetypal forms and structures that could be read in different objects.

The archetypal form is a three-dimensional configuration that does not depict one particular object, but alludes to many. It can be based on natural, man-made, or plant forms, but without

Right: Composition using negative spaces derived from two images

BEYOND THE LOOK

reference to anything specific. In the following project you are going to use the strategies of the previous chapter–crosssectional, surface, and planal analysis and different tonal elaborations–to qualify your own archetypal forms.

Abstracting from observed forms

BEYOND THE LOOK

PROJECT 4 FORM ARCHETYPES

One three-hour session **Materials:** 22- x 30-in paper, black and white pastels (not oil pastel)

You can derive an archetypal form from any

The finished drawing should allude to and suggest existing forms.

object-from the human figure to a pebble. However, you may wish to use a simple natural form or forms. A bone, a shell, a simple flower, or a selection will do. Try to see a number of fundamental forms within the object. Although you are seeking something a little richer than the fundamental forms, they are worth bearing in mind when you draw the abstracted forms. Imagine you are doing a sketch for a sculpture based on your subject. The object is not for the subject to be recognized, but generalized.

You should follow the same pattern for abstraction as Mondrian in his drawings of the tree. If you were to draw for a sculpture of a head, the first drawing in a series might represent the head of a particular individual, detailing the individual set and form of the head and features. The last in the series would present an ovoid (the head) on top of a cylinder (the neck). This drawing sets out to produce the last in the series without recourse to the earlier ones. (If you feel unable to go directly to the final drawing, you may wish to work through a series of sketches in which you can simplify the figure.)

Draw the figure large to the format, using black pastel. At first, work only in line. Do not be afraid to revise and change the drawing. Do not worry if "mistakes" show: they are part of the drawing. When you have arrived at the line drawing you desire, smudge it so that you can work into and on the smudged middle-tone ground with eraser and white pastel, using the eraser to work in the light areas. It is your choice which tonal strategy you use. With white pastel, draw in the surface analysis. Once you have completed this part of the drawing, you may or may not wish to relate the form to a ground or to introduce other forms.

CHAPTER 5

ASSOCIATIONS

It is useful to define and make distinctions between the three abstract categories–reflexive, visual, and associative–in order to locate the tap roots for particular creative endeavors in abstraction. However, it would be disingenuous to mark only the differences between them. Both the reflexive and the visual abstract are born in observations of the world and ourselves in order to express opinions, feelings, and ideas to a viewer. The reflexive category suggests that there is an acsthetic grammar through which one can create "aesthetic ideals"–ideals that resonate with the way humans experience the world. The principals and motives that govern the making of this aesthetic grammar and the reception of reflexive abstract work by a viewer are ordained by the world; they are not found somewhere outside our observations, beliefs, and feelings.

In Chapter 1, "Flat as a Pancake" (page 172), the example of a leaf was used to suggest a connection between the vital energies in botany and aesthetics. If this analogy is extended further, it may be possible to find connections in social, physiological, and natural structures that will lay the foundation for an aesthetic system. In the 1920s, Paul Klee (1879-1940) and Wassily Kandinsky (1866-1944) made a beginning in the formulation of a new aesthetic science. They evolved theories of creative visual structures that, like those in music, would not prescribe an expression but be the basis for expression. Their instincts for the necessary, appropriate, and harmonious are what these theories anticipate. We (the authors) are justified in asking you to trust your own intuitive judgements; after all, they come from observations of structures and behavior in the world, and also reflect your own emotional makeup and cognitive structures.

In the associative abstract, a particular event, circumstance, or idea is the cause of the work, but the reflexive or visual abstraction may be used to help realize its expression. The experience or idea at the root of the associative is, to all intents and purposes, already abstract as it does not have material form. It is specific, however; it makes a

direct association to a cause. The associative abstract can be thought of in three categories: sensory, expressive, and conceptual.

SENSORY ASSOCIATIONS

In art, the sense of touch is represented through pictorial equivalents. Touch is part of the way babies gain experience of the spaces around them, and they learn through their fingertips the feeling of being in physical contact with the world. Our sense of space is partly derived from touch, although our vision of surfaces preempts what they may feel like, and it is possible to produce a series of marks that describe the surface of objects, or the texture of vegetation, or rocks in the landscape.

We can also address the sensation itself, making marks that attach to the sensation, not to the object that caused the sensation. But perhaps because the tactile is so attached to seeing and the flow of tactile sensation is so difficult to orchestrate, the pure sensation of touch is not as rich a field for abstract representation as those of the other senses. Texture, however, can be an essential part in representing the other senses. To be able to represent a sense, there has to be a link between the impression of one sense and that of another; this is a definition of "synaesthesia." Kandinsky purportedly was a genuine "synaesthetic"—he actually saw sound. Able to transform the sound he heard into an actual mental "visual," Kandinsky would paint images of musical compositions that were records of the images he really saw.

The other senses can also be used in these transpositions. Students at the Royal College of Art in London worked with a "nose" from Grasse who had evolved a perfume made up of over 200 essences. The students had access to the separate essences, which were grouped according to their qualities, like the keys of an organ. The perfume itself was composed like music, assembled with different olfactory chords and notes. The drawings produced by the students based on this perfume were sensational.

Drawing based on the scent of a perfume

However, to appreciate such drawings one needs to have *sympathy* (in both senses of the word), and synaesthesia is also defined as an "agreement of the feelings or emotions of different

individuals as a stage in the development of sympathy." Sympathy is an important part of the associative abstract, for without it associations cannot be made.

One of the projects in this chapter uses sound, more especially music, to explore sensorial associations. You may also wish to try an abstract drawing representing a smell or a taste.

EXPRESSIVE ASSOCIATIONS

Abstract artists may work to create moods, express emotions, or portray psychological states in their work. As with the sensory approach, sympathy is a necessary condition for the understanding of this type of work. The work of art does not ask for an agreed upon or absolute meaning, but it does point to an area of significance, feeling, or whatever, that it wishes the viewer to share. For example, a fractious, hysterical mark engenders a fairly prescribed response–you would not find it calming. Artists working expressively use marks, shapes, or forms sympathetically to deliver their message.

CONCEPTUAL ASSOCIATIONS

Abstract work can be conceptual-it can address social, political, or philosophical issues. The 1980s neo-geometric conceptualism of Peter Halley's paintings was inspired by Jean Baudrillard's philosophy of the same period. The pattern and decoration movement in the United States in the mid 1970s-80s questioned the distinction between the concerns of the applied arts (craft) and the mainstream art movement by making pattern and decoration the theme for mainstream art. Sol le Witt (b.1928) makes minimal artworks that question authorship, ownership, and art as a commodity. Some of his works consist only of the instructions for the production of an artwork and the certificate of ownership.

Although there is no project to highlight this area, it is an important way in which the abstract work can operate.

PROJECT 1

MUSIC AS THE SUBJECT FOR A DRAWING

One three-hour session

Materials: sheets of newsprint; 22- x 30-in paper; soft (3B-9B) pencils; black pastel, conté chalk, or charcoal; kneadable eraser

Choose a piece of classical music lasting approximately ten minutes. Play it through once to get an overall impression of the whole piece. Play it through again, but this time track with pencil a line marking the changes in tempo, volume, and mood. The drawing should last the time of the piece of music.

On a sheet of 22- \times 30-in newsprint, draw five rectangular formats, or cells. Now replay the piece of music, stopping every two or so minutes. At each stop, draw for ten minutes with a soft pencil, trying to represent in shapes, lines, and textures the passage just completed.

For the final drawing, take two hours. On 22- x 30-in paper, do a drawing with charcoal, pastel, or conté in which you represent the music-the actual sounds-as marks, but tempered by the effect it has on you.

PROJECT 2

ABSTRACT PORTRAIT OF AN INDIVIDUAL

One three-hour session

Materials: sheets of newsprint, a number of sheets of 22- x 30-in paper, numerous drawing mediums in black and white, glue, scissors

For the first one-and-a-half hours, produce different textures, patterns, and marks on newsprint and paper (see illustrated overleaf). Be inventive in doing these. A mark can be made with any substance and a range of different actions. Take textural rubbings working with

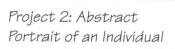

ink and oil pastel. Use a white oil pastel as a "resist" to black ink. Invent textures with repetitions of different marks. When you have collected this textural material, think of a person you would like to portray. Think beyond his or her appearance. This is not a portrait in the usual sense, but a character analysis or psychological profile. It is a reflection of the individual's character, but it is also about you and your relationship with him or her, expressed in abstract, textured shapes.

On 22- \times 30-in paper, select a format in which to compose a collage. Use the lessons of the first two chapters to help you compose on the surface and with shapes in space. You can cut or tear out shapes. Then use the textural experiments to make the collage. Make sure that you have considered all areas of the collage before stopping. Work intuitively and without inhibitions.

PROJECT 3

COLLAGE AS A SKETCH FOR THE FOUR HUMORS

Three hours for four drawings

Materials: newsprint, two sheets of 22- x 30-in paper, glossy magazines, glue

The subject of this project is again a collage of a psychological profile, but this time it is not of a particular individual but of a category of individuals.

The collage is based on one of the four humors. The humors were medieval categories for marking the behavior of individuals. It was believed that each person's character was shaped by a preponderance of one of the four bodily fluids: blood, phlegm, choler, and black choler. The humor characterized by blood is known as sanguine. The sanguine temperament is hale, hearty, jovial, and garrulous, but it can also be bellicose or belligerent. The phlegmatic temperament is civil,

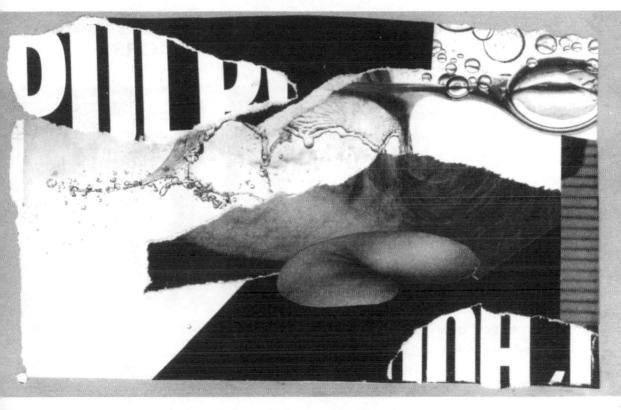

Collage of the sanguine humor

judicious, even-tempered, and not given easily to extreme emotions. The choleric humor is irritable, highly strung, and given over to big mood swings—a nervous individual. The melancholic humor (black choler) is dark and brooding, and prone to bouts of depression. You can research the humors further before beginning the project.

Choose one of the humors to work with. Select a rectangular format that does not exceed 10 in (25 cm) in length. Select areas of images from glossy magazines that have different textural or tonal values, and avoid any recognizable elements. If you can, choose black and white and gray images, but if this is difficult, do the collage in color. Now assemble the collage so that the shapes, textures, and tones, and the overall arrangement, give an impression of your chosen humor.

PROJECT 4 DRAWING OF ONE OF THE HUMORS

One four-hour drawing

Materials: two sheets of 22- x 30in paper, black and white pastels (not oil pastel), pencil, kneadable and plastic erasers

Join the 22- \times 30-in sheets of paper together and make a drawing of your collage from Project 3. First, draw a proportionally correct format. Next, with a pencil, draw an accurate grid over your collage-draw diagonals from corner to corner; then draw medians through the point of intersection of the diagonals. Then do the same to the four squares this has created. Do the same on your drawing surface. Next, map out the shapes of the collage pieces. Proceed to draw, matching the tones and textures of the collage. If the collage is colored, squint your eyes to assess the tones. The collage and the drawing are built through observed comparisons and contrasts, so the way in which one textured or tonal area meets another is important in conveying the character of the humor.

Drawing of the sanguine humor made from the collage

CHAPTER 6

ON YOUR MARKS

light upstroke, a heavy downstroke. It was with this dictum (some twenty or so years ago) that schoolchildren learned to write. The teaching of writing went beyond legibility; an aesthetic script was thought to be important in the presentation not only of the ideas in the text but of the sensibilities of the writer. The calligrapher still forms letters with a delicate upswing and a downstroke done with controlled pressure. But even in this formalization, no two people's scripts have ever been exactly the same. Our signatures are still one of the most important ways of marking our identities and individuality. And not only our signatures. Our uniqueness is evidenced in our everyday writing. Graphologists are employed to read character in the formation of pothooks and hangers, in flourishes and curlicues, and in the squiggles of the upstrokes and downstrokes of our handwriting.

A child's first drawings show the rapture of that first interaction of its hand with the matter of drawing, matter being both material and act. The welter of lines produced are not descriptions of things; they are nothing other than pure drawing. It is an act of discovery. The child discovers that an action may leave its history-or trace-which means that the action may be preserved and appreciated by others. By scribbling, smearing, or dirtying, a child marks its presence. A child's drawing will be made with whatever is at hand. If the drawing happens to have been done on paper or another acceptable support, a parent of the child will probably put a name on the drawing (formally identifying the child as the author) and date it (marking the child as a presence in time). The drawing is labelled so that it has a significance in the life and development of the child. The drawing is often stuck on a wall so that the child knows that its efforts are appreciated. In terms of the drawing, however, the parent's labelling is redundant because the information exists in the fact of the drawing. These are a child's autograph in the purest sense

The marks laid down in a drawing not only denote or represent, they also reveal the activity of its making. Its production is an inescapable part of the meaning of the drawing, and the drawing's production is significant. In drawings of landscape by Vincent van Gogh (1853-90), much is made of the expression. The source of the expression is not in the choice of subject matter, but in how he has depicted it. The landscape is a motif that he uses to realize an expression of himself and the human predicament. The marks–whirls, stabs, slashes, and dots–are particularly expressive; they join the sky, vegetation, thatch, and so on to the psyche of Van Gogh, expressing the artist as subject. They are what communicate Van Gogh's emotions and psychological state. Van Gogh's marks are autographic in the same way that the child's scribbles are. They point to himself, but he used himself as example: and he used the particular in himself to reach a universal expression.

In traditional Chinese art, the techniques and methods of production are not just handmaidens in the service of an idea; they are integral to the idea. In Chinese painting, every mark carries an individual meaning and spirit that is culturally ordained. When combined with other marks they add up to the bigger meaning of the picture. The Chinese artist will spend years perfecting his technique; learning how to make marks that contain different spiritual qualities, which he then uses in representing the natural world. The marks themselves can designate the "yin" and the "yang" (the male and female principles)–the principle of binary opposition that lies in all things, in heaven and Earth, dark and light, and so on. The marks produced and executed in a drawing need not be solely autographic; they may have sociocultural, philosophical, or natural roots.

Modern artists have also sought to use the mark itself symbolically or conceptually, to express qualities such as energy, noise, sexuality, gender, creative principles, and so on.

A drawing is produced in time and a drawing is a temporal record of the period of execution. As a viewer, one can, like an archaeologist, dig through a drawing, tracing the movements, hesitations, decisions, false trails, and other paths that lead to the final drawing. In reading a drawing in this way, the viewer can track and engage in the act of drawing itself, and may eventually be led to the artist's emotions or to other events and meanings.

To recap: a mark is born in an action. The way it is produced may be read by a viewer. The mark or marks carry meanings leading to and from the act of drawing. The marks can be *autographic*, acting as and expressing the person drawing; or they can be *symbolic/conceptual*, using the actions evidenced in drawing to stand for or act as ideas that lie in society, religion, and so on. In viewing a drawing, one may be able to "reverse produce" it, reading the last marks first and then excavating back to the first marks.

Finally, a drawing is made with different materials. The drawing tool and support themselves carry meanings. The German artist Joseph Beuys (1921-86) used such bizarre materials as machine oil, hare's blood, iron chloride, and fat, along with traditional materials such as pencil and watercolor, for his drawings. These materials were essential to him for linking the inner life to the corporeal world–for a "feeling of substance."

PROJECT 1

THE ACT OF DRAWING AS MOVEMENT

Four thirty-minute drawings

Materials: four sheets of 22- x 30-in paper, pencil or pen and ink

You will need a moving person, creature, or image as a model for these drawings. If you have access to a life model, or a friend who does not mind helping out for a couple of hours, that would be ideal. You can work from animals as long as they are active. You can also work from film, video, or the television, but ensure that you have a subject that has movement.

If you are using a model, ask her or him to do four different movement routines—one for each drawing. Now, while the model is moving, draw not the model but the pure movement.

In each drawing, develop an action that captures the essence of the movement—a gestural mark (a gesture is an action that produces a meaningful mark) that moves as a correlative of the movement you are observing. You can think of it as a tracking of a point or points on the anatomy of the model. Do not try to draw the model or the model's features. Just place your pencil as if on a particular point on the model and move the pencil at the speed and in the direction that the point on the model moves. You can switch points of concern on the model at any time.

At the end of the thirty minutes you will have a drawing of pure movement. The object is dematerialized (there is no representation of the model); there is just the movement of the point on which you concentrated: its rhythm, its pauses, its speed, its weight-its movement. It will create a trail that moves through, around, and over itself.

AUTOMATISM

To date we have been essentially formal in our approach to abstract works, particularly in the reflexive abstract. However, abstract drawing, and painting, can be aformal, or not determined in its composition, and still be reflexive. So how can a work be aformal yet still issue from concerns with picture-making itself?

The "process" becomes the significant feature of the aformal work. It does not start with an ideal, but with the act of making the picture itself. The process seeks to disrupt around an intention for the work, and chance becomes an important feature. The spontaneous, unrehearsed gesture supplants the self-conscious and rehearsed. In the 1940s the Abstract Expressionists—particularly Jackson Pollock (1912-56)—sought to free procedure and imagery from the restriction and control of formalism and representation. Surrealist "automatic"

procedures were employed by Pollock and other Abstract Expressionists. *Automatism* is a term describing any procedure employed as a means of avoiding control over the formal (compositional) aspects of a picture.

Automatism may involve the artist in creating his or her own "automatic" actions, or allowing the materials of picture-making to behave in noncontrollable ways. The following projects are concerned with automatic procedures in the creation of abstract drawings.

PROJECT 2

WRITING WITHOUT AN ALPHABET

One three-hour session

Materials: several sheets of 22- x 30-in paper, water-based ink (black, brown, and white), bleach, brush and pen, bamboo rod with end cut and shaped to create a pen stylus

Writing without an alphabet

This project is concerned with the abstract in writing. You should avoid writing with existing letter forms. In the previous project, the movements were linked to external influences—the movement of a figure or image. In this project, the writing comes from the movements of your own body—a dance of muscle, bone, and sinew.

For the first drawings, tear two pieces of 22- x 30-in paper in half along their length and join them together at the back with masking tape to make one long drawing surface. With a brush, write along the length of the paper (from left to right) creating new letterforms. Repeat the exercise, writing from right to left. Vary the pressure and movement of the brush along the length. Repeat the procedure again, drawing with the bamboo stick and ink. It is difficult to anticipate how long each text will take, but repeat these automatic scripts for about one hour. You can vary the format for the later exercises, perhaps writing a number of lines. You may want to get rid of the notion of the line eventually. Think of starting in the middle of the picture, letting the line run over and through itself.

In the next one-and-a-half hours, continue experimenting with automatic writing, but now introduce different materials. For the first effort, spread a thin film of water-based black ink over the drawing surface. Let it dry, then proceed to write on the inked surface with a brush, using bleach. The bleach will act as a solvent to the ink, leaving a bled white line on the black ink. You can repeat the exercise, but now trying to write with bleach that you drip or pour onto the inked surface. Later on, you can write different scripts with different inks, including bleached script.

For the last half-hour, take a few of your least successful drawings from all the efforts, tear them up, rearrange them, and stick them down on a fresh sheet of paper. Then work back into the drawings with brush and ink again, making new "sense" or "nonsense" from them.

Left: Writing without an alphabet, using bleach

PROJECT 3 CHANCE AND MATERIALS

One three-hour session

Materials: numerous sheets of 22- x 30-in paper, black and white sugar paper (a coarse, inexpensive paper), and newsprint; mixed media—such as oil (linseed or other), ink, charcoal, paint, pastel, and crayon (keep essentially to earth colors, black, and white)

On each type of paper make experiments, creating different textural effects. For instance, scribble on a sheet of paper with white oil crayon, and then brush black ink over it. The oil crayon will act as a resist to the ink. Take rubbings of various textures (a technique called *frottage*) with pastel; create other textures using oil with the ink. Tear or cut up the different texture experiments. Shuffle them about and drop them onto fresh sheets of paper to distribute them randomly. To make it truly random, drop them from a height. Stick the pieces down as they have landed.

PROJECT 4 CHANCE AND CONTROL

One three-hour session **Materials:** 22- x 30-in paper, pencil, conté crayon, bleach, pen and ink

This final project explores ways of using controlled and uncontrolled processes in the same drawing. Think of musical notation. The staves can be considered as set or controlled, and the music as the random element. In a series of drawings, draw grids or geometric figures, around, in, through, and over which you will use automatic techniques. This will create aesthetic tensions between the intended figures and the unintended drawing actions.

Lett: Chance and materials. Overleaf: Chance and control

CONCLUSION

bstraction is not one thing. In making an abstract work you may wish to employ vestiges of descriptive functions in your work–using natural forms (biomorphic) or machine forms (mechanomorphic). Or you may opt for a pure abstraction where, instead of representing objects that signify something, the work itself is significant (metamorphic). Furthermore, you may consciously evolve the abstract work to reflect a belief system, narrative, or myth. No one can prescribe a method or technique for you to adopt; the choice must be yours, based on what moves you.

In a way, it is not even a matter of choice. The way in which you make pictures will be based on an impulse, although this impulse is not something that you need to know beforehand or to rationalize afterwards. It can be born out of a belief or ideology to which you subscribe and which motivates your work; or you may find motivation in the action of making art itself. However, it is important to acknowledge that abstract work does have a subject matter, and that this is a matter for the subject–the artist.

Kandinsky described the impulse to create as an inner need built with three mystical elements. Every artist, as a creator, has something, in him or her, that calls for expression. Every artist, as a child of his or her age, is impelled to express the spirit of that age. Every artist, as a servant of art, has to help the cause of art. In other words, we make art for a reason. The work is about ourselves, about the world we live in, and about art itself.

LANDSCAPE DRAWING

INTRODUCTION

S tudents sometimes begin drawing with set preconceptions about what a drawing should portray and how it should look, and this is particularly true in the case of landscape. In particular, they think that a drawing should provide a copy of the scene they are looking at. However, this is not possible, and any attempt to match reality in this way will not lead to successful or satisfying drawings.

There are many different approaches to drawing the landscape, depending on the feelings, ideas, and observations that it provokes in you, and it can be difficult to decide how to set about it, and what to include and what to leave out. The best solution is to break down the subject into its different aspects, and concentrate on just one of them in any one drawing. For example, landscape can be approached by looking at the textures of the different features and finding ways of creating the illusion of those textures by using your materials in different ways. Or you can study the natural elements of atmosphere, water, fire, and earth, finding different ways of using your materials to respond to them.

Each chapter in this section tackles a different way of looking at and analyzing the landscape, such as through texture, ordering the space, or concentrating on your emotional response, and then describes techniques to use for describing that way of looking. By the end, you should have a broad experience that will enable you to work with a number of techniques to express your ideas and feelings. You should work through the projects in the order in which they are given, as later ones build on those in earlier chapters. And by trying out all the approaches described, even if they do not feel quite right for you, you should begin to find out where your strengths and interests lie.

INTRODUCTION

Some of the projects involve drawing for a few hours in the landscape, and in addition to drawing materials you should take suitable clothing for the weather and supplies of food and drink. It is also important that you are comfortable while working, and a folding chair or stool is a definite advantage.

Shape and texture in the landscape

CHAPTER 1

PRECONCEPTIONS

The projects in this chapter involve going into the landscape to make several quick drawings in a sketchbook, using a number of broad-based but mainly gestural techniques. By the end you should have developed confidence in approaching landscape drawing and feel happy about working outdoors, which can be difficult and intimidating for a beginner. The projects should also help you to respond quickly to the environment and enable you to draw, without fear or constraint, in a number of different ways that express your feelings and responses.

The projects have certain conditions attached to them. Some are very quick, with precise times. Others have very specific instructions, such as using both hands. You should comply with these conditions even if they feel strange or restrictive because, as well as trying to break down preconceptions about drawing, the aim of these procedures is to undermine any notions you may have about landscape.

GESTURE

The first seven projects involve gestural drawings, and the attitude that you adopt is crucial to success. A gestural drawing is an action statement. You should allow your eye to scan your field of vision, seeking the primary objects in that field and their positions in relation to each other. In other words, you should draw the scene simultaneously with seeing it. It is a fusion of observation and drawing, done quickly, and placing the whole landscape down almost at once. Imagine you have never drawn before and know nothing about it.

MATERIALS

For all the projects in this chapter you need an 8½-x 11-in hardback sketchbook, 3B or 4B pencils or graphite sticks, erasers, a pencil sharpener, a watch or clock, something dry to sit on, suitable clothing for the weather, and food and drink if appropriate.

PROJECT 1 HAND-EYE RELIANCE

Three five-minute drawings

The aims of this project are to prevent you from copying what you see and to help you accept your drawing as an expression or metaphor for what you see. A general misconception is that visual artists should be able to draw "properly," in the sense of reproducing or making an exact likeness of what they see. This attitude puts a lot of pressure on beginners. In other art forms, artists are applauded for using metaphor. When William Wordsworth wrote *The Daffodils*, he used metaphor to express his feelings.

> I wander'd lonely as a cloud That floats on high o'er vales and hills, When all at once I saw a crowd, A host of golden daffodils.

Wordsworth could have written: I am walking in the hills. I am alone. I have just seen a field with approximately 4,000 daffodils in it, and so on. Instead, he chose to use metaphor to describe his experiences and feelings. Unless they are recording something for a specific reason, visual artists do not need to be literal.

Hand-eye reliance

Do not look at your drawing while drawing.

Using pencil or graphite sticks, make three five-minute drawings. You should be looking at the landscape continuously during this period of drawing, not at your drawing. If your pencil is moving, you should be looking at the subject. You can look at your drawing a couple of times while you work, but not while your pencil is on the paper. This approach should give you a sense of hand-eye coordination, just like when you hit a ball with a bat.

PROJECT 2 GESTURE

Three five-minute drawings

Using pencil or graphite sticks, do three five-minute drawings. Fill the page with each drawing. You need to approach this with confidence. Imagine your hand is an Gesture is a meaningful, descriptive scribble and the best approach is to draw with speed and pressure.

extension of your eye. Do not concentrate on detail. Let your pencil line swing from the top to the bottom of the composition, and from side to side, until the landscape is drawn. You are creating an artificial statement for what you see, in this case with gesture. Remember that your drawing is a metaphor for the real world.

Gestural drawing

PROJECT 3 GESTURE

One one-minute drawing, one three-minute drawing, one five-minute drawing

Each drawing should depict a different view. Speed is of the essence in these drawings. The thought processes that go into drawing and the physical act of doing the drawing must be simultaneous. Trust your reactions. This can be difficult at first because we respond to most things in life in a more controlled, calculated way, taking time to reflect, whereas in this drawing you should be spontaneous.

PROJECT 4 UNFAVORED HAND

Three ten-minute drawings

Work using the same approach as in the previous project. Make three ten-minute drawings using your unfavored hand: if you are righthanded use your left hand, and vice versa. The movements of your favored hand are rooted in habit, and you need to break this in order to progress. The unfavored hand will open up new opportunities and allow you to be more expressive and less predetermined.

PROJECT 5 USING BOTH HANDS

Three five-minute drawings

Again, work in a gestural way. In this drawing, use both hands simultaneously. Let one hand start the drawing at one side of the picture while the other hand starts on the other side. Begin to draw,

but do not move each hand in the same direction. Make each hand draw in different directions, working on different parts of the drawing. Let your hands cross over so that they both draw on both sides of the picture.

PROJECT 6 CONTINUOUS LINE

Three five-minute drawings

Place your pencil or graphite stick on the paper and associate this with a point in the landscape. Look around the location, scanning it and observing the features. Coordinate this with the movement of your hand to make the drawing. As you draw, compare and locate points in the landscape in relation to each other, establishing rough proportons in this search. Do not take the pencil off the paper while you are drawing.

Try to make the line appear as though it is travelling through space, indicating depth in the scene by varying the pressure on the pencil at appropriate points. If you want something to appear near, make the mark darker and thicker. If you want something to appear in the distance, make the mark lighter and thinner. As the line moves through the air from one point to another, imagine that it is a bird flying from tree to tree, leaving the line as a trace of its movements. At the same time, try to make spatial sense of the trace so that it moves through and activates the depth of field.

Continuous-line drawing

PROJECT 7 HOLDING THE PENCIL

Three five-minute drawings

We readily pick up a pencil in the same way, holding it as we have held it thousands of times before, never questioning this procedure or the limitations that it forces on us. However, by holding the pencil as for writing, you restrict the flow of the drawing as you can only move the hand and wrist. Instead, think of ways to make marks using other parts of the body. Each provides a new, exciting experience that will also bring about a different sense of control, scale, and expression. Here are a few suggestions, but also try to think of other ways to evolve a drawing.

Hold the pencil like a dagger. This brings the action of the whole arm into the making of a drawing.

Hold the pencil right at the end, between thumb and forefinger. This limits the drawing action and the pressure that you can apply.

Hold the pencil in your mouth. This brings the movement of the head and torso into the drawing.

Place the sketchbook on the ground. Take off a shoe and sock and hold the pencil between your toes. The whole balance of the body is brought into this drawing.

PROJECT 8 SILHOUETTE

One ten-minute drawing

This drawing is done more slowly than the gestural drawings. It is considered rather than spontaneous. Look for a landscape that has a foreground, a middle ground, and a background that meets the sky at

the horizon. You should also look for objects in the foreground, such as a tree or building, that overlap the middle ground and background and break though the horizon line. Look for similar objects in the middle ground that overlap the background and the horizon line. This overlap creates the illusion of space.

The aim is to draw the silhouettes of the objects and the way they link up with other objects in the same plane. Effectively, you are drawing the shapes of the objects, both positively and negatively.

Start with the background. The first stage is to draw the horizon line and the silhouettes of all parts of objects that are above the horizon line from your viewpoint. Starting at the edge of the paper, draw the horizon line until you meet the first object that protrudes above it. Draw up and over this object until your pencil returns to the horizon line. Then continue to draw along the horizon line until you come to the next object that protrudes above it; draw up and over this object until you return to the horizon line. Continue with this until you reach the other edge of the paper. You have now effectively cut the paper in two (Step I).

Silhouette drawing, Step 1

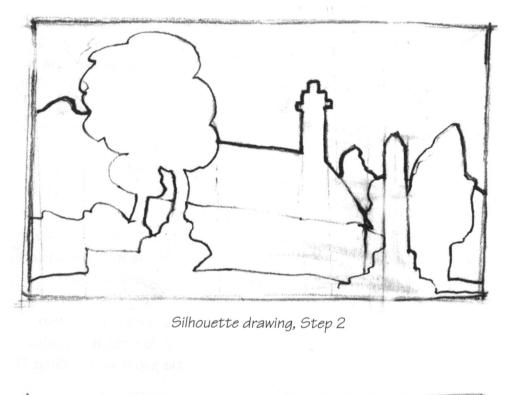

Planal recession

The next stage is to draw the middle ground, linking it to the horizon line with objects that overlap, drawing the silhouettes of all parts of objects that are below the horizon line from your viewpoint.

Put your pencil on the original starting point on the horizon line and begin to draw along that line again until you come to the point where you meet the first object. This time take the line down around the object until it meets the ground. Then continue this line along the ground, returning back to the edge of the paper (below your original starting point on the horizon line). Now find where the other side of this object touches the horizon line. Begin to draw down this side of the object until you come to the point where it meets the ground, and follow this line up and over other objects as they appear either to meet the horizon line again or to go out of the other side of the picture. Do the same with the other objects that overlap the horizon line.

Continue in this way until you have established the three areas of background, middle ground, and foreground (Step 2).

PROJECT 9 PLANAL RECESSION

One thirty-minute to one-hour drawing

Planal recession means creating the illusion of different planes (like flat sheets of card) overlapping each other and appearing to go back in space.

This is very similar to Project 8 (page 260), and you could use the last example as a basis for this drawing, as you have already created planal recession through the use of the overlap. The aim here is to emphasize recession by using tone.

First, make the foreground area a very dark tone. Then make the middle ground area a slightly lighter tone, and the background area a very light tone. This will help the illusion of space and depth. You can

leave the sky white or make it dark from the horizon line to the top of the paper, or the reverse.

Play with the tone combinations to see how they affect the idea of depth and space.

PROJECT 10 MEMORY

One half-hour drawing

We are continuously using our memories when drawing. The only situation when we do not is when using hand-eye reliance. In every drawing, even though it may only be for a fraction of a second, as you turn your head away from the scene back to your drawing, you are using your memory. This project extends the idea of memory.

Look at your landscape subject continuously for ten minutes, assessing the composition. What objects are in the scene and where are they positioned? How do they relate to each other and the space they occupy? Assess the light: how is it falling on the landscape and what effect is it having? You can also take into account things such as texture (see Chapter 2, "Landscape Textures," page 266). When you have completed your observations, start a drawing of what you remember without making any further reference to the scene. Spend about twenty minutes on the drawing itself. When you have finished, compare the drawing with the original view.

Try to develop your memory skills as this will be useful in later drawings. It will also allow you to be less reliant on drawing from observation all the time. Eventually, good memory skills will enable you to use more artistic license in your work.

PROJECT 11 REDUCED LINES

One twenty-minute drawing

First make a continuous-line drawing as in Project 6 (page 259). Then break this line by rubbing out sections in order to reduce the number of lines needed to describe the scene in front of you. First, use only ten lines. From that drawing, try to reduce the number of lines to seven, and so on until you are down to three lines, or even one. Throughout, do not lose the essence of what you are describing.

Reduced-line drawing

CHAPTER 2

LANDSCAPE TEXTURES

ouch is a sense that we all possess, yet we often take it very much for granted. We are constantly using touch, and, even if at an unconscious level, we are being made aware all the time of our immediate textural environment. This experience is automatically stored in the mind for future reference, and we can very easily access our memory of textural information.

Artists throughout history and across cultures have been fascinated by the challenge of re-creating a sense of touch. Whether consciously or unconsciously, their focus has been pulled towards the surface qualities of the scene portrayed. Texture may not have been the primary concern of the artist, but that did not stop them trying to excel at describing it. There are many good examples, but the following, in particular, will help you to understand the issues raised in this chapter: the drawings by the Chinese artist Xu Xi (c.1020-90) of early spring and winter landscapes; the mountain landscapes, studies of rocks, a storm, water and eddies, and numerous studies of plants by Leonardo da Vinci (1452-1519); studies of trees by Titian (1488-1576); the landscapes of Pieter Breughel the Elder (c.1525-69) and Rembrandt (1606-69); the landscape and seascape drawings of Vincent van Gogh (1853-90); and the dreamlike textural landscapes of Max Ernst (1891-1976). All these drawings have great intensity expressed through variation in mark-making. They are also visually exciting drawings that can hold the viewer's attention.

The experience and understanding of mark-making that the following projects provide should enable you to create landscape drawings that express texture, surface, space, and form. The projects provide a number of clear procedures to give confidence in drawing the landscape using a textural approach, and in mark-making through experimentation with different mediums. They involve some closely observed individual studies of the different types of objects encountered in the landscape, a more complete study of the landscape that expresses the texture, space, and form observed there, and the technique of frottage used to construct a landscape drawing.

PROJECT 1 DEVELOPING MARK-MAKING

One one- to two-hour session

Materials: sketchbook, pencils (2H-6B), graphite sticks, charcoal, compressed charcoal, inks and dip pens, felt-tip pens, plastic and kneaded erasers, and any other drawing material you want to work with

You need to know what your medium is capable of in terms of markmaking. Far too often, people take things for granted, in particular the way in which they hold the drawing tool and how they use it. Because of this, they persistently make the same statement. This project demands that you break with these ingrained habits and develop your own vocabulary of marks. Endeavor to make an inventory of marks that you can refer to later–like a dictionary divided into sections: one for pencil marks, one for graphite marks, one for charcoal marks, and so on.

For example: take the charcoal and, instead of drawing with the end to make a line, place it flat on its side and pull it down the paper. Notice what a fine, tight line this makes. Lay the charcoal on the paper in the same way and drag it sideways; look at the different impression made. Repeat the process again, but this time instead of dragging the charcoal, twist it as though you were using a compass. There are many more ways in which to develop and use the medium. Think of making as varied a collection of statements as possible: fluid marks, rigid marks, dark marks, light marks, hard marks, and soft marks. Position these experiments on the paper so that you have marks next to each other that create an obvious contrast. And think about how you hold the drawing tool to make your marks. Be open in your attitude and approach towards this and try different methods. This research will enable you to broaden and develop your mark-making and prepare you for the next two projects.

Right: Examples of mark-making

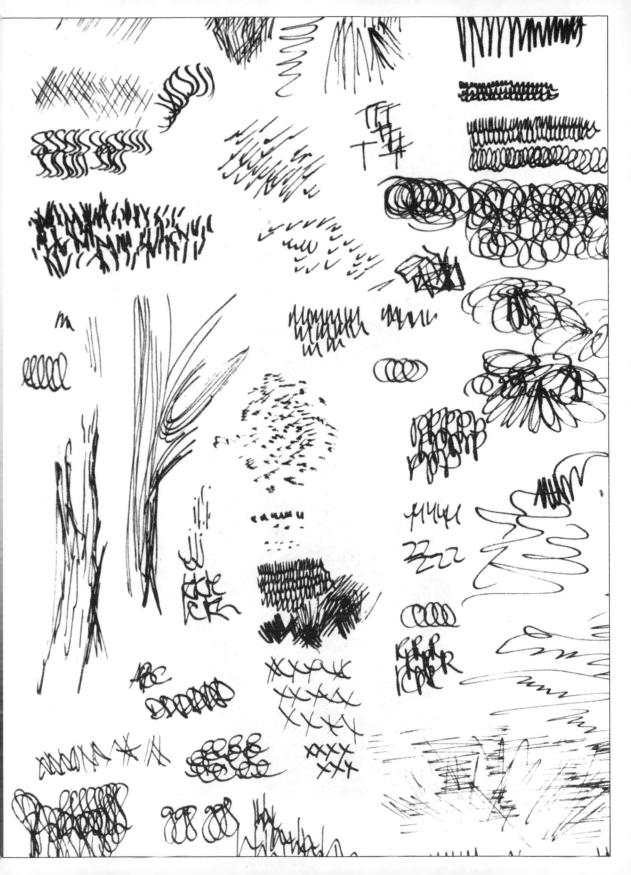

PROJECT 2 CLOSE-UP STUDIES OF NATURE

Each study no longer than thirty minutes **Materials:** 22- x 30-in paper, any of the drawing materials used in Project 1 (page 268)

Having done some research in mark-making, you should be ready to attempt a close-up drawing from nature. Go into the landscape and collect examples to bring home and draw. It is usually possible to find various fungi, a broken branch with interesting bark, a thistle, and so on. If you live near the sea, you can scour the beaches for interesting textural objects.

Select an object and lay it on a neutral ground, such as a piece of white paper. Observe and analyze this object closely, becoming very familiar with what it looks like. You need to understand its form and texture, and how that texture is constructed. Once you have

Observe closely. Understand your observations, and analyze how the object is texturally constructed. Then draw that understanding, not the literal observation. For example, if you are drawing a piece of wood, the grain of the wood should echo its form. It would not just lie flat over the surface (unless, of course, the surface is flat). sufficient understanding of the subject, you can think about how to draw it.

In the first part of the drawing, you should deal with the structure of the object. Use line to describe the basic proportions and to give a sense of the underlying fundamental form. For example, the fundamental form of a thistle-head is a sphere. Use cross-sectional analysis to describe the form. Not all objects

will have an obvious form: if you are drawing a flat object such as a leaf, you would not draw the form but the shape, and then proceed to imply the texture within that shape.

Left: Close-up textural studies of natural objects

Draw the object larger than life-size. This will make your drawing easier and less fiddly. Once you have drawn the basic outline, begin to put in the different textures. Students often make the mistake of including every detail that they see. If you do this, however, your drawing will soon become laborious and uninteresting. A certain type of concentration and understanding are required for this drawing. You need to draw a textural metaphor; that is, you need to invent a visual language of marks to describe what you see and understand.

First draw objects individually; then together, to give textural comparisons.

PROJECT 3

STUDIES OF OBJECTS IN THE LANDSCAPE

Each study no longer than thirty minutes

Materials: 8½- x 1 1-in hardback sketchbook, pencils (2H-5B), graphite sticks, pencil sharpener, plastic and kneaded erasers, felt-tip pens, pen and inks (not charcoal or compressed charcoal because they are too cumbersome on a small page)

The aim is to select individual objects within the landscape to draw, and to make studies of these objects as with the objects that you took home.

Choose an object, for example a tree. Draw it in isolation on the sketchbook page, making a textural observation of it. Use the methods described in the previous project to approach these studies. In your sketchbook, continue to experiment with different ways of making marks, as you did in Project I. You should become gradually more familiar with the elements that occupy your chosen landscape. Look at the landscape drawings of John Constable (1776-1837) and his studies of clouds, Titian's studies of trees, and Leonardo's studies of water running around a post. Make lots of studies, as this will broaden your textural experience and give you the confidence to approach the next drawing: a full landscape.

Right: Textural study of an object in the landscape

MAKING A WINDOW-MOUNT

A window-mount helps you to frame and organize your composition. You can buy plastic versions with a grid printed on one side, but you can quickly make one out of 8½- x 11-in paper.

Take an 8½- x 11-in sheet of paper. Draw a line from one corner to the diagonally opposite corner. Repeat this with the other two corners. This finds the center point of the paper (Step 1).

From the center point, draw a horizontal line and a vertical line to form four rectangles (Step 2).

Subdivide the four rectangles in the same way (Step 3).

sheet of paper. Step 2 Step 1 Cut out this rectangle, and you have a windowmount with four measuring marks along the top, bottom, and sides around the edges of the window Step 3 Step 4 WINDOW-MOUNT

This gives you a central rectangle which will be in proportion to your 22- x 30-in

(Step 4). USING A

You can select a composition by looking through the window-mount. If you are righthanded, use your left hand to hold the window-mount. and vice versa if you are left-handed. Always look through the mount from the same position.

PROJECT 4 THE LANDSCAPE

One five-hour drawing

Materials: 18- x 24-in hardback sketchbook, pencils (2B-5H) graphite sticks, pencil sharpener, plastic and kneaded erasers, felt-tip pens, pen and inks, charcoal or compressed charcoal, window-mount

You are going to draw a selected part of the landscape and you will be in this position for some time, so it is essential to be comfortable.

Use the window-mount to choose your composition, and begin to draw the outline of the objects within it. While doing this, you Remember that you are making a metaphor for texture, not drawing literally from observation.

should establish the relationship of the objects to each other, in space and proportions, so that you have the basic layout. Now start to deal with the main issue-texture. Begin to draw the contrasting textures that the landscape and the objects within it imply. Think back to the mark-making project, and on another page in your sketchbook make experimental marks that could be used in this drawing.

The difference between this and the previous drawing is one of context. Each object is drawn both in space and in context with the other objects, rather than in isolation. The way that you draw texture should work not only texturally, but should also imply spatial understanding. For example, if you are drawing the bark of a tree close to you, and you are also drawing the same type of tree further away, you can use the same mark for both trees, but the scale and weight of the marks should be different. The scale of the mark in the distance should be smaller and lighter in tone than the scale of the mark for objects close to you. This drawing is quite intense, and needs a lot of attention and concentration, so be prepared for a long session.

Overleaf: Textural landscape drawing

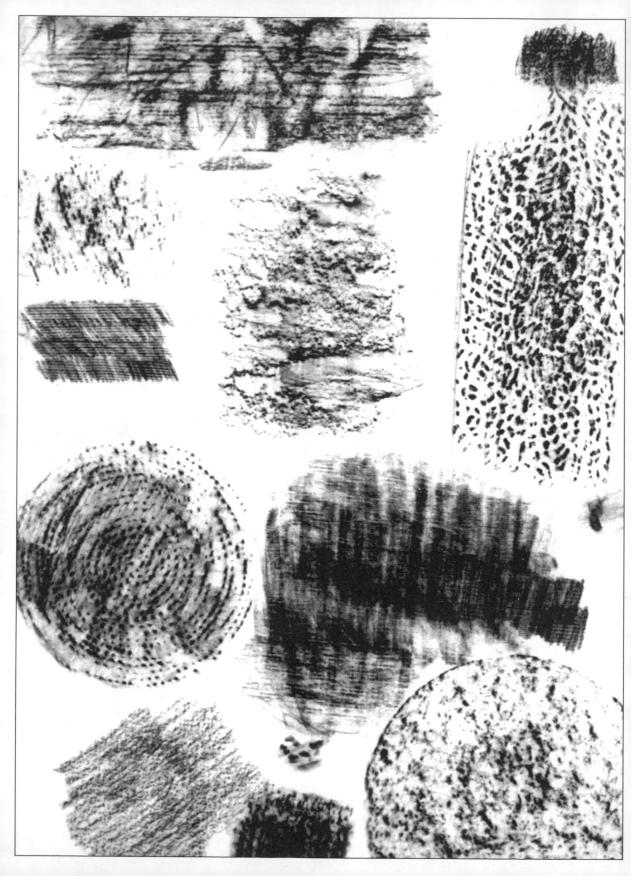

PROJECT 5 FROTTAGE AND COLLAGE

One five-hour drawing

Materials: about twelve sheets of 22- x 30-in newsprint paper; 22- x 30-in paper; graphite sticks, charcoal, or compressed charcoal; water-based glue (PVA); brush

In this project you are going to construct a collage landscape using a technique called *frottage* (see page 113). Gather a lot of examples of frottage on newsprint. Go around the house and outdoors, taking impressions from any textured surface by laying the paper over the surface and scribbling on the paper with a pencil or other drawing material. This gives the impression of the texture underneath. Make these areas of frottage quite large–about half a page of newsprint each. Whichever medium you start with, such as graphite (which works particularly well for this), stay with it for the whole project. Make different types of textures, as you are going to use them to construct a landscape.

Take a 22- x 30-in piece of paper and draw the plan of a landscape on it. You can do this at home using a landscape drawing from your sketchbook. Once you have this plotted out, cut and tear the frottage pieces and begin to stick them down on the landscape in appropriate places (see illustrated overleaf). Select frottage that is appropriate for the area that it is describing. For instance, when doing tree bark, select frottage that you think best describes that tree bark. Also, as you arrange the collage, try to emphasize contrasts in textures, both in scale and in weight of mark, so that they create a spatial and textural metaphor for the landscape.

Always start from the furthest point in the landscape because, as you build forwards, you will enhance the sense of space by the physical action of overlapping. You can do any number of these drawings.

Left: Examples of frottage Overleaf: A collage landscape using frottage

CHAPTER 3

CLASSICAL SPACE

he way in which artists have used landscape can be roughly divided into two approaches. From the classical tradition are those artists who impose order on and look for order in the landscape. From another tradition, the romantic school, are those artists who render the landscape through a more naturalistic interpretation. This and the following chapter look at ways to organize and analyze the landscape based on the classical sense of order.

The classical artist Claude Lorraine (1600-82) always referred to an underlying composition in landscape. This involved a foreground with a dark mass, usually a temple or a mass of trees, to one side, casting a shadow over this front plane. The foreground is where the human activity usually takes place and is the focal point of the picture. The eye then moves back through the picture space to the middle ground. About two-thirds across the picture in the middle ground there would be another feature, usually a group of trees. The eye is then taken back through another two planes. The first possibly being occupied by another group of trees and the last plane by distant mountains and a city. Claude used a number of other devices, such as bridges, rivers or cattle fording a stream, to help the sense of space and composition. However, perhaps the most important device that he used for creating space was tone. He created the illusion of recession within the picture space through a very dark yet clear foreground leading to a light, atmospheric background.

You will not be using as complicated a system as Claude's, but you should use some of these devices and apply them to your observations. The aims of the projects are to help you organize the compositional space in a drawing, to analyze and structure a drawing, and to abstract a composition with a sense of order.

To be successful with this approach, you need to be the type of artist who tends towards the analytical rather than the emotive. Those who are more expressive will enjoy the last two chapters more. However, there is no reason why you should not attempt this

way of working, as it just might inform you of new ways to express your ideas, feelings, and responses. Before tackling the projects, look at the work of classical landscape artists such as Nicolas Poussin (c.1593-1665) and Claude. Study how they constructed their work using the basic analysis described opposite. Also look at the work of Paul Cézanne (1839-1906), Georges Seurat (1859-91), Lyonel Feininger (1871-1956), and Piet Mondrian (1872-1944).

PROJECT 1

A LANDSCAPE CONSTRUCTED WITH TONE

One five-hour drawing **Materials:** 11- x 17-in hardback sketchbook, 3B or 4B pencils or graphite sticks, plastic and kneaded erasers, pencil sharpener, window-mount

A landscape constructed with tone

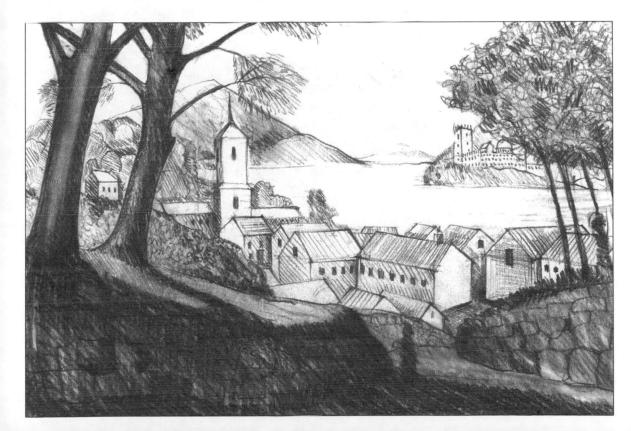

In this project you are going to record and order a scene, rather than render it in its natural state. In the next project, you will use this research to construct a landscape drawing, using tone to create form and space.

You need to select the type of landscape that lends itself to a classical composition. Do not pick wild or overgrown scenery, but look instead for a landscape that has been influenced by human activity, such as farmland, a stately home, or gardens. The grounds around stately homes provide the perfect landscape for this project as they are not only ordered, but often harbor follies in the classical style.

Having selected a place to work, compose the picture using the window-mount. You need not draw exactly what is in front of you; you can reorder it to create a balanced and harmonious composition. Objects can be moved within the composition to give a clearer sense

A landscape constructed with tone

of order. For example, you might decide to move a clump of trees to the right or left. Think about how the Claude landscapes were composed and base your thinking on this. It is a good idea to have some examples of Claude's work with you for reference. Remember that the landscape should have a clear foreground and middle ground, and the distance should contain the horizon line. Begin by drawing these areas in silhouette using line (see "Preconceptions," Project 8, page 260). Then draw in any elements, such as trees, fences, rock formations, and houses within the shapes of the silhouettes.

The next stage is to lay down the fundamental tones or tonal base. Still following the rules of Claude, start by making the whole of the foreground the darkest tone. The middle ground should be a shade or two lighter, and the background the lightest tone, leaving the sky white. You have now established the tonal base and created spatial

recession on the picture plane. Next, begin to refine the drawing, using tone to describe the objects within the space in more detail. Observe how light hits the forms of objects in the landscape, and then use this as a means of describing and creating the forms, by modelling the objects with light.

You can use the natural light source, but this is continually changing and can create confusion in a drawing of this nature. Instead, you can invent a directional light source for each plane to emphasize the form. For example, the foreground could have an imagined light source illuminating all the objects within that plane from the right, whereas the middle ground could have an imagined light source illuminating all the objects within that plane from the left or the front. Draw all the objects within each plane, modelling every object clearly with its imagined light source. When you have completed a number of these drawings, you should have a group of drawings that you can reconstruct on a larger scale at home.

PROJECT 2

SCALING UP A LANDSCAPE DRAWING

One five-hour drawing

Materials: 30- x 44-in paper, 2B and 3B pencils, charcoal, plastic and kneaded erasers, pencil sharpener, 11 - x 17-in sketch from the previous project or a black-and-white copy of a Claude or Poussin landscape, 3-ft (1-m) straightedge or ruler

One way to develop drawings done directly from nature is to scale them up, using a grid, to $30- \times 44$ -in size, or $22- \times 30$ -in size if you do not have much space. This project works much better at the $30- \times 44$ -in size, so only use $22- \times 30$ -in if absolutely necessary. If you want to gain confidence with this type of work, you could start with a black-and-white copy of a painting by Claude or Poussin, scaling this up and working from it.

Carefully tear an 11- x 17-in sketch from Project I (page 283) out of your sketchbook and place it in the corner of the 30- x 44-in or 22- x 30-in paper (Step 1). Using a pencil, draw a diagonal line through the sketch and extend it to the opposite corner of the large sheet (Step 2). Where the extended line meets the top edge of the paper, draw a vertical line (Step 3).

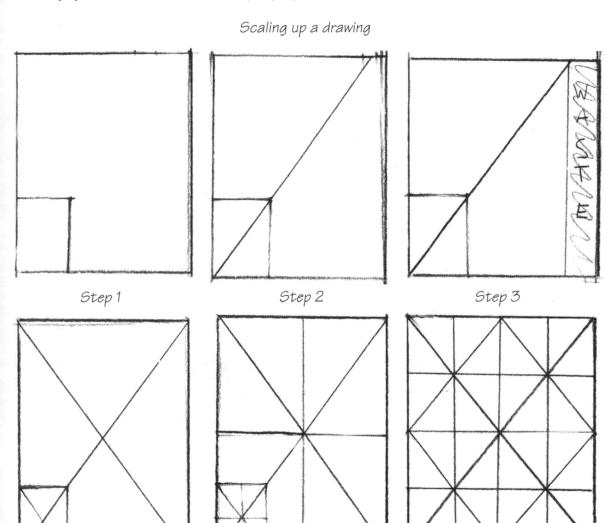

Step 4

Step 5

Step 6

This will give you the proportions of your original sketch, although in this case the 11 - x 17-in sketch should be the same proportions as the 30- x 44-in or 22- x 30-in paper.

Tear or cut off any waste.

The next stage is to grid up both the original sketch and the drawing paper. On the original sketch and on the large sheet of paper, draw a diagonal line between the other two corners (Step 4). You have now established the center of each, and you can construct the grid. Draw horizontal and vertical lines through the center of both (Step 5) and subdivide both again (Step 6).

30- X 44-IN PAPER

You may be able to buy a sheet of 30- x 44-in paper. If not, you can join two sheets of 22- x 30-in paper. Butt two sides together without any overlap and stick a strip of masking tape all along the join. The side with masking tape will be the back of the drawing. If the paper is too large to use on your drawing board, attach it to a wall.

Next, map out the drawing on the large sheet, using charcoal. Use line to place the landscape, and then put in the tone. When you have finished, you should have a scaled-up drawing that is far more dramatic than the original sketch. You can make this into a true classical drawing by adding figures in the foreground, perhaps with some anecdotal reference. Look again at the way in which Claude and Poussin used figures.

PROJECT 3

FORMALIZING THE LANDSCAPE (AFTER CEZANNE)

One three-hour drawing

Materials: 11- x 17-in hardback sketchbook, 3B or 4B pencils or graphite sticks, plastic and kneaded erasers, pencil sharpener, window-mount

In this project you are going to look at nature in its raw state, and from that create your own sense of intrinsic order. We are leaping forward

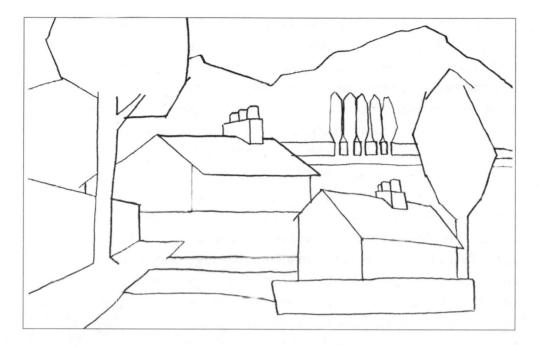

Formalizing the landscape, Step 1

from the eighteenth century of Claude to the twentieth century to examine the attitudes of Cézanne and Seurat towards the landscape. Before starting, look at the work of Cézanne and Seurat—in particular Cézanne, who was the richer and more productive of the two. Cézanne's compositions are made up of straight lines rather than the natural curves of the landscape. The horizontals, verticals, and angled vectors to which Cézanne reduced his compositions are the scaffolding on which his work hangs.

A rural landscape that still possesses a raw, natural look is better for this project than one that has been organized by humans. For example, you could choose a series of farm buildings next to a natural feature such as an outcrop of rock, or worked land that edges onto untamed land. The space in the landscape should echo the classical idea of space, with a foreground, middle ground, and background, but in a more natural setting.

Look for the horizontal and vertical accents. These usually occur at the sides of trees, houses, roads, hedges, and so on. If certain angles in the landscape are very close to a horizontal or a vertical, treat them as that; the idea is to refine and reduce the composition. Draw these lines in the correct proportion to each other and to the whole scene.

Next, assess the more acute angles in the landscape, and link them to the horizontals and verticals where appropriate. These will be the angles of roofs, branches, mountainsides, hills, roads,

and so on (Step I, page 289). You can get a better understanding of these angles by measuring them with a pencil. Hold up a pencil either horizontally or vertically and assess the angle made by the edge of a roof receding in space. Is the angle smaller or greater than 45 degrees? You may find it easier to judge the angle if you move the pencil so that it is aligned with the edge. For either method, you need to shut one eye and, most importantly, hold the pencil as if you are holding it against a window; do not twist it away from you.

At this stage, the drawing will have no form or spatial recession. What you have on the drawing surface is the scaffolding on which to build the rest of the landscape. The next step is to create the illusion of space (Step 2). You have created a number of edges and planes in relationship to each other. It is these edges and planes that you need to work on to construct the idea of spatial recession, using shading on either the inside or the outside of each edge. For instance, if you are applying this system to shading the planes of a building, the plane that recedes into the picture space should be shaded at the edge where it

Right: Formalizing the landscape, Step 2

meets the plane that is in front of it. This system brings some edges of planes forwards and sends others slightly back in space, allowing the eye to move back through the picture space.

This is a very regimented way of producing a drawing, but you can play around with these ideas, abstracting them further. Look at early Cubist work to see how these ideas were developed.

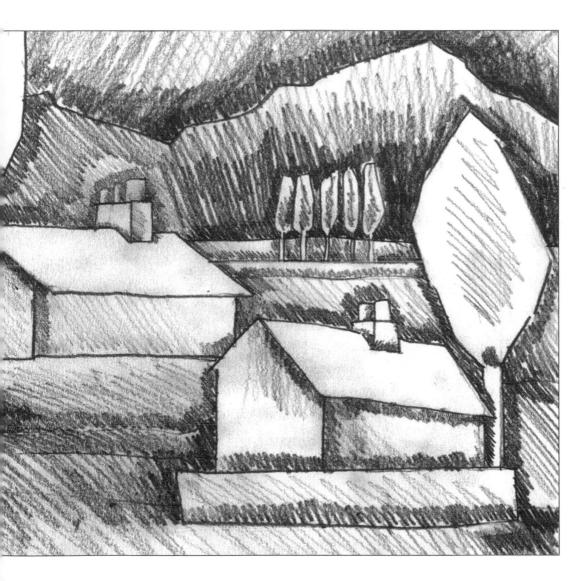

CHAPTER 4

THE CITYSCAPE

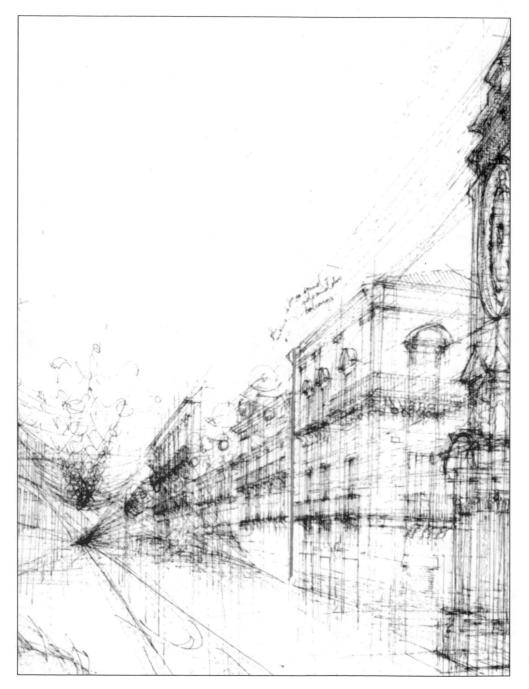

ities and towns have played a significant but usually secondary role in art. Like other landscape subjects, cityscapes were used as a device to contain an important event such as a religious, historic, or poetic scene. They were either based on realistic cities, recording the architecture of the time, or they were cityscapes of fantasy aspiring to the classical or divine. Cityscapes were also often combined with the natural but ordered landscapes of the classical ideal.

As the city or town has been designed, created and conceived by human rather than natural forces, this type of landscape has its own intrinsic order. By its very nature, this subject lends itself to a structured way of working. Before starting to draw a cityscape, you must deal with the inherent order of the subject, and the approach adopted in the following projects is a formal one, using theory to realize and present observations. Nevertheless, many artists have depicted the city very successfully without using a formal approach (covered in Chapter 5, "The Natural Landscape," page 304 and Chapter 6, "Expressionism," page 317).

In this chapter, we will look at the basic theory of perspective. This will enable you to approach and demonstrate drawings of towns and cities from observation, to abstract compositions from your observations, and to make drawings that have a sense of order, harmony, and balance.

Before starting, look at Leonardo da Vinci's studies of perspective for his *Adoration of the Magi*, as well as *The Stonemason's Yard* by Canaletto (1697-1768), and the architectural drawings of Antonio Sant'Elia (1888-1916).

PROJECT 1

PERSPECTIVE DRAWING OF A STREET FROM OBSERVATION

One three- to four-hour drawing

Materials: I I - x I 7-in sketchbook, a range of pencils (2H-6B), plastic and kneaded erasers, window-mount

This project is based on some basic rules of perspective. First, choose your location. You need to select a place that contains perspectival depth, such as a street that recedes into the distance from your viewpoint. If possible, choose one that contains a simple block of terraced houses. Choose a simple composition rather than a complicated cityscape for this first drawing, as this will make the rules of perspective easier to understand.

Buildings

Use the window-mount to select a composition. Include four or five houses receding into the distance and ignore the rest of the view. Treat this block of houses in isolation. Make sure that the roofs and bases of the houses are included. The composition should have a definite starting point in the foreground, such as the corner of a building. With a simple block of houses, this point of departure should be self-evident. Although there is nothing wrong with taking another starting point, by starting with a building in the foreground you can establish the rest of the drawing from this point. Once you have started, continue to draw from the same position and viewpoint throughout, otherwise the drawing will become very distorted.

Draw a vertical line depicting the corner of the first building, bearing in mind where it is positioned when seen through the window-mount, and make this line the correct height and proportion

Right: Perspective drawing of buildings from observation

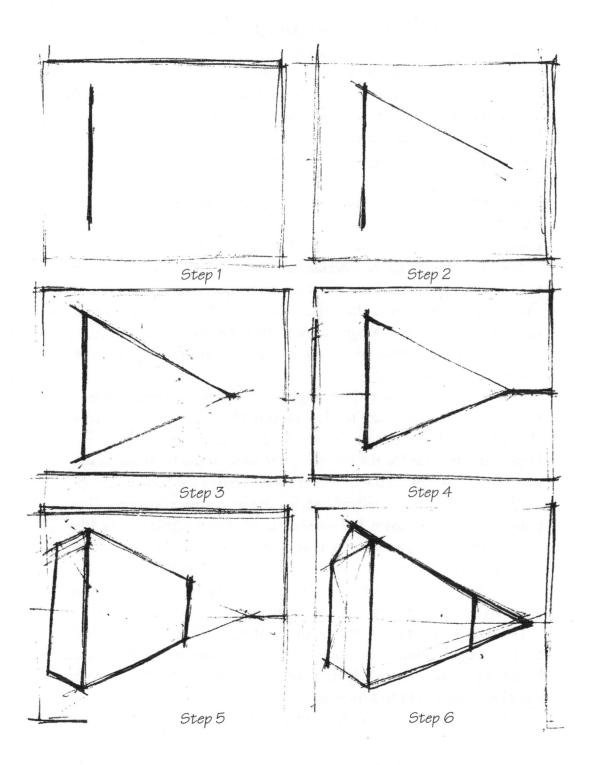

in relation to the window-mount and your paper. This is your first measurement. It will be a benchmark for the rest of the drawing so it is important to be accurate (Step 1, page 295).

At the top of the vertical, observe the angle of the side of the building very carefully. There are two ways of assessing the angle. One method is by holding a pencil against the direction of the top of the building, but as if you are holding it flat against a window, not twisted away from you; then, still holding the pencil at that angle, move it to the point on the paper at the top of the vertical and draw this angle. Make sure that you don't twist the pencil into the angle as you look at the scene; rotate the pencil, imagining that it is against a vertical sheet of glass.

This way of working, however, is for the experienced eye, so practice until you feel more confident with the technique. Another, perhaps easier, way is to calculate the angle of the side of the building by holding up two pencils to form a right angle so that the line you are assessing cuts through the corner where the two pencils meet. Judge the angle against the right angle.

Once you have an idea of the angle, draw it from the top of the vertical line (Step 2). Make the line reasonably long, but do not worry about its length yet, as it can be adjusted as the drawing progresses. Repeat the process for the line along the base of the building. Draw this line, continuing it so that it eventually crosses the top line (Step 3). These two lines run at different angles and ultimately converge. The point where they cross is the *vanishing point*. The vanishing point falls on the horizon line, and is also at your eye level (Step 4). This is the basis of an understanding of perspective using observation. Repeat the process to draw the other side of the building (Step 5). In effect, you are analyzing and plotting the angles and lines of perspective.

The next step is to find the depth of the block of houses in relation to their height. This can be done by seeing whether the width of each house is greater than its height, and if so by how much. Alternatively, the block may be tall and narrow, in which case the height would be greater than the width. This is a simple process of observation (Step 6).

Architectural details

You now have the basic form of the building, and you can begin to embellish it with architectural details such as windows, doors, and roofs. This can be done using the same system of measuring angles as for the top and bottom of the buildings, or with a more mathematical procedure that involves dividing the sides of the building to give a perspectival and proportional framework within which to place the other elements. It looks rather technical, but it trains your eye in the understanding of perspectival recession.

Start with the largest facade of the building, which is a rectangle going back in space. You are going to subdivide this rectangle using a system that produces what appear to be a number of Union Jacks within it. First, draw a diagonal line from one corner to the opposite corner. Do the same between the other two corners. This creates a cross within the rectangle that gives its perspectival center (Step 1). Draw a vertical line through the center point from the top to the bottom of the rectangle. Then draw in the next

Architectural details

In this drawing you have applied a theory, or drawing system, developed from your own observations. However, theory is for weaker moments; it can prove a dangerous crutch to lean on. This process of drawing is very mechanical, and you need to bring your own creative mark into the drawing. When you become more familiar with perspective and can use it without thinking, you will be able to make a more confident and personal type of line.

perspective line using the center point in the rectangle and the vanishing point. This should produce a Union Jack motif within the rectangle (Step 2, page 297). Continue this process until you have a detailed enough framework on which to add architectural detail (Step 3). All you need to do now is calculate how and where features such as doors and windows fit into this framework (Step 4). Repeat the process on the other side of the building.

Try a number of drawings using this system to familiarize yourself with the procedure, and gradually impose your own identity on the drawings.

PROJECT 2 FROM OBSERVATION

One three- to four-hour drawing

Materials: 11- x 17-in sketchbook, a range of pencils (2H-6B), plastic and kneaded erasers, window-mount

Now that you are more familiar and confident with perspective, you can embark on a drawing that takes in a full view of the cityscape rather than just one street (see illustrated overleaf). Use the window-mount to select an interesting perspectival composition. Use the same system as in the previous project; that is, assess the angles from the verticals for each individual building. Some buildings, especially if they are on the same street, will have the same orientation, but others will have a different orientation.

Observed perspective drawing of a cityscape

PROJECT 3

ABSTRACTION AND ORDER

Two drawings, three to four hours **Materials:** 11 - x 17-in sketchbook or 22- x 30-in paper, a range of pencils (2H-6B), plastic and kneaded erasers

You need not go outside for this drawing; instead, you can base it on drawings from the preceding projects.

Abstraction and order, Drawing 1

Before starting, look at the work of Lyonel Feininger (1871-1956) and Piet Mondrian (1872-1944). Feininger used the angles of buildings by extending them to create a flat, yet dynamic, picture space. Mondrian reduced the elements of the cityscape to their basic essence, using only variations on the vertical and horizontal accents in the composition to give a pure state of proportion, which in turn creates a sense of harmony.

In the first drawing, take the perspectival directions or vectors of buildings and extend them. Do the same with the horizontal and vertical lines. This will create an unusual web of lines that, in turn, create a series of shapes across the picture plane. The next step is to create the illusion of an invented space by using shading at the edges of shapes. Where an edge is shaded, the shaded part will recede and the unshaded part will appear to come forward (see Drawing I, page 301). At this stage, you can develop the drawing however you want. Try to find your own intrinsic sense of space and proportion. Play around with this type of drawing: you will probably enjoy the freedom of composing a drawing without the responsibility of representation.

The second drawing involves simplifying the composition even further. This drawing should be based purely on horizontal and vertical lines, as in Mondrian's work (see Drawing 2, opposite). You can use all the horizontals and verticals in your original drawing; put them down keeping the same proportions. The next step is to decide whether the angled lines are closer to the vertical or the horizontal. Then draw them as horizontals or verticals. Next, decide how to make the drawing into an interesting statement. You can imply a sense of space using scale, weight of mark, overlap and so on. Again, the drawing is now in a state for you to organize and develop in your own way.

All the projects in this chapter have been based on technical processes, and ultimately you must bring into the work your own identity, ideas, and feelings about this way of working. Otherwise, the work will go no further than demonstrating method or theory.

Right: Abstraction and order, Drawing 2

CHAPTER 5

THE NATURAL LANDSCAPE

S ince the 1650s, landscape has increasingly been seen as something beautiful in its own right. As human understanding of the universe grew, nature did not seem so threatening. Artists were inspired by the natural view rather than by the ordered scene, and people became more responsive to the pleasure that spectacular scenery provided. As a result, a more naturalistic approach to the landscape in art became increasingly popular.

In northern Europe, artists such as Jacob van Ruisdael (c.1628-82) and Meindert Hobbema (1638-1709) began to render the landscape in a natural, unordered manner with windswept skies and shadows on the ground cast by clouds. These artists and their ideas were a major influence on British landscape artists such as John Constable (1776-1837), who in turn influenced French artists, in particular the School of the Barbizon, which included Théodore Rousseau (1812-67), Jean-Baptiste-Camille Corot (1796-1875), and Gustave Courbet (1818-77). Meanwhile, Constable's great rival J. M. W. Turner (1775-1851) greatly influenced Impressionist painters such as Claude Monet (1840-1926), Alfred Sisley (1839-99), and Camille Pissarro (1830-1903). Turner, who was himself influenced by Claude, excelled at describing and expressing the elements and the landscape in their fullest glory.

Before starting the projects in this chapter, study Turner's work. In particular, look at *Rain, Steam and Speed* (1844); *Snow Storm* (c.1812); *Steam Boat off a Harbour Mouth* (1841); *Norham Castle Sunrise* (1840); *Peace Burial at Sea* (1842); *Sunset at Rouen* (c.1830); and *The Burning of the Houses of Parliament* (c.1835). These pictures deal with the elements of earth, air, water, and fire in a very vivid way. Obviously color plays an important part in Turner's work, particularly in capturing fire and sun, so try to find black-and-white reproductions. You will not get such vivid effects without color, but you can achieve scenes with strong and dramatic contrasts. This should help you in your observations and studies of the elements and give you experience using tone without the additional complications of introducing color.

The projects should help you become aware of these elements as physical entities, and suggest ways to represent them in a naturalistic way. The aim, also, is to give you an experience that will enable you to appreciate the physical forces of nature.

PROJECT 1 STUDIES OF THE ELEMENTS

One to two hours for each drawing **Materials:** sketchbook (no bigger than 8½ x 1 lin), pencils (2H-6B), pencil sharpener, graphite sticks, charcoal, inks, dip pens, water-based felt-tip pens, erasers, water and containers, cotton wool, any other materials you feel are appropriate

This project concentrates on the four elements of air, water, fire, and earth. The drawings should be made from observations of different states that the landscape implies, using the appropriate materials for the different subjects. Many artists have made studies of this type as a way of collecting visual information on, and becoming aware of, the potential in landscape drawing.

Atmosphere

These studies deal with the effects of light and atmosphere. This element is constantly changing, and the resulting drawings will probably be very dramatic and moody. Choose a landscape that contains space and distance. If it

A study of atmosphere

is practical to do so, select a remote area that has not been ordered by human activity, such as a field or wooded area. If possible, make your studies of atmosphere on a day when the weather is overcast. When doing this type of drawing, it is best if the elements are at their most extreme. If they are not, do not hesitate to exaggerate.

The first step is to understand the air, or atmosphere, as something tangible. Atmosphere is not solid, and unless the weather conditions are extreme it is not opaque. It is also not stationary. We are not talking here about clouds, which can be dense and opaque; by atmosphere, we mean the air between you and the next solid object or objects. How do you go about drawing something that is so transitory?

In the attempt to understand what atmosphere is, you will need to try out different materials. Atmosphere is continually changing, so

These studies are designed to allow you to find out what your materials can do and to experiment with them to create the effect of atmosphere. There are no hard-and-fast rules for making this type of drawing; it is a process of learning by doing. you need to be able to push your material around the paper. Choose a medium that can be easily applied to the paper and just as easily removed. The drawing should be fluid, and have no suggested state of permanence. Start your observations by squinting your eyes, which helps to define the changing nature of light. It is this transitory scene that you want to depict. The drawing must be quick, spontaneous, and responsive so that you can capture the continually changing conditions.

One method is to start by laying down all the dark or black areas first with charcoal, so that you have a blackand-white drawing. Do not draw the landscape with line, as this will impede your work. With a cloth or your hand, lightly smudge the drawing, making all the white areas gray. You might at this point need to reestablish the dark areas. You should now be able to recognize the beginnings of atmosphere in the drawing. Next, establish the light areas with an eraser, rubbing out what you see as light. Push and move this tone around the paper like the air that moves, establishing and reestablishing the lights and darks until you feel happy with the drawing.

Any of the materials listed for this project could be used, and you should experiment with as many as possible. Mud and water applied

with the hands can be very successful at capturing atmosphere. When using charcoal, pencil, and graphite stick, your eraser is the vehicle that allows you to move your medium around the picture surface to create this atmospheric transience. When using inks, dip pens, and water-based felt-tip pens, water has the same function. You can apply water using cotton wool to dilute the inks and felt-tip pens in order to create thinner veils of air and atmosphere where you want them.

Be prepared to experiment extensively with all these materials, pushing their possibilities quite physically, even to the point where you might tear the paper, in order to create a range of effects.

Water

Water occurs within the landscape in a number of different forms, such as lakes, rivers, streams, the sea, or rain. Make a number of studies of these different manifestations of water.

The water in a lake can have different characteristics, depending on the circumstances. For instance, the water could be choppy and rough, or it could be still and calm. Each condition needs to be observed and drawn. A calm surface will reflect objects by the lakeside and those, such as boats, floating on the surface-reflections that might be distorted by a ripple. In choppy or rough water, the characteristics are very different as the water has a surge to it, and this in turn implies movement and direction.

The sea is another form of water. It has some characteristics similar to a large lake, but it is more extreme in its moods, and more violent and powerful. It can be dark, with waves crashing against rocks; or tranquil and gentle, lapping against a sandy shore.

A stream or river has different characteristics altogether. In places a stream may meander along its way. At other times it may suddenly rush over a fall of rocks, coming instantly to life, only to become calm again just as quickly. Of course, this all depends on various other conditions. If there has been a lot of rain recently, the stream will probably become a torrent of fast, running water that is out of

control; there may even be flooding. A stream eventually becomes a river, and this has different characteristics again. Although both a river and stream are

You are drawing the effect of your observations and you are making a visual equivalent for what you see.

constantly moving, a river is generally more predictable, except in extreme conditions.

Rain is another manifestation of water in the landscape. If you are sitting in a landscape looking across to the furthest distance, you may observe rainfall over part of it. Rain is a particular type of occurrence and it has particular characteristics. For example, it is drawn downward by gravity. Rain may be a gentle drizzle or a heavy torrent blown by the wind across the landscape. It also sometimes has a transparent quality, like a veil descending over the landscape.

There are no rules for finding a visual equivalent for what we see and what we understand of a particular element. It might seem at first glance that this way of working-responding with materials emotionally to what you see and experience-would be relatively easy, but in fact it is not. At the same time that you are making your response, you have to

A study of water

understand intellectually the mechanics of your statement. You need the memory and experience of successful methods and drawings to use as a basis for further observations.

Fire

Fire might be caused by something burning in the landscape, or, more often, by the effects of a very strong sun. When the sun is very strong, it makes the landscape appear crystal clear, creating sharp contrasts of light and dark. Because the sun can be damaging to look at, draw what you know of it, not relying just on what you see. (The sun can damage your eyes, so never look directly into it.) Sunlight sometimes has a smoldering effect that creates a hazy atmosphere, particularly when it is shining through mist or thin cloud. This usually

Construct a tonal reading of the scene that endeavors to create the illusion of form and mass. happens either in the early morning or late in the day when the sun is going down. Another effect of a strong sun is where it creates shafts of light through clouds or between trees in a forest or wood. Sunlight also varies depending on the season and country. Look at the way in which Turner captured the fire of sunlight, particularly sunsets, when the skies can appear to be on fire.

Earth

Earth is the land mass, and is affected by the other elements in one way or another. Mass is an expression of weight and form, in contrast to atmosphere and air, which are more ethereal. Mass is constant and needs to be modelled, in this case using tone. Choose a landscape that contains mountains, valleys, streams, and lakes, or at least some of these.

It is important to gain a basic understanding of fundamental form and distance, as these are the foundations on which the other elements are usually imposed. Use line to create the basic layout by

Left: A study of fire

A study of earth

making a quick outline drawing showing where the main features of the landscape lie. Then create the idea of distance by observing the way the tone changes from the foreground to the background (see drawing above). Usually it tends to be darker in the foreground and lighter in the background, although this is not always the case. You can then give the impression of mass by modelling using tone (see "Classical Space," Project I, page 283).

Make a number of drawings of all four elements so that you become familiar with the processes. This will put you in good stead for Project 2.

PROJECT 2 THE LANDSCAPE DRAWING

One four- to five-hour drawing

Materials: 22- x 30-in, 18- x 24-in, 11- x 17-in sketchbook or paper, drawing board if necessary, pencils (2H-6B), graphite sticks, charcoal, inks, dip pens, water-based felt-tip pens, erasers, water and containers, cotton wool, any other materials you think are appropriate

The aim of this project is to do a drawing that gives a complete picture of the landscape, using the experience gained from doing the studies in Project I. First, plot the composition on paper, making a quick outline drawing showing where the main features of the landscape lie. Then you can create the idea of distance by observing the way the tones change from foreground to background. You can then give the impression of mass by modelling using tone.

Once you have laid down the basic foundation for the drawing and have described the space and form, begin to observe how other elements affect the underdrawing. For instance, there might be rain falling over a part of the landscape, obliterating some of the far distance. Mist might make the view very soft and hazy, and so on.

This is a responsive drawing, but try to maintain the freshness of your approaches in the studies for Project I (see illustrated overleaf).

Do not assume that you know how to draw something; approach each element in the spirit of gaining more knowledge and understanding of your subject.

A complete landscape drawing

CHAPTER 6

EXPRESSIONISM

xpressionism has its roots in our feelings and emotional responses, and these are influenced either by what we see and experience, or from within, or a combination of the two. The intention in the previous projects was to record nature, and at the same time to capture reactions of awe or serenity but without particularly focusing on them, drawing from observation, but allowing feelings for the scene to influence the drawing, even if on an unconscious level. This is one basis for an expressive piece of work. To take the process a stage further, the subject can evoke an emotional response, and that response becomes the dominating force in the work. In the early work of Vincent van Gogh (1853-90), the landscape is heavy, cold, and brittle, whereas in the later drawings it has a lighter, more celebratory, rhythmical, and optimistic warmth. Van Gogh was obviously affected by two very different landscapes and climates, the cold winter of northern Europe and the warm, more picturesque landscape of southern France. Although they work on other levels too, these are expressive drawings.

In this chapter we shall explore three different ways of creating an expressive drawing. The first starts from the eye, drawing from observation with an external stimulus for the work. This will be a development of the approach in the previous chapter.

The second project starts from the heart. You will be imposing your innermost emotions on the scene, using the scene as a vehicle for your feelings, unlike the first approach, in which the emphasis is on the external world. Often the feelings that we express have to do with our anxieties, so these works have a tendency to be on the more depressive side of our nature. Look at the seascapes of Emile Nolde (1867-1956), the landscapes of Edvard Munch (1863-1944), and the work of Chaim Soutine (1893-1943). In creating this type of work, you have to expose that innermost state, and this is not an easy thing to do. This type of work can fail tragically. You cannot just spill out a series of marks, tones, or whatever to act as an expression of how you feel and then link it to the subject. You have to fuse the creative act with your knowledge of other drawing skills

in order to make the drawing work from an aesthetic and compositional point of view. At the same time, those skills should not get in the way of a personal, creative act or statement. It is at this point that you begin to find your own voice and originate your own way of working.

The third project consists of constructed fantasy landscapes. These are an expression of something that is developed out of the mind rather than the heart. Look at the invented landscapes of Max Ernst (1891-1976).

Although each of the three projects concentrates on one approach–observation, emotion, or intellect–they all have some crossover with the other two.

PROJECT 1

EXPRESSION FROM OBSERVATION

One three- to four-hour drawing **Materials:** your choice

This project deals with the emotion that you first feel when you are confronted with a dramatic and inspiring landscape. Although it may appear very similar to the projects in the previous chapter, there are subtle differences. In this project you are responding in an emotional way to your observations of the landscape. It is not an easy project to direct, as we all feel very differently, and there is very little in terms of a procedure. Before you embark on the project, take a look at the landscape drawings of Frank Auerbach (b.1931), as they are a fine example of this type of work.

Draw intuitively and be prepared to take risks. Rely on your instincts for the first two hours, not questioning whether what you have done is good or bad. You can then begin to make value judgements on what you have done and rework the drawing. Do not be afraid to continually rework a drawing of this nature.

Be aware of precious areas in a piece of work. You can try to keep an area that you think is working well and alter everything around it, but sometimes you have to sacrifice these areas for the sake of a better overall drawing.

Exaggerate elements in the drawing, such as

Above and below: Expression from observation

tone or line, or aspects of observed features, such as scale, proportions, or depth of field. Because you are trying to come to terms with your feelings about what you see, your drawing will

probably not be a representational record of the scene before you.

Be prepared for a difficult yet very rewarding drawing if you get it right. However, only you can be the judge of your own intentions, and that is the difficult part.

PROJECT 2 DRAWING FROM THE HEART

One one- to five-hour drawing **Materials:** your choice

The length of time you spend on this project can vary from drawing to drawing. Sometimes you must accept that you can do a very successful drawing very quickly, and that more time spent on a drawing will not necessarily produce a better one. You have to accept something for nothing, although at first you might feel some guilt about this.

The basic starting point for this drawing is the heart. With some people, their feelings are already burning inside them, waiting for the moment when they can make their escape, and generating an uncontrollable need to begin working. This can be a regular occurrence for some artists, but others experience gaps in their working life. This is quite natural. It is not easy to conjure up emotion if it does not lie just under the surface waiting to appear at a given moment, and you may have to wait until an appropriate time presents itself before attempting this way of working.

You may find this heartfelt way of working very difficult if your main source of stimulus is the eye or the mind. You may also be surprised by the type of drawings that you make. For example, not all happy people make happy drawings, and not all sad people make sad drawings. Sometimes the opposite happens; it could be that we compensate for how we are feeling at the time. When the time is right, you can approach the drawing by working from memory and using drawings from previous projects, or by working directly from the landscape.

Working from memory and other drawings

You will probably find that this is the best approach for this project because when you feel like producing a piece of work you do not

In the Western tradition, this type of drawing is usually placed in a conventional picture space. However, it can be just as successfully done in a flat, symbolic manner, as in the drawings of Paul Klee (1879-1940). Klee put images together in a very unorthodox way, yet they make a statement that is both expressive and symbolic.

Working from the heart

need to draw directly from the landscape. There is no set way of going about the drawing. Identify the type of emotion you want to describe, and use a previous drawing for the basic composition, which gives you a structure to work with.

Develop the drawing expressively, using your intuitive sense of markmaking. Let your feelings and emotions take the lead at this stage. It is not possible to say exactly how your drawing should develop, but one useful method is to exaggerate elements in the drawing, such as light, shadow, texture, space, and scale, and to juxtapose and contrast elements in the landscape in order to express your ideas.

The next stage is to examine what you have produced and see how you feel about it. You may have made what you believe is a successful

EXPRESSION

drawing. If so, that is fine; but be prepared to look at the drawing for some time before you make a final decision. It is generally better to change your mind at this stage and continue working, rather than coming back to it the next day, when you may have lost impetus. If the drawing is not satisfactory, think about why it is not working in the way you want, and then respond instinctively to your thought processes again. Repeat this procedure until you feel the drawing is finished. A great exponent of landscape work in this manner is the German artist Anselm Kiefer (b. 1945), who has used a constructed landscape to unearth a whole history of emotions.

Working in the landscape

This approach is a fusion of observation and emotion, but with the emphasis on inner feelings, using the environment as the structure. The procedure is the same as in the previous drawing. A very good example is the work of contemporary British artist John Virtue. His working process is quite unusual in that he works in the landscape on very large canvasses (about 12×9 ft/4 x 3m). He lays the canvas down in a field overlooking the chosen scene and then begins to let the work evolve.

Although there is a certain amount of recognition of the scene in this type of work, you feel that the artist has created a type of performance on the canvas that is more to do with himself, his materials, and the act of doing the work, rather than the scene in front of him.

PROJECT 3

CONSTRUCTING THE LANDSCAPE

Two twelve-hour drawings, each over two days

This project consists of two drawings. The first is a fantasy landscape that is drawn from vegetables. The second is a drawing based on a small structure that you will construct out of rubbish.

EXPRESSION

Drawing I

Materials: 22- x 30-in paper, charcoal, plastic eraser, masking tape, a selection of vegetables

The aim is to create a drawing that has a strong mood, such as anxiety—in effect, a landscape of anxiety. This type of drawing is much more considered that those in the previous two projects, which is why it is referred to as an expression of the mind.

First, you need to get a selection of unusual vegetables, such as asparagus, broccoli, mushrooms, celery, ginger, chillies, and any others that would be interesting. The idea is to place these in a constructed landscape, making their scale much larger than is natural, to create a mood of anxiety. Each vegetable should be drawn as a separate item, but placed in the context of a landscape space. So, on the 22- x 30-in paper, create the space or environment for the vegetables to occupy. You can base this on a previous drawing, using the basic land mass rather than features such as trees and buildings. This should give you a barren, desertlike scene.

The next stage is to take one of the vegetables and set it up to draw from. Select a place for it in the drawing. If it is in the foreground, it should be quite large in scale. If you draw more than one of the same vegetable, make them smaller as they are placed further back in the landscape to emphasize the receding space. And draw the vegetable so that it sits convincingly in the space. For instance, you could make one appear from behind a hill. If you are unsure how to place the vegetables convincingly, look at your original drawing to see how features such as trees exist in the landscape. Approach this drawing using texture as a way of interpreting the scene (see Chapter 2, "Landscape Textures," page 266), and remember to draw the space in between the objects, otherwise they will look like gaps in the drawing. Look again at the original drawing for this information.

Constructing the landscape, Drawing 1

EXPRESSION

Drawing 2

Materials: four sheets of 22- x 30-in paper, charcoal, plastic eraser, masking tape, contact adhesive glue, 8- x 12-in (20- x 30-cm) piece of board, household rubbish (see below)

You should spend at least a morning constructing the landscape for this drawing. Collect a number of small items such as cups, bottle caps, packaging, and so on. Cover the board with something textured. Glue the rubbish onto the board to make a landscape. When you have completed the construction, spray-paint it black, as this will unify the color and help in the drawing.

You are now going to draw a panoramic view from all four sides of the structure, linking the drawings together. First, use a 22- \times 30-in sheet of paper in a landscape format (horizontal). Position the

Constructing the landscape, Drawing 2

EXPRESSION

construction so that you are viewing it from one of the longer sides, and draw so that your drawing fills the paper. Use line to plot the composition, and complete the drawing with either texture or tone. If you use tone, illuminate the group with a directional light source. Then rotate the structure so that you are looking at one of the shorter sides. Attach a second sheet of 22- x 30-in paper, in portrait format (upright), to the edge of the first with masking tape on the back to form one long piece of paper. Draw this side in the same manner, linking the two drawings across the join. When you have finished the second side, rotate the structure again and draw the other long side in landscape format on a third piece of paper that you have attached to the first two. Finally, draw the second short side in portrait format on a fourth piece of paper, also attached. Trim the portrait sheets if you wish.

When finished, you will have a long, panoramic view of the structure.

CONCLUSION

It should be clear by now that there is no one way to approach landscape drawing. Rather, after working through the different processes described in these projects, you should be able to begin understanding where your own strengths lie and what type of artist you are becoming. Some artists lean more towards the constructive side of the working process, starting from the mind, whereas others lean towards the emotional and expressive side. Others still take observation as their starting point.

It is not necessary to become adept at all three approaches in order to develop further. However, they are all present at some point in any drawing. Identify where your natural direction as an artist lies, and begin to develop that direction.

DRAWING SYSTEMS

INTRODUCTION

I n the Palaeolithic caves of southwest France and Spain, Cro-Magnon man has left the earliest images yet discovered in Europe. Preserved on the walls of Lascaux, Pech-Merle, and other caves in the region are some of the earliest attempts by humans to draw a representation of the world in which they lived on a two-dimensional surface. Included on the walls are images of reindeer, ibex, bison, horses, and even people. These, like all pictures, cannot literally contain the objects they represent. Instead, they contain only swathes, blots, or traces of pigment–called *picture primitives*–that stand for various elements of a scene (or subject), such as edges, volumes, and elements of the body–called *scene primitives*. The primitive is the most elementary unit in representation and perception.

In one of the scenes in the drawings in the caves at Pech-Merle is the traced outline of a human hand, dated about 15,000 BC. This is among the first known drawings that were made using a *projection* or *transformation system*. In a projection system, the

spatial elements in the picture are related to spatial elements in the world. In this instance, the hand of the artist is placed on the drawing surface (the wall) and traced. The direct relationship between the hand and its image is defined as a *secondary geometry*. In a secondary geometry, the directions on the picture plane relate to directions in the scene. It is based on the transformation of the image onto the two-dimensional surface.

In Greek mythology, the invention of drawing is ascribed to a Corinthian maid who, under the influence of Cupid, tried to prolong or record the ephemeral by drawing the outline of the

INTRODUCTION

unique silhouette of her lover's shadow cast by the light of a flame onto a wall. The rays of light became projection rays marking the edge of the sleeping body of the maid's lover. The light rays traveled in a straight line, projecting a particular set of points on the wall that were derived from set relationships between the positions of the lover, the wall, and the light source. This relationship between object and image, in which projection lines, or rays, from points in the scene travel through space to hit the picture plane and make a picture, is defined as a *primary geometry*.

Our interest in this section is to investigate some of the systems for drawing based on projective geometries. We can consider three variables in a projection system.

The object or scene to be depicted The object or scene can have a number of different orientations to the picture plane and the projection lines.

The picture plane The picture plane is the imaginary plane on which relationships are mapped. Imagine looking through a window at a scene; the configurations on the drawing paper should match those seen through the window. In other words, the drawing surface and the picture plane coincide. The picture plane can be angled to have different relationships to the object or scene and the projected light rays.

The lines of projection These are the visual rays (straight lines) that travel from the scene through space to hit the picture plane, enabling the artist to place the picture primitives in a consistent relationship to the scene primitives. They can converge, diverge, or run parallel to each other.

In the following pages we shall offer explanations and practical projects exploring a number of projection systems. We are indebted to John Willats and Fred Dubery for much of the information in this book (*Perspective and Other Drawing Systems*, 1972).

CHAPT_R1

PROJECTION SYSTEMS

Projection systems can be approached in terms of secondary geometry–the Pech-Merle hand–or primary geometry–the Corinthian maid's drawing of her lover's shadow. In primary geometry, the relationship between scene, picture plane, and lines of projection is understood and used to derive the picture. In secondary geometry, a system of rules is used for orienting and scaling picture primitives (usually lines marking edges and corners) on the drawing paper to give a particular result.

ORTHOGRAPHIC PROJECTION

In the *orthographic projection system* there are, surprisingly, no orthogonals–lines that run into the illusory space of the picture. An orthographic projection is quite specific. In primary geometry, it is a system with projection lines that intersect at

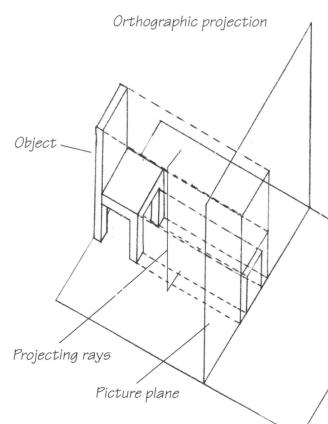

right angles to a flat picture plane in both horizontal and vertical axes. The drawing of the hand at Pech-Merle, for example, is an orthographic projection.

An orthographic drawing considered in terms of secondary geometry can be thought of as a depiction of one side of the object created as if it were pressed into the drawing surface. The outline of the hole made by cartoon characters when

they run through a wall is an orthographic projection in secondary geometry.

Orthographic projections are object-centered projections. They are not constructed with reference to a viewer–viewing distance and viewing height are not considered. The image is not given a scale calculated by its position in space relative to a viewer. Instead, it is given a scale according to the desired image for the drawing format.

In an orthographic projection, the actual vertical dimension in the scene provides the vertical dimension of the picture, likewise the horizontal dimension. Of course, the dimensions from scene to picture can be scaled up or down, but comparisons of dimensions within the picture hold the same ratios as those in the scene.

The eighteenth-century engineer Gaspard Monge formalized the orthographic projection into a system that has since been adopted by engineers and architects.

The orthographic projection is useful for constructing objects and

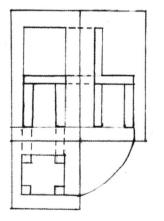

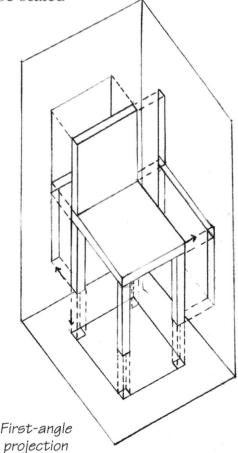

buildings because it gives true or easily calculated sizes that are consistent with the view depicted. Monge evolved a system that uses three interrelated depictions of three different aspects of the same object or scene: the plan, front, and side elevations. Most objects can be constructed from the information provided in these three views. If not, further information can be relayed by orthographics of the missing aspects–the back or other side elevation, for instance.

Monge's relationship of plan, front, and side elevations is known as *first-angle projection*. First-angle projection can be understood by

Third-angle projection

thinking of the object placed inside a box with its faces parallel to the planes of the box. Each face of the object is projected onto one side of the box, and the box is then opened out. In the United States, however, we use a *third-angle projection*. Instead of the object being projected onto the sides of the box, the box is imagined as transparent and the image of the object produced is the view through the transparent planes of the box. The front

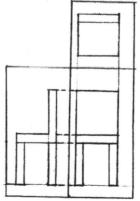

elevation is derived from a plane in front of the object, the plan is derived from above, and the side elevation from the opposite side to that used in first-angle projection–giving the same result as firstangle projection, but organized differently.

The orthographic projection has been used in art from earliest times. In Egyptian art, figures were realized as a series of joined orthographics, the head in side elevation, the torso in front elevation, and the legs in side elevation. And in Greek art, frescoes, and decoration on Attic vases, the orthographic projection is often the preferred mode of depiction.

Artists in the twentieth century have also used the orthographic projection. The still-life pictures of Giorgio Morandi (1890-1964) are essentially orthographic projections. The bottom and top of the bottles and other cylinders are usually flat, and rectangular-based solids tend to be shown flat on. By reducing orthogonals (lines into depth) and by making most of the line "primitives," which use the elementary principles of horizontal and vertical lines, Morandi created a sense of calm in his work. In the 1960s, Jim Dine (b.1935) did a series of drawings of tools in elevation that have a quiet beauty. These are the inspiration for the first project.

PROJECT 1

AN ORTHOGRAPHIC DRAWING OF A TOOL

One four-hour drawing

Materials: two sheets of 22- x 30-in paper; 2H, HB, 3B, and 5B pencils; plastic eraser; ruler; T-square; set square

Select a tool or tools to draw. If you have chosen a monkey wrench, plane, or another complicated tool you can draw it on its own. If you chose tools with simple forms, draw a group.

Draw a rectilinear grid (see "Flat as a Pancake," Project 3, page 180) on each of the sheets of paper-use a hard pencil (2H) for this

and draw lightly. Make sure that the horizontal and vertical lines are at right angles to each other (this is where the T-square and set square come in handy). Make the grid a little longer and wider than the tool. For most tools, the side elevation will provide the most interest. A grid of ½-in (10-mm) units will be more than adequate. Position the object on the grid. In most instances, you can just lay the object flat against the paper. However, in the case of the front elevation of a hammer, you would need to support the handle about 2 in (5 cm) over the surface to ensure that its faces are parallel to the picture plane. Position the bottom and side of the tool so that it sits in the grid. A flat board placed on a low table or stool will provide the best position for viewing the subject.

Orthographic drawing of a tool, Step 1

On your grid, lightly and with straight lines draw a rough of the silhouette of the tool, seeing the features of the scene, such as the edges of the tool (scene primitives), in relation to the grid, and using the picture grid to assess the placement of the picture primitives. Allow the straight lines to extend beyond the limits of the silhouette. The grid will provide the information for placing the different features of the tool–by extending the straight lines you can see and read the relative positions of features. You can also draw in further lines to determine the angles between features, and this, along with the grid itself, will give you a way of determining the distance between features (Step 1, see page 337).

The straight line used to measure and determine angles in this way is called a *vector of analysis*. Draw the vectors freehand as this will give expressiveness to the drawing. Use the vectors to block in the

Orthographic drawing of a tool, Step 2

general outline of the tool. Then proceed to the more particular aspects, still using the straight line or vector. Once you have completed the analysis with the vectors, select a softer pencil with a sharp point. Use the vectors of analysis to draw the actual contours of the tool. Draw the line with confidence, but vary its weight, thinking about what heaviness of line is merited by the different materials and forms. Do not attempt to render light or tone. You can erase the grid within the tool, but leave the grid around it as this gives the image a background–a spatial context (Step 2).

You can use tone in the space around the tool; alternatively, use the eraser to create textural effects in the background space, or drag it across the whole image at one angle to create atmosphere in front of the object.

AXONOMETRIC OR PLANOMETRIC PROJECTION

The *planometric projection* is included with the orthographic projection because it is derived from the plan in a secondary geometry. In a planometric projection, a plan is drawn on a sheet of paper and twisted so that the lines running along the edges of the plan are at 45 degrees, or some other angle, to the horizontal axis (thus the term *axonometric*). Lines parallel to the edges of the paper define the horizontal and vertical directions for the picture. By adding verticals of the required length, the sides, front, and back faces can be derived. The lines completing the top edges of the sides will (if top and bottom are the same) give you the top of the form as an echo of the plan (see illustration, page 340).

Planometric projections have been used in architectural drawings since the end of the nineteenth century. They are particularly suitable for architecture as they give a feeling of the volume and space in a building without compromising the actual relationship between element sizes. The Russian Constructivists, Theo van Doesburg (1883-1931), Le Corbusier (1887-1966), and many other architects and furniture-makers have found use for the planometric in their work.

PROJECT 2 PLANOMETRIC FORMS

One one-hour drawing **Materials:** 22- x 30-in paper, pencil, colored pencil, plastic eraser, ruler, T-square and set square if available

Use the paper in a vertical, or portrait, format. At the top of the paper draw two rectilinear grids with $\frac{3}{4}$ in (2-cm) spacings. The grids can be 2 x $1\frac{3}{4}$ in (5 x 4 cm) or $1\frac{1}{4}$ x $2\frac{1}{2}$ in (3 x 6 cm). The choice is yours.

On one grid draw a shape that extends out to all four edges; repeat it on the second grid. You can use curves and diagonals as well as horizontal and vertical lines to construct the shape, but do not have a hole in the middle as this will make the next project impossible. This shape is the plan for the planometric projection.

Near the bottom of the paper, draw grids in the same format and dimensions as those at the top, but turn them so that their edges are at oblique angles to the horizontal and vertical edges of the paper.

On each grid, draw vertical lines from the corners of the shapes parallel to the vertical edge of the paper. Draw them to a predetermined length. For the sake of clarity, the vertical from the lowest corner should clear the level of the top corner. If all the verticals are the same length and really are vertical, you need

Planometric projection

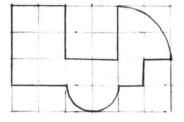

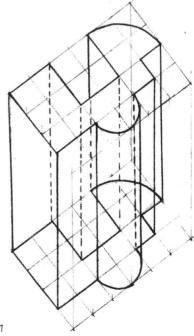

only join them up in order to form another rectangle whose edges are parallel to the edges of the lower rectangle.

Grid the top rectangles with the same size units as the bottom ones. What you should now have is two planometric boxes with checkered grids at top and bottom. On the top and bottom of each box, map out the same shape in the same orientation. Now join top to bottom shape with verticals to each corner. The "hidden" edges should be marked with a broken line. You can pick out the form from the lines of placement with colored pencil.

PROJECT 3

One three-hour session **Materials:** 22- x 30-in paper, pencil, ruler, plastic eraser, tracing paper

In this project you are going to design one flat figure that can be cut out and folded to make a scaled model of the planometric projection from Project 2. The flat figure is called a "net."

In the middle of the sheet of paper, draw the shape/plan of the planometric from Project 2 at half scale—with ½-in (1-cm) units instead of ¾-in (2-cm) ones. From the sides with straight edges, draw lines to

Scaled model of the planometric projection in Project 2

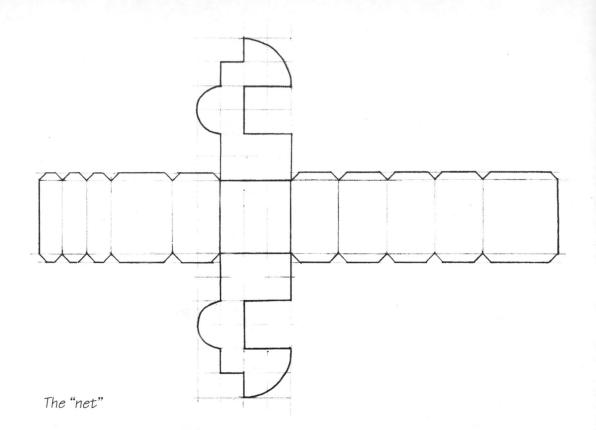

form flaps that can be folded up to give the faces of the sides. These will correspond to the verticals of the planometric, but will be drawn in this instance at right angles to the line that forms the edge of the plan. The length is again half the length of the planometric. You can carry on joining sides to the straight edges, but proceed with caution as sides should not overlap each other. To avoid this and to attach the curved sides, the sides can continue in a line next to each other. When the side attached to the plan folds vertically, the other sides attached to it can be folded back along the plan to complete the form. You will also need to draw the top attached to one of the side flaps. Imagine how it will bend back and over to complete the figure.

Finally, trace the net onto tracing paper to keep a record of it, because you will need it for the next project. The drawing on paper can be cut out, scored, bent, and folded and then secured with tape to make an actual model of the planometric.

PROJECT 4

A PLANOMETRIC BUILDING WITH DIFFERENT LEVELS

One three-hour drawing

Materials: 22- x 30-in paper, 2B pencil, plastic eraser, ruler, colored pencil

Redraw the net in the lower section of the paper, or transfer it from the tracing paper. To do this, rub with a pencil on the back of the drawn line. Then place this on the paper with the pencil-rubbing side down and redraw the net, letting the marks come through.

Once you have the net drawn, you can consider each unit as having a different height, and tops that slope at different angles. You can determine the sides in the same way as for the simple planometrics of the second project, but you can play with different volumes and spaces, roofs, and slopes.

Keep all the work from this chapter as you will need it for later projects.

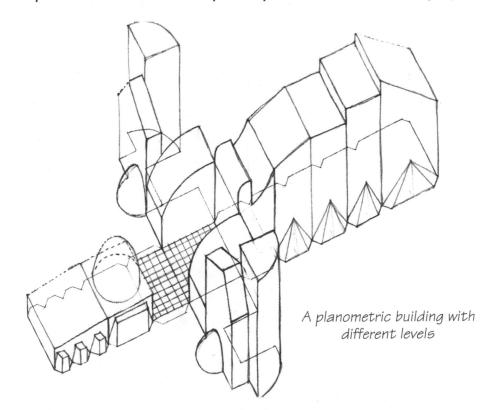

CHAPTER 2

LINEAR PERSPECTIVE

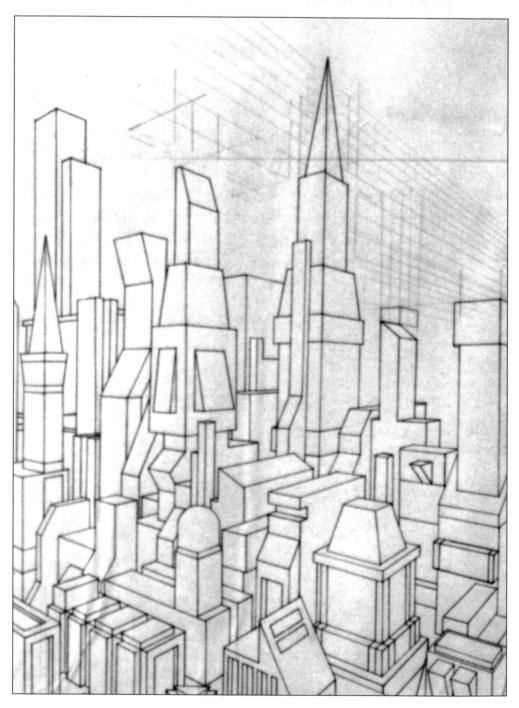

LINEAR PERSPECTIVE

eonardo da Vinci (1452-1519) asserted that, "Perspective is the rein and rudder of painting." Leonardo was referring to a system of perspective called *scientific* or *artificial perspective* developed by two Florentines, the architect and artist Filippo Brunelleschi (1377-1446) and the theoretician and architect Leon Battista Alberti (1404-72). There is some debate as to who was the originator. In 1402, Brunelleschi painted a picture of the Baptistry in Florence that represents the building in an accurate perspective. Many theories have been advanced as to how he achieved this. The picture was believed to have been done on a mirrored surface or on glass, so it is not clear whether Brunelleschi discovered a procedure for producing perceived images, or in the process of painting discovered and applied the principles of perspective.

In his *Della Pittura* (*On Patnting*) of 1435, Alberti set out a method for making pictures in perspective. This may have been gained by observation of the working practices of the artists around him–Brunelleschi, Tommaso Masaccio (1401-c.28), and others were employing the new perspective in their work prior to the writings of Alberti. Alberti, however, demonstrated the relationship between the primary and secondary geometry of perspective.

The claim made for perspective then–and it resonates down the centuries to today–is that it is "truthful" to the eye. And it is truthful to an eye, but it is not the full truth about our vision. The "eye" to which perspective is truthful needs to be fixed at one point in space; to have no thought or feeling about what it sees; to be thought of as a mechanism independent of the rest of human physiology. It also requires "time" to be frozen at a particular instant so that the object, the picture plane, and the eye are all still, and thus hold a constant relationship to one another. Finally, it is only applicable within a relatively narrow angle of view.

These conditions are never upheld totally in the situations of our seeing. Therefore, although linear perspective is part of the truth of seeing, it is only a fraction of the picture. Margaret A. Hagen, in her article "There Is No Development in Art" (*Visual* *Order*, 1985), claims that "natural perspective" is the sum of all relationships between light and the eye under all conditions. Since human vision is bifocal, and our eyes are constantly scanning to complete what at any instant can only be a partial image, it seems that we receive and process visual information in numerous ways concurrently. Hagen believes that all possible conditions of realism can be described by four projection systems–orthogonal (see Chapter 1, "Projection Systems," page 332) similarity, affine, and projective. She calls the sum of these systems *natural perspective*.

Artificial perspective is only one of many approximations of the way we see. Perspective theory is based on the way in which light rays issuing from an object converge to a single, stationary

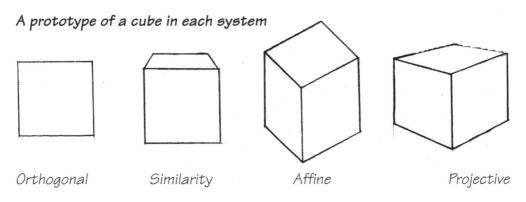

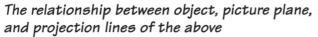

eye. It differs from the orthographic projection in that the position of the viewer is all-important. The image that is drawn is the view from a particular point.

It is important, initially, to play with drawing shapes and forms in perspective and to evolve their placement in relation to each other through intuition–by seeing what looks right without getting confused with projection lines in space. An explanation of the primary geometry of perspective is therefore left until the next chapter; this chapter deals with a secondary geometry perspective–working out the effect of perspective through geometric constructions as relationships on paper.

THE FUNDAMENTAL FIGURES: SHAPES

There are three geometrical shape figures, or prime shapes, from which more complex figures can be constructed. These are the rectangle, the circle/ellipse, and the triangle. Any shape is twodimensional. By knowing how to place shapes in perspective,

FORMS

There are three essential forms, and they can be used as the basis for evolving other, more complex forms (see Chapter 4, "Trimetric Projection," page 372). A form in drawing is defined as a figure that has the illusion of three dimensions. The three fundamental forms are the rectangular-based solid (and cube), the sphere (and ovoid), and the cone (and cylinder, which is an extreme cone–some might consider it a fourth fundamental form, but it is essentially a section of a cone with parallel sides).

LINEAR PERSPECTIVE

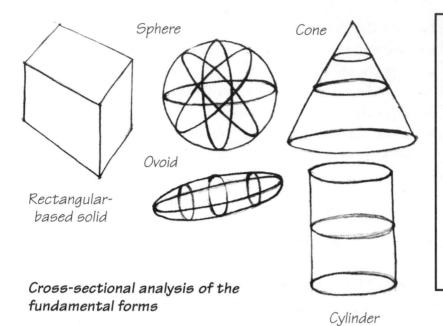

DRAWING AN ELLIPSE FREEHAND

When drawing an ellipse, move your hand fluidly in order to feel its circumference. Do not construct the halves of the ellipse separately, or you will get a pinched ellipse that destroys the illusion.

CROSS-SECTIONAL ANALYSIS

To describe a form, it is not always enough to describe its silhouette and sides. A form with a smooth surface needs further qualification. One way to do this is by describing what a cut through it would look like. This is called *cross-sectional analysis*. The cut needs to be taken at a propitious angle to avoid optical confusion, usually in a horizontal or vertical axis along the form. The sphere is an exception as there is no single, clear vertical or horizontal axis.

The cube's cross section consists of planes parallel to its side, and this provides little further information about its form. The cross sections of the sphere, cone, and cylinder are drawn as ellipses, although in actuality they are circles. Also, the base of the cone and the base and top of the cylinder are derived from the ellipse. In the examples above, the forms are viewed from one side and the distortion of the circle in perspective is anticipated. Without its cross-sectional analysis, the sphere has no clues as to its form because its silhouette is the flat shape of a circle.

LINEAR PERSPECTIVE

ONE-POINT PERSPECTIVE

An explanation of perspective in secondary geometry is best done with examples, and these are best understood by following the examples through drawing them, as you need to understand the principle not only intellectually but in action.

PROJECT 1 SHAPES AND FORMS IN ONE-POINT PERSPECTIVE

One three-hour session **Materials:** sheets of 11- x 17-in paper, 2B pencils, plastic eraser

Make drawings from the examples that follow so that you become familiar with the process of establishing basic shapes and forms in one-point perspective. This will help you understand the principles by which they are established and give you the wherewithal to draw your own configurations.

A rectangle horizontal to the ground

On a sheet of 11 - x 17-in paper, about onethird of the way down from the top, draw a line across the sheet parallel to the bottom edge of the paper. This will perform as the horizon line (HL) or eye level. To understand what defines the eye level, take a box and

place it lower than your head. You will be looking down on the top of it. If you raise it above your head you will see the bottom of the box. When you hold it at your eye level, you will see only the sides of the box.

On the horizon line, in the middle of the page, make a point. This is the vanishing point. Perspective is a system for establishing a sense of depth on a two-dimensional surface, and describes how objects get smaller as they recede into the distance; the vanishing point marks the furthest limit of this diminution.

From the vanishing point, produce two oblique lines below the horizontal line, one to the left and the other to the right of the vanishing point. These will be orthogonals. Then, parallel to the horizon line, draw two lines, one below the other, joining the orthogonals. This will give you a rectangle—the crosshatched area in the example on page 349. The front and back edges are parallel to the horizon line. In onepoint perspective, the front face of the object or shape is always parallel to the picture plane, being a *similarity projection*.

A shape can be drawn above the eye level in the same way, but this time the orthogonals would be drawn *above* the horizon line instead.

Vertical and parallel rectangles

A vertical rectangle whose face is parallel to the picture plane will be depicted by a flat, rectangular shape with its sides horizontal and vertical (an orthographic projection, in other words). A vertical rectangle that recedes back into space can be produced by extending two orthogonals on the same

side of the vanishing point. If the whole rectangle is below your eye level, the orthogonals will be *below* the horizon line; if above, they will be *above* the horizon line. The orthogonals now mark edges parallel to the ground plane. The other edges are vertical.

We have shown two rectangles, one parallel to the ground, the other standing at right angles. A rectangle can also be drawn at an incline. The leading and further edges are still parallel to the picture plane, this being one-point perspective. Both orthogonals go back into the picture plane on the same side of the vanishing point, but the lines joining them, although parallel to each other, are not drawn as verticals, but are drawn at an angle the same as the tilt of the rectangle. Other shapes can be drawn in perspective if you understand how they relate to a rectangle, by placing them in a perspective rectangle. You can find the middle of a rectangle by marking the point where the diagonals cross. Then draw the medians (lines bisecting the sides) through the mid-point parallel to the sides, "Union Jacking" the rectangle. An ellipse can be drawn within the rectangle so that it touches the points that mark the middle of all four sides. A circle can be drawn in the same way within a square. A circle in perspective—in other words, an ellipse—is drawn by placing it in a rectangle drawn in perspective.

More complicated shapes can be placed in perspective by dividing the rectangle into smaller units and mapping the figure onto the resulting grid. It is possible, for example, to plot telegraph poles in recession. At this stage you should guess at the dimensions of the perspective rectangle by eye. The next chapter provides ways of determining its dimensions consistently.

A rectangular-based solid

This can be drawn by putting together all the planes created by the perspective rectangles. Thus, the front plane, which is parallel to the picture plane, can be drawn and the sides produced back from the corners to the vanishing point. Think of each side as a rectangular plane going back in space. The rectangular-based solid can also be shown to the left or right of the

vanishing point, revealing another side.

The front plane is always parallel to the top and bottom of the paper. There are no distortions. Its corners are always right angles. However, the more you move the rectangle away from the center, the more distorted the other sides will look.

Perspective only operates within a limited angle of vision (60 degrees being an optimum), and distortions occur outside that angle.

LINEAR PERSPECTIVE

A cone

Draw a square parallel to the ground in one-point perspective. (This is done the same way for the rectangle.) Draw a circle in perspective, i.e., an ellipse, within it. From the center of the ellipse produce a vertical line. From each side of the ellipse, draw lines to the top of the vertical line. Now draw in the cross-sectional analysis.

The cross sections are also influenced by perspective, so at the eye level you see only a line (the edge of the cross-sectional disk). Above the horizon you see the underside of the disk; below the horizon line you see the top of the disk. The further you move below or above the horizon line, the more the ellipse comes to resemble a circle. Look at a coin in these various positions as an example.

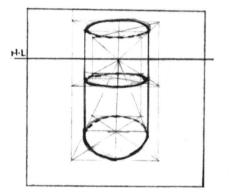

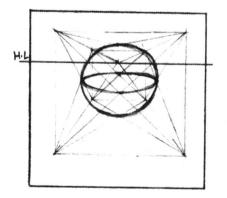

A cylinder

This is produced by drawing a rectangular solid in perspective and mapping an ellipse on opposite ends. Then, for each side of the cylinder, draw a straight line that connects the ellipses.

A sphere or ovoid

Mark the mid-points of each side in a rectangular solid or cube, and draw ellipses in the horizontal and vertical planes that join these points. Then draw a circle or ellipse that grazes the edges of these cross sections. However, this can get confusing. A perspective sphere does not distort much in silhouette from the circle, so you can draw the sphere as a circle and then draw its cross section.

PROJECT 2

A ONE-POINT PERSPECTIVE LANDSCAPE

One two-hour session

Materials: sheets of 22- x 30-in paper, 2B pencil, plastic eraser The aim is to construct a one-point perspective landscape of geometric forms using the strategies outlined in the previous examples.

Complex geometric forms can be evolved using the simple principles you just learned. For example, a staircase or arch can be derived in the following manner:

Draw a perspective box. Divide two vertical sides lying opposite each other by "Union Jacking" the whole rectangle, and then continue the process through the smaller rectangular units until you

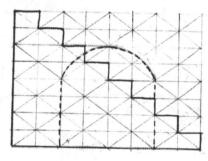

Stairs and arches can be plotted in perspective by "Union Jacking" a rectangle.

have a grid. Use the grid to map the regularity of the stairs or the arch. Now connect the necessary points on the two sides.

Further, more complex forms can be made by taking further sections out of basic forms using cross-sectional analysis or other constructed sections. Forms can share the same vanishing point or have their own, but the vanishing point must be consistent for each form. The horizon line never changes for a perspective scene, but in this project it can be low, high, or in the middle of the page. The choice is yours.

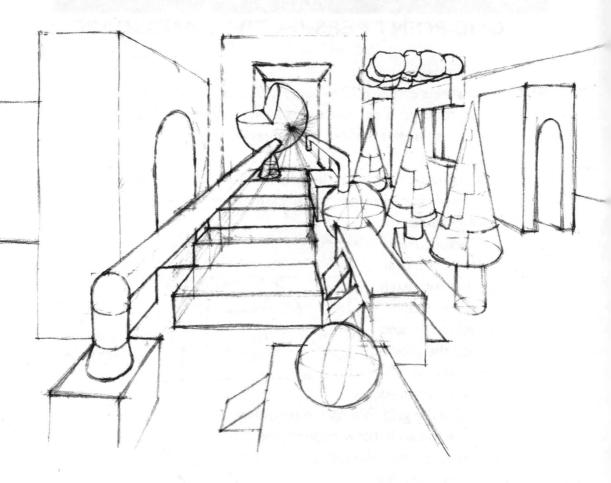

A one-point perspective landscape

TWO-POINT PERSPECTIVE

One-point perspective deals only with the specific instance where the front plane of an object such as a box is flat to the viewer's gaze–or the picture plane. If the box is angled so that no one face is parallel to the picture plane, two vanishing points are needed. The vertical edges of a box parallel to the ground will still be vertical in the picture; all the other lines will be orthogonals.

PROJECT 3

FUNDAMENTAL FORMS IN TWO-POINT PERSPECTIVE

One two-hour session

Materials: sheets of 1 - x + 7-in paper, 2B pencil, plastic eraser. These drawings should be done freehand rather than with a ruler.

Use one sheet of 11 - x 17-in paper for each form. Use the paper in landscape format (horizontally), and draw a horizon line on each. On the horizon line near the edges of the paper mark two points; these are the vanishing points (VP).

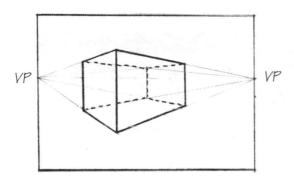

A rectangular-based solid

Draw a vertical line to mark the leading edge of the rectangle. Produce orthogonals from the top and bottom of this line back to each vanishing point. Then establish the two receding planes by drawing verticals between the two pairs of

orthogonals. These verticals define the side planes of the solid. Now, from the left-hand vertical (top and bottom), draw orthogonals back to the right-hand vanishing point, and from the right-hand vertical back to the

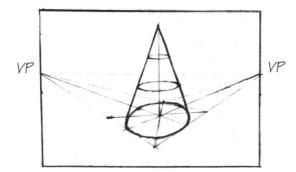

left-hand vanishing point. This will complete the rectangle.

A cone

Produce a rectangle by running a pair of orthogonals below the horizon line from the left-hand vanishing point. Intersect these

LINEAR PERSPECTIVE

with a pair of orthogonals from the right-hand vanishing point. Adjust the orthogonals so that the rectangular figure becomes a square in perspective. Divide the square by "Union Jacking" it. Produce an

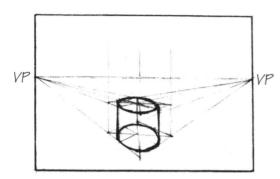

ellipse and then a cone as in onepoint perspective.

A cylinder

Draw a box in two-point perspective. On the top and bottom of the box plot and draw the ellipses, and then connect top and bottom.

PROJECT 4

LANDSCAPE FORMS USING ONE- AND TWO-POINT PERSPECTIVE

One four-hour drawing **Materials:** 22- x 30-in paper, conté crayon or 2B pencil, plastic eraser; or two sheets of 22- x 30-in paper, charcoal, and kneaded eraser

Do not become too literal, such as trying to make forms represent buildings, cars, and so on. It is not a building but the forms from which a building is composed that you should be concerned with.

If you have the space, you can work on a large scale, using two

or more 22- x 30-in sheets butted and taped together, or a larger sheet of paper if you have one. If you work large, use charcoal; otherwise use an 22- x 30-in sheet of paper with a conté crayon or 2B pencil.

Select where you wish the eye level/horizon line to be and draw it in on the paper. Mark two vanishing points on the horizon line within the format. Then start to evolve forms and place them in relationship

LINEAR PERSPECTIVE

to each other. When using two-point perspective, you can move the vanishing points on the horizon line for different forms. For consistency, if you move one vanishing point to the left, move the other one the same distance in the same direction. Within the same landscape you can also draw figures in one-point perspective.

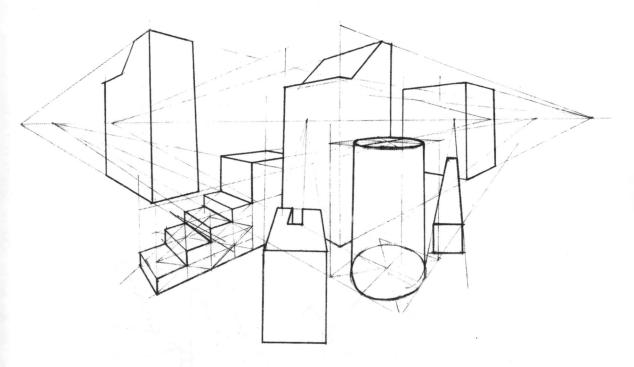

Landscape forms using one- and two-point perspective

CHAPTER 3

PERSPECTIVE GRIDS

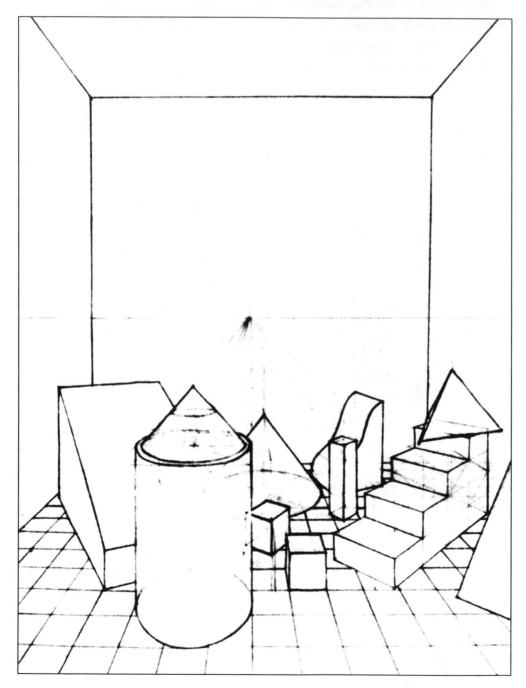

Ibrecht Dürer's treatise on measurement, first published in 1525, has illustrations of a number of drawing machines. One of these is an apparatus that Dürer himself invented. A description of the apparatus and its workings will clarify what is meant by perspective in a primary geometry. The object to be drawn, a lute, is placed on a tabletop. On the table at a (variable) distance from the lute is a window frame (in effect, the picture plane), to which a hinged plane is attached. The hinged plane allows a sheet of drawing paper to be swung in and out of the window frame, the drawing plane and picture plane thus coinciding. Fixed to the wall beyond the frame is an eyelet representing the viewing eye. A string passes through the

Dürer's drawing machine

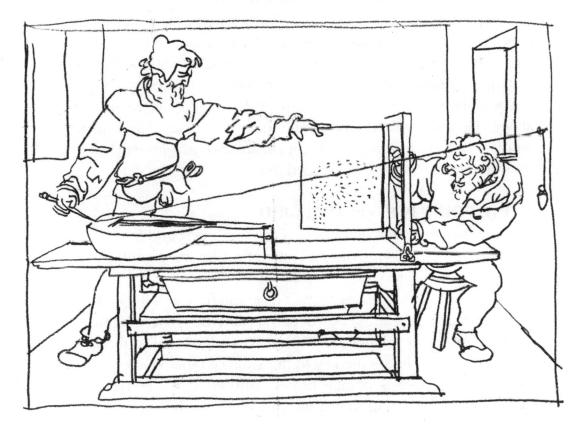

eyelet (a weight on the wall ensuring it is straight), and travels through the viewing frame to the top of a pointer. The pointer is placed on the spot on the object to which the "eye" is directed. The window frame (picture plane) has two taut threads, running vertically and horizontally across it, that can be moved to mark the point at which the visual ray (represented by the string) intersects the picture plane. Once this is done, the string is released, the sheet of paper is swung inwards into place, and the point is marked on the drawing. By doing this for a number of points (scene/picture primitives) one will have mapped the contours of the object as a series of dots. By joining up the dots, one will have a line drawing of the object–in Dürer's illustration, a lute.

The prerequisites for the working of Dürer's apparatus are laid out in Leon Battista Alberti's *Della Pittura*. In it he defines what is meant by the picture plane and the fixed viewing point, which upholds a specific eye level or horizon line. He also speaks of a central vanishing point and a ground line, all of these conditioned by fixed distances between the elements. He worked out a theory that governs the production of an image under the conditions set out above. He also evolved a practical method for placing and mapping an object's form in space, calling it *construzione legittima* ("the truthful construction") and claimed it the best method.

A ONE-POINT PERSPECTIVE GRID

The *construzione legittima* places a checkerboard grid in perspective, and this provides a system for plotting complicated figures in a measured space.

The *construzione legittima* is based on the height of a viewing eye. Alberti imagined the artist/viewer at the same height as a figure standing on the bottom of the picture. This edge is called the *ground line*. The ground line is the key to the scale of other elements in the picture. The vanishing point is placed halfway across the picture plane, and its height above the ground line is the height of the viewer

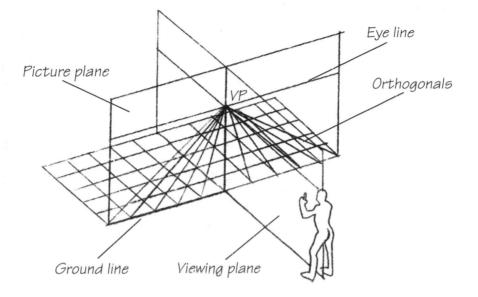

The construzione legittima, front view

at the scale decided on for the picture. The height of a vertical line from the ground line to the vanishing point is therefore called the *viewing height*. The plane along which the figure looks is called the *viewing plane*. Along the ground line is set a scale of equal units.

To establish the sides of the squares or rectangles of the grid receding in space, orthogonals are drawn from the vanishing point to the divisions on the ground line. The distance between two orthogonals measured on a horizontal (parallel to the ground line) anywhere in the picture represents the width of the divisions of the ground line.

The problem in laying out the rest of the grid is one of placing the horizontal lines of the grid–known as the *transversals*–receding back into the illusory space in equal divisions towards the horizon line. Alberti solved this by analyzing a view from the side of the grid, looking at the picture plane edge on (the grid is composed of squares, so it is the same viewed from the side as from the front): the picture plane in the front view is moved through 90 degrees. The edge of the

The spectator has moved to view the scene from the side of the picture plane

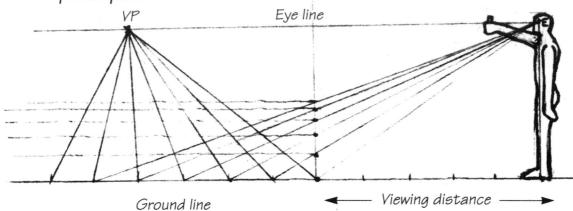

The visual rays from the eye, drawn to the divisions of the ground line, will give the spacing for the transversals by the points at which they intersect the picture edge (the picture plane viewed side on).

picture then becomes the picture plane viewed from the side.

In the side view, the eye's distance and position out to the side is established by measuring off the distance from the picture plane to the figure along the scaled units on the ground line, and moving up from this point to the eye level. From the "eye," lines are drawn along the viewing plane to the divisions on the grid. The points where these lines intersect the edge of the picture give the positions of the transversals.

To put the theory into practice when drawing the grid, the side view should be added to one side of the picture area. Draw in the orthogonals from the vanishing point. Establish the "eye" out to the side along the eye/horizon line and draw lines from this point to each division on the ground line. The points where these lines hit the side of the picture determine the positions of the transversals. They are drawn from these points, parallel to the ground line.

Alberti's system offers a one-point perspective grid. Figures can be reoriented by mapping a rectangle turned on a vertical axis on this grid.

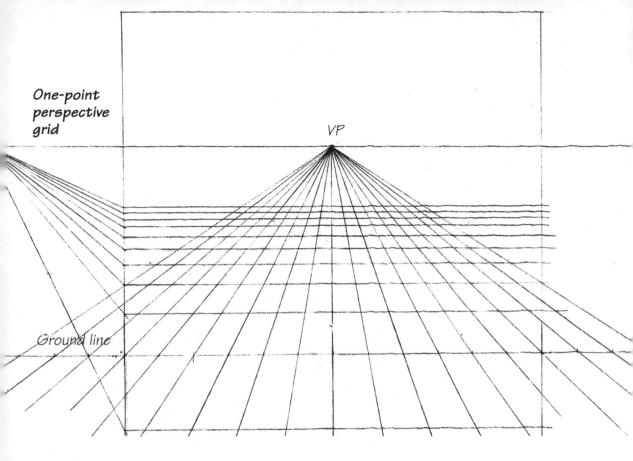

A TWO-POINT PERSPECTIVE GRID

A two-point perspective grid is not quite as adaptable as Alberti's grid in that, because the two perspective points are fixed, it makes the object exist in one specific orientation. It is useful, however, if one has one object to place, or if all objects are oriented on the same axes, such as the buildings and streets in Manhattan.

A two-point perspective grid can be laid out in the following manner: Draw a rectangular format on a piece of paper. Draw a horizon line that extends beyond the format in both directions, and do the same with the ground line, which can be placed somewhere between the bottom edge of the format and the horizon line (eye level). Mark out measured divisions on the ground line that extend out beyond the format in both directions. On the horizon line, mark a vanishing point on either side of the format. From the vanishing points draw orthogonals down and through the units of division on the ground line, thus forming a grid.

DETERMINING HEIGHT

The height of figures can be set in both the one-point and the two-point perspective grids by taking a vertical measurement from the ground line and running orthogonals from the base and top of the vertical back to the vanishing point. All vertical lines drawn between the same pair of orthogonals will have the same height, and that height is measured on the vertical from the ground line.

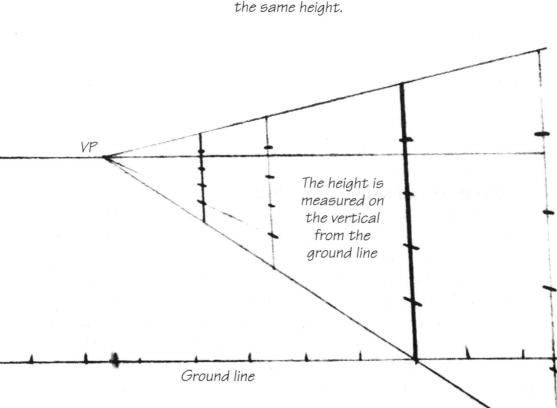

All verticals drawn between the same two orthogonals will have the same height.

PROJECT 1

A FORM IN A TWO-POINT PERSPECTIVE GRID

One three-hour drawing Materials: 22- x 30-in paper, 2B pencil, plastic eraser, ruler

You can use a ruler or longer straightedge as accuracy is essential for a successful project. You will need the drawings of the planometric form from "Projection Systems," Project 2 (page 340). In this project, you are going to draw the form in a measured perspective.

On the 22- x 30-in sheet, draw a rectangular format and mark out a two-point perspective grid. The scale along the ground line should give at least eight units within the format. Draw the orthogonals out to all the units on the ground line beyond the format, and extend them all the way to the edges of the format. Within the grid, mark out a rectangle that has the same number of units as the rectangle for the plan in the planometric. It can extend in front of or behind the ground line. In the perspective rectangle, plot out the plan of the form. The height of the verticals are found by placing a vertical at the intersection of the ground line and the orthogonal that runs along one of the sides. From the height of the vertical, run an orthogonal back to the same vanishing point as the orthogonal on the ground line. At the corners of the rectangle, erect verticals that will complete the side plane of a box.

The next task is to grid the top. This is done by running verticals from intersections of the grid at the edge of the ground rectangle up to the orthogonal that defines the edge of the top rectangle. You need do this only on the front two faces. To complete the grid on top, run lines from these points back to the appropriate vanishing point.

At this stage, plot the plane again, but now on the top rectangle. This can be a little confusing to do if the top of the box is near the horizon line, because the shape will become distortedly reduced and

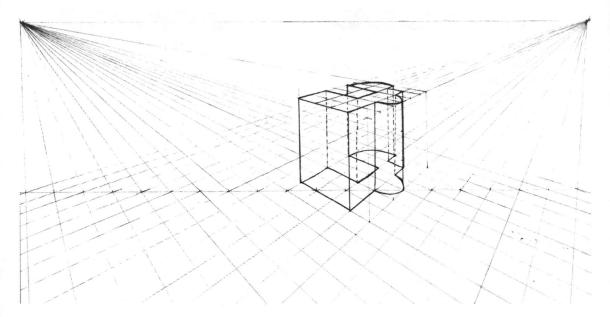

A form in a two-point perspective grid

look wrong, although it usually is not; or if the top of the box is above the horizon line, in which case the plan may appear disoriented.

You can check this when you draw vertical lines from the corners of the top plan, making sure the equivalent edges are paired up. Visible edges should be drawn in with a strong line; hidden edges with a broken line.

PROJECT 2

A THEATER OF FORMS

One four-hour session

Materials: 22- x 30-in paper, pencil; or three sheets of paper, charcoal, plastic eraser

If you have the space to work large, join the three sheets of paper along their longer sides by butting them up and running masking tape down the back of the joins. Otherwise, use one sheet of 22 - x 30-in paper.

Draw a horizon line somewhere in the middle of the page. Extend it beyond the paper onto added paper or the board to find the viewing point. Now, on both the bottom and top edges of the paper, mark out a scale of regular units that start and finish at the edge of the format. From the viewing point, draw in transversals for the top and bottom. The orthogonals coming from the corner of the page will act as the edges of the inside of a box. Join the points where the last orthogonal meets the last transversal on each side with vertical and horizontal lines to give the back of the box.

The format will act like a proscenium for a gridded stage. Referring back to the previous chapter, draw a series of forms in the gridded space. Build ramps, further stages, steps, and flaps. Now place forms and simple objects into this space. You can develop forms using two-point or onepoint perspective, but make sure you use the same eye level throughout. You can also draw forms that are suspended from the ceiling.

PROJECT 3

READING A PERSPECTIVAL DRAWING

One five-hour drawing

Materials: card stock of different thicknesses, glue, ruler, cutting knife, metal straightedge, cutting surface

The proposition here is to read the information from the previous drawing to build a scaled model of the theatrical space.

First draw a rectilinear grid on card stock taken from the scale of the units on the ground line in your drawing. Select a suitable scale for your model, taking into consideration the weight of the card stock you are using. Make sure the grid has the same number of units as the drawing.

Now start to build the forms out of card stock. The width and depth of each object can be calculated using the orthogonals and

transversals, as their spacing accords with the units of the ground line. The height of objects can be calculated at the ground line by taking an orthogonal from the central vanishing point through the highest point in an object. A vertical from the ground line to this orthogonal represents the object's height. Now build and assemble the card model.

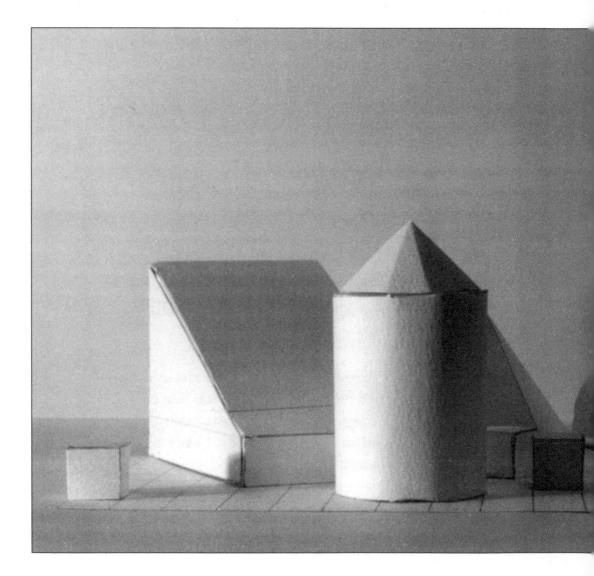

FREEHAND PERSPECTIVE DRAWING

To measure and plot a drawing from observation, imagine that one of your eyes is the fixed eyelet in Dürer's apparatus and that the window frame is at arm's length from you. You can plot the scene by determining angles and distances between salient features of the view projected onto the picture plane. The straight line is the best way of analyzing angles and taking measurements between points because it

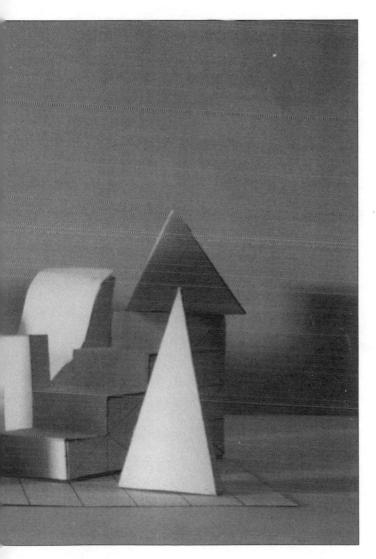

has a fixed trajectory and marks a fixed distance between two points.

To determine the angle between two points in a subject, you can place a straightedge flat to the picture plane and swing it until it runs through the two points in the scene. Then transfer the angled instrument to the drawing surface and mark the angle.

To determine the length and position of and between elements in the picture, you need to determine a scale and take measurements from it. Fix an arbitrary distance between two points and mark them

Reading a perspective drawing

on your paper. Keeping your arm straight (the distance between eye, picture plane, and object must be constant for this kind of drawing), place your straightedge along these points and note the distance between them on the straightedge. The distance between the points in the scene are then noted as a fraction or multiple of this measurement. The equivalent measurement in the drawing is used to calculate other distances.

PROJECT 4

OBSERVATIONAL PERSPECTIVE DRAWING

One two-hour drawing **Materials:** 22- x 30-in paper, 3B pencil, plastic eraser

Hide the theoretical drawing of the theater of forms and set yourself

up in front of the card model you built in Project 3 (page 367). The middle of the model should be at your eye level.

Measure with the straight line (vector) and then draw (freehand) the angles of the edges of forms, the angles between points in space, and the distances between them. Over time you will build up a lattice of measurements in which the forms and space will be discernible. Do not rub out the vectors of analysis. In the final stages you can draw the contours of the forms with a more emphatic mark. When the drawing is complete, compare it to the drawing from Project 2 (page 366) that started the whole process.

Observational perspective drawing

CHAPTER 4

TRIMETRIC PROJECTION

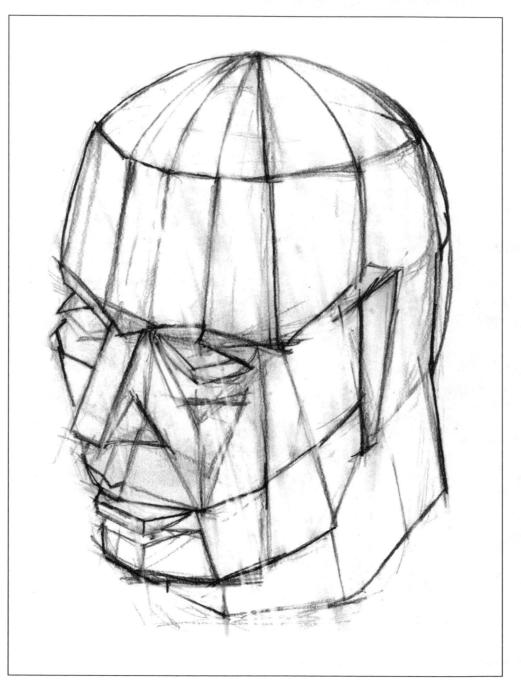

Provided a stronomer, projected a rectilinear grid onto the heavens and the Earth in order to map their features. The grid provided a matrix in which to locate and measure the position of particular points. The land mass or sky to be mapped was treated as flat, and was plotted within the grid. This assumed that the world was a flat plane without hills, dales, mountains, or any other undulations. However, the world is spherical and has an uneven surface. In order to allow for the world being spherical, cartographers distort the Ptolemaic grid, drawing it as if it were a net thrown over a sphere. In the case of a globe, the land masses are drawn onto the sphere itself; for a flat map, it is as if the globe is cut in a number of places and folded back to form a flat plane.

The French mathematician and philosopher René Descartes (1596-1650) evolved a model for mapping a figure in space. It uses three axes, defining length, breadth, and height, that intersect each other at right angles, and any figure can be plotted in space using coordinates that relate to these axes.

The Ptolemaic grid uses the rectangle, and the Cartesian axes feature three intersecting planes, like the corner of a rectangularbased solid. The fundamental forms (cone, sphere, and the rectangular-based solid itself) can be derived from the rectangle and/or a rectangular-based solid located in a perspective space. By combining Ptolemy's grid and Descartes's axes, we can use a gridded, rectangular-based solid to map coordinates in order to draw a three-dimensional figure.

But there is more than one way of projecting a rectangularbased solid itself on the picture plane. While Gaspard Monge was using orthographic projections in his engineering works in France, Sir William Farish in England found and formalized a projection system called *isometric*. The isometric projection, or something quite close to it, had been used before the eighteenth century, by the ancient Greeks and Romans and others in the West, and it also appears in Chinese and Japanese art. However, Farish's contribution was to make clear the projection in a primary geometry and to formalize methods for deriving this projection in a secondary geometry.

The isometric projection, like the orthographic, is a parallel projection system—the projection rays (visual rays) travel parallel to one another and intersect the picture plane at right angles. Unlike

False line attachment

the view of the object in the orthographic projection, however, the object does not have its sides flat to the picture plane; it is turned 45 degrees and tilted at an angle of 35.36 degrees to the ground plane. In the past, the isometric projection was used for architectural and engineering drawings, but because it was not produced from an elevation or plan, and because it took too long to draw, it dropped out of favor for a while. It came back into fashion because it can explain the complexities of an object in one view by linking the information of the plan and elevation. In terms of a secondary geometry, the horizontal edges in an isometric projection lie at angles of 30 degrees to the horizontal; the vertical edges remain vertical. The

horizontal edges of the objects are parallel to either of the first orthogonals drawn at 30 degrees.

Sometimes there can be a problem of false attachments in the isometric cube, when the edge of the back of the cube lines up with the front edge. This can cause a problem in reading the third dimension. To compensate for this, variations on

isometrics, called *dimetrics* and *trimetrics*, were introduced. In these projections, the object can be set at any angle in the picture. The scale used for the sizes of the edges varies according to a system that takes into account diminution with distance. Reference tables are available that give the changing proportions of trimetric and dimetric projections, but there are also apparatuses to help in drawing a trimetric projection.

In the following projects, you will be using approximations (guessing at the dimensions of an object by eye) of trimetric projections of cubes and rectangular-based solids as basic units for sculpting more complicated forms. The first project involves drawing by cutting out sections from a rectangular form; the second, "crating" (building blocks around forms in order to understand and represent them in a drawing). These methods are then used in combination to explain how an object is constructed.

PROJECT 1 STEREOMETRIC HEAD

One five-hour session

Materials: two sheets of 22- x 30-in paper (or larger); charcoal, pastel (black, white, burnt umber), or pencil; plastic eraser

In this project you are going to construct a three-dimensional representation of a head by breaking it down into planes, and then support this drawing with its related plan, front, and side elevations.

On one sheet of paper, draw a trimetric projection of a rectangularbased solid—the top and bottom edges of each face are parallel. The head can be tilted, but at this stage it would be advisable to keep upright edges vertical and thus parallel with the edge of the paper. Also, as this is to be a drawing of a head, the dimensions of the rectangular form should be

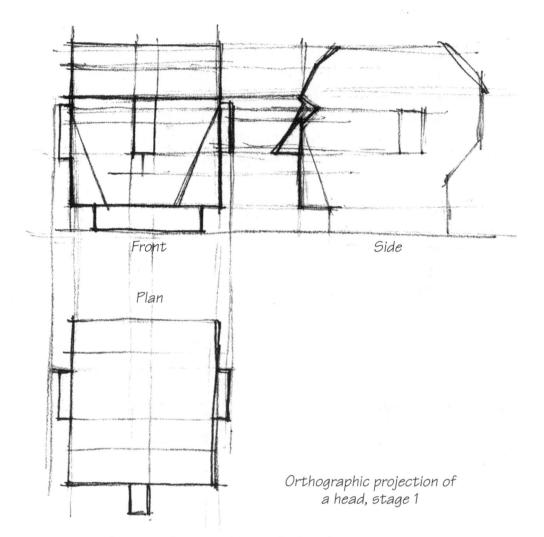

approximately equivalent to those of a head; i.e., the side view should be slightly wider than the front view. You can adjust the dimensions at any time during the drawing, so do not anguish over them. This is the trimetric solid into which you are going to carve the features of a head (stage I, see overleaf). On the other sheet of paper (if you are working in pencil you can use the same sheet), draw three orthographic projections—plan (top or bottom view), front, and side elevations. Initially, draw three rectangles that are the same proportions as the face in the trimetric projection (see stage I, above).

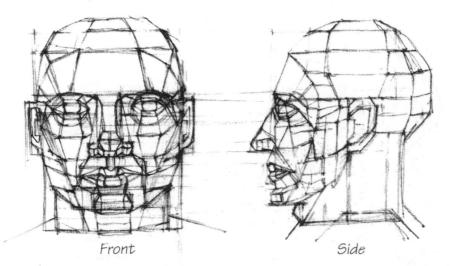

Plan Orth of

Orthographic projection of a head, stage 2

Begin carving into the trimetric solid, using your own head as reference. You can use a mirror, but feel your head as well. Any action that you take on the trimetric projection (see stage 2, overleaf) must be recorded on the orthographic projections (stage 2, above).

In the same way as a sculptor would conceive a carving, your initial efforts should lie in creating the larger forms of the head, not in carving details. For example: cut a wedge from the front plane that will give the incline of the forehead. A further section can be taken off the lower part of the back of the head to give the cranium. You can

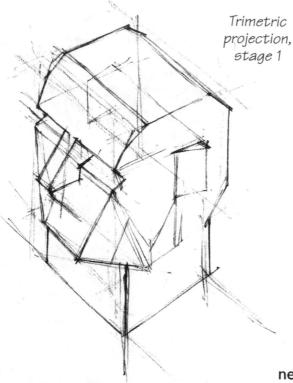

Mouth

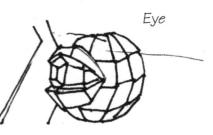

add blocks, wedges, and so, onto the solid where necessary and carve into them. The nose, for instance, can be

added as a wedge onto the front face. Wedges can be shaved off the sides to show how the face curves around from front to side plane.

The trimetric projection allows you to produce lines easily and lightly through the solid to find the equivalent point or action on the opposite face. If it were a perspective rectangular solid, you would have to refer all lines back to vanishing points. This can be done, but makes for added difficulties in what is already a difficult task. Continue removing facets to produce the curved surfaces and volumes of the face. It may start to get difficult as facets can behave erratically in the illusory space. You may be unable to tell which is the leading and which the receding edge. At this point, you can use cross-sectional analysis at the surface to provide clues to the planes and draw these in

Right: Trimetric projection, stage 2

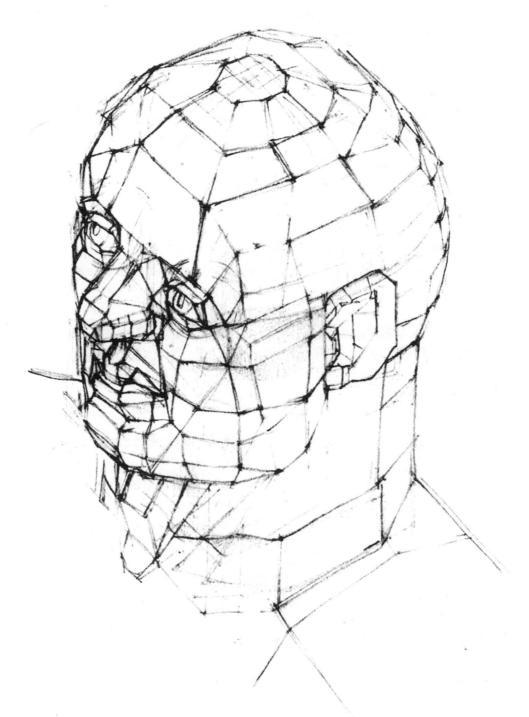

without reference to the section cut out. Use straight lines to describe the planes.

The eyes, mouth, nose, and ears may cause problems, but if you relate them to simple forms and take sections from these forms, it will be easier. The eyes are orbs in sockets, so an eye can be constructed by taking the sphere and dealing with its cross section in terms of planes. The lids cover the eyeball and thus echo its form. The top part of the eyeball, as you can feel on your own head, fits under the bony part of the forehead, so make sure its size and position are relatively correct. Do not try to preconstruct the features and then place them in your drawing. Work them out in the drawing itself. The drawings of the features in the plan and elevation will inform the stereometric (trimetric) head.

PROJECT 2

EXPLODED DRAWING OF A TOOL IN A TRIMETRIC PROJECTION

One four-hour drawing

Materials: 22- x 30-in paper, pencil, conté crayon, plastic eraser

Select a tool made of two or more forms. Imagine the smallest possible box into which each form will fit. Draw these boxes in trimetric projection in approximately the right alignment to each other. Cylinders, conic sections, spheres, spherical sections, and other forms can then be constructed from the trimetric boxes or "crates." Adjust the drawing as you proceed to compensate for any error in setting out the crates. Once you have completed the drawing of the tool, you can project lines out from the original crating, or from the forms themselves, into the space around the object to reproduce the individual forms and record their assembly.

Right: Exploded drawing of a tool in a trimetric projection

CHAPTER 5

SCIAGRAPHY

S *ciagraphy* is the name for drawing systems that deal with cast shadows. Just as there are many projection systems for representing objects and scenes, there are a number of different methods for constructing shadows.

The Shorter Oxford Dictionary defines sciagraphy as: "the art or practice of finding the hour of the day or night by observation of the shadows of the sun, moon, or stars upon a dial." On a sundial the time of day is read by the length and position of the shadows cast from a vertical feature onto a calibrated, horizontal dial face, which can be called *the plane of projection*. The plane of projection for a shadow need not be horizontal, but its position and length depend on the relative position of the Sun.

In the case of the Corinthian maid tracing her lover's shadow on a wall, the plane of projection was vertical and so was the picture plane. In a drawing, the plane or planes of projection are constructed in the illusion of space; objects cast shadows onto the ground plane of the space and onto other objects sitting in that space. This makes the whole thing a little more complicated than in the Corinthian maid's drawing.

Three factors affect the construction of a cast shadow: the light source, the object, and the plane of projection (the surface onto which it is cast). Not only is the position of the light source important, but also whether the illuminating rays that emanate from it diverge or run parallel. A lightbulb would be a light source from which the rays diverge–called a *point light source*. The sun or moon are light sources with parallel rays. In the case of the lightbulb, the source of light has a particular position that can be located in the picture. Because the sun is so far off, its light has a consistent direction and inclination that is the same for all objects in a scene.

Sciagraphy becomes quite complicated when you are trying to evolve or explain it in a perspective space, so in the examples and projects in this chapter, a simple approach is followed that

uses an interdependent plan and elevation, and consequently a planometric projection, to construct the shadows in a scene. For the same reason, parallel illuminating rays are used. It is possible to figure out from the examples of parallel rays how a diverging or point light source would work.

RAYS HITTING A FORM VIEWED IN ELEVATION

Consider a rectangular-based solid sitting on the ground, viewed in elevation, with light rays coming in at a 45-degree angle to the ground from the left of the picture. One ray will hit the top right corner of the box at A as a tangent. It will meet the ground at a particular point, B. This gives the shadow point of the top corner of the box on the ground plane. The front corner's shadow projection can likewise be plotted, as can other points on the solid–remember that illuminating rays in this example are parallel.

If another form is introduced, the projection ray that hits point

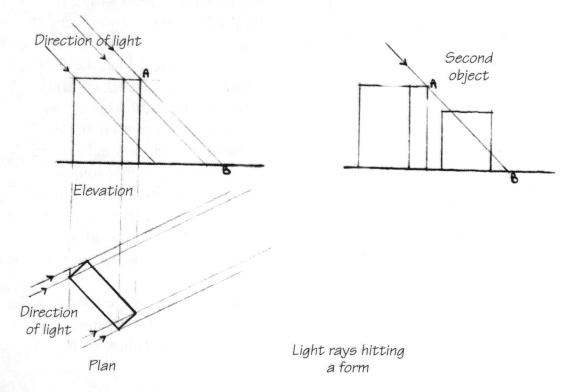

A may hit the new form anywhere along its projected length, or not at all; it depends on the direction of the light. By using the plan in conjunction with the elevation, you can determine the point at which the illuminating ray will hit the projection surface of the second object.

RAYS HITTING A FORM VIEWED IN PLAN

From the plan, we can map the direction of the shadows. In the example, when the projection ray hits corner A of the rectangular solid, it will travel in a straight line until it hits the ground, as it will with the other corners. From the plan you can read the direction of the shadows, but because there is no information on the object's height or distance from the ground, there is no way of knowing where the shadow will meet the ground. If you introduce a second form, as in the elevation, you can determine which points or sections on the first object will cast shadows on the second.

THE PLAN AND ELEVATION USED TOGETHER

Set the plan and elevation to relate to each other as in the first-angle orthographic projection (see Chapter 1, "Projection Systems," page 332). The plane on the left needs to be positioned far enough away from the plan to allow for the shadows (see illustrated overleaf). The corner Ae of the rectangular solid will cast a shadow that hits the ground at Ce in the elevation, as we have already seen. Point Ce will lie somewhere on the line produced through point A on the plan (Ap). By producing a vertical line down from Ce on the elevation and noting where it crosses the projection ray through Ap on the plan, you can find point Cp on the plan. You can do the same to plot other shadow points on the ground for the rest of the figure, until there is enough information to trace the shadow shape. By noting from the plan what faces the path of light from the designated direction and what the light cannot reach, you can see which planes are in light and which in shadow.

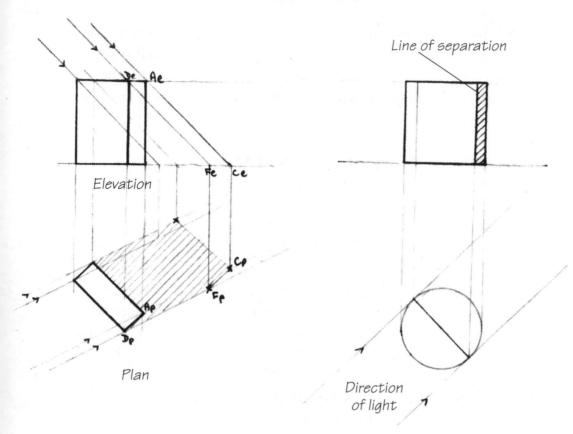

Plan and elevation used together

For the shadows on the plan, the points on the back of the figure De can be used to produce the shadow length, hitting the ground at Fe and giving Fp on the plan. The shadow can be completed in this manner. The demarcation line between the light area and the shadow area is called the *line of separation*.

By plotting the line of separation, you can get the shape of the shadow. In the case of the cylinder, the rectangular solid, and other figures with perpendicular verticals, it is fairly easy to do this. Note the points at which the tangential projection rays hit the top of the figure. Plot these, and by relating projection rays on the plan and elevation and mapping all the necessary points for the line of separation, you can plot the shadows.

PLOTTING THE SHADOWS ON A SPHERE

It is a little more problematic to plot the shadows on a sphere or a cone (the incidence of the light is at a greater angle than the slope of one of the sides in elevation) than it is on a rectangle and cylinder, although the method is essentially the same.

The sphere can be explained on a two-dimensional surface through its cross section. Because the sphere's surface curves in

all directions, shadow falling on it will be a particular cross section. In elevation, this is defined by an ellipse, one of whose axes is parallel to the incident light and the other at right angles to it. On the plan, the ellipse follows the direction of the light and its narrow axis is at right angles. In the elevation, a line Ae at right angles to the two tangential projection rays defines the line of separation in a cut through the middle of the sphere in the direction of the light.

In the example overleaf, the AeAe elevation is the profile of ApAp. ApAp runs through the middle of the sphere in the direction of the light. Drop lines from the points where AeAe hits the circumference (at the tangential points) down in straight vertical lines to intersect ApAp at Cp and Dp. Lines drawn through these points, Cp and Dp, at right angles to the projection rays, will give the rectangle into which the cross section

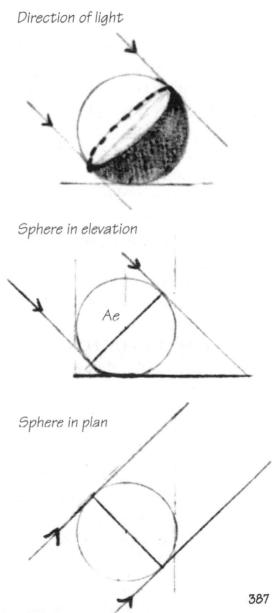

ellipse can be drawn.

Similarly, by projecting up from the two points where the diameter (BpBp) hits the circumference and finding where they intersect the line BeBe on the elevation (Ce and De), you can find the rectangle that governs the ellipse on the elevation. The axes of the ellipse are

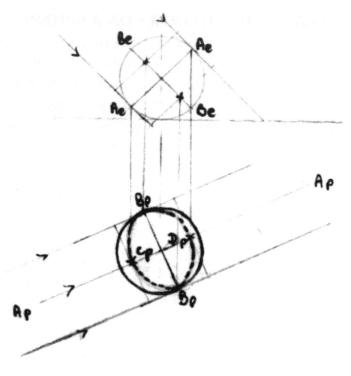

Plotting the shadows on a sphere

presented by ApAp

and BpBp within the confines of the rectangle. You can draw the ellipse freehand. There are, however, accurate ways of plotting an ellipse (described on page 390).

SHADOWS OF FORMS FALLING ON ONE ANOTHER

You can plot the shadow of one form falling on another fairly easily. Again, you have to work from the related elevation and plan. In the example opposite, we will cast the shadow of a rectangle onto a cylinder.

Through BT on the elevation, draw the incident ray. If it were to hit the top of the cylinder, you would drop a vertical down to the plan from the point where the directional light ray through B on the elevation hits the cylinder. This would give a point on the line that separates shadow from light on the plan.

In the example, the whole top of the cylinder is in light and the elevation takes the shadow. The direction ray through B on the plan hits the cylinder's circumference at Ep. Take a vertical up from Ep on the plan to intersect the incident ray through B on the elevation at Ee on the cylinder. The point where rays through A and C (on the top of the rectangle) pass and fall on the cylinder can be plotted in the same way. The shadow on the vertical face of the cylinder will meet the shadow on the ground, so the whole shadow shape can be plotted.

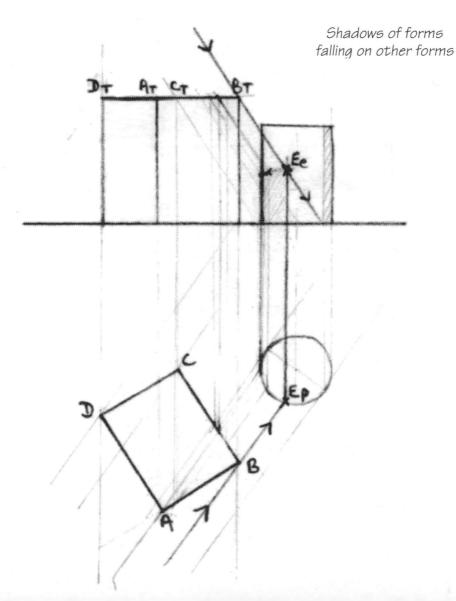

A METHOD FOR PLOTTING AN ELLIPSE

One method of setting up an ellipse is to plot the points through which its circumference will pass. Within a rectangle, you can set up the major (AB) and minor (CD) axes of the ellipse. The ellipse will pass through A, B, C, and D.

The center of the ellipse, O, is at the intersection of the major and minor axes. Divide AO into a number of equal divisions and the side of the rectangle, AE, into the same number of divisions. Draw lines from C through the divisions of AO and from D to the divisions on AE. The ellipse will pass through the intersecting points of these lines. You can do the same for the other quadrants. A fairly accurate ellipse can then be drawn passing through these points and A, B, C, and D.

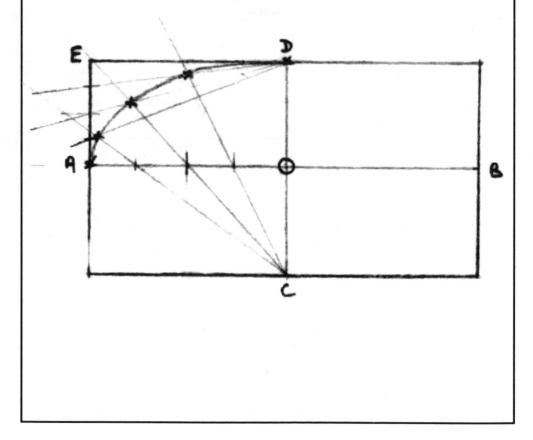

PROJECT 1

SHADOWS ON GEOMETRIC FORMS IN PLAN AND ELEVATION

One four-hour drawing

Materials: 22- x 30-in paper, pencils, plastic eraser, ruler, compass, set square, adjustable right angle (or 45 degrees), T-square

Take four or five geometric forms and lay them out in plan at the bottom of the paper (see illustrated overleaf). You can place one or two on top of each other. Place a ground line about one-quarter of the way down from the top of the paper. From the plan, project verticals up to the ground line and draw the elevation on the ground line relating to the plan. Select an angle of incidence for the light for the elevation and a direction of light for the plan. They should be on the same side of the paper–left or right. If you have a sphere or hemisphere, place it on this side to avoid shadows being cast on it.

Map the shadows using the methods described above. Do this as accurately as possible; in the next project, you can take liberties.

PROJECT 2

STILL LIFE IN PLAN AND ELEVATION WITH SHADOWS

One three-hour drawing

Materials: 22- x 30-in paper, pencils, plastic eraser, ruler, compass

On a tabletop, mark a rectilinear grid with equal divisions using masking tape. On this, arrange a still life; ceramic pots, bottles, and boxes would be appropriate. Record them in their plan, drawn on a scaled-down rectilinear grid, and try to keep them in proportion to

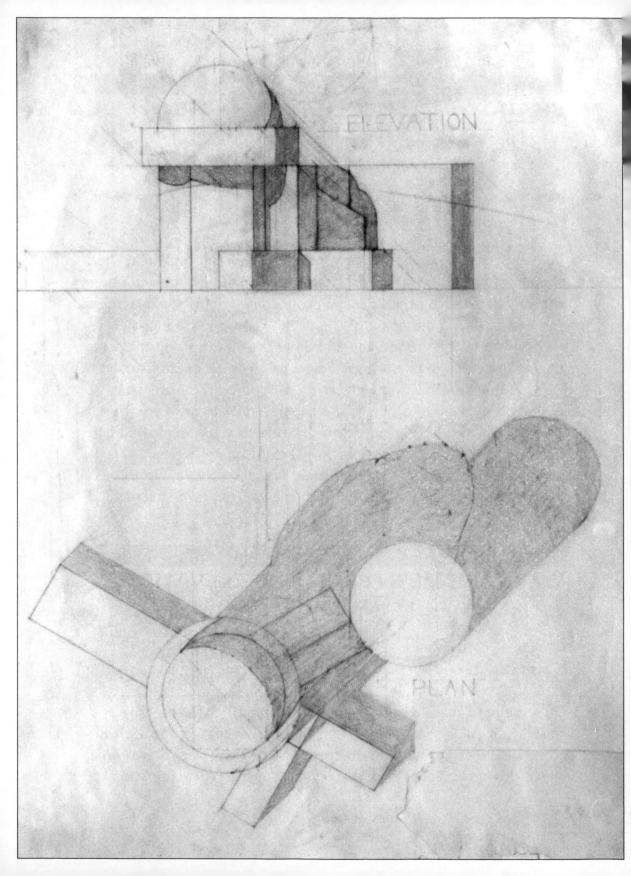

the grid. This should, as in the first project, be drawn in the lower section of the paper. Project up to the ground line and lay out the elevation. The elevation should hold the same scale throughout, regardless of how near or far the objects are, so measure the heights of objects with a ruler and scale them accordingly.

Now use the same method as Project I (page 391) to plot the shadows.

PROJECT 3

PLANOMETRIC OF A STILL LIFE

One two-hour drawing

Materials: 22- x 30-in paper, pencils, plastic eraser, ruler, compass

From the plan and elevation you drew in Project 2, draw up a planometric of the still life. Remember to twist the plan so that it is not on a tabletop with edges parallel to the edges of the paper. You can use the planometric itself to plot shadows as plan and elevation integrated, or you can transfer the information about the shadows from the plane and elevation to the planometric. Follow either route to plot the shadows in planometric projection.

Left: Shadows on geometric forms in plan and elevation Overleaf: Still life in plan and elevation, and planometric

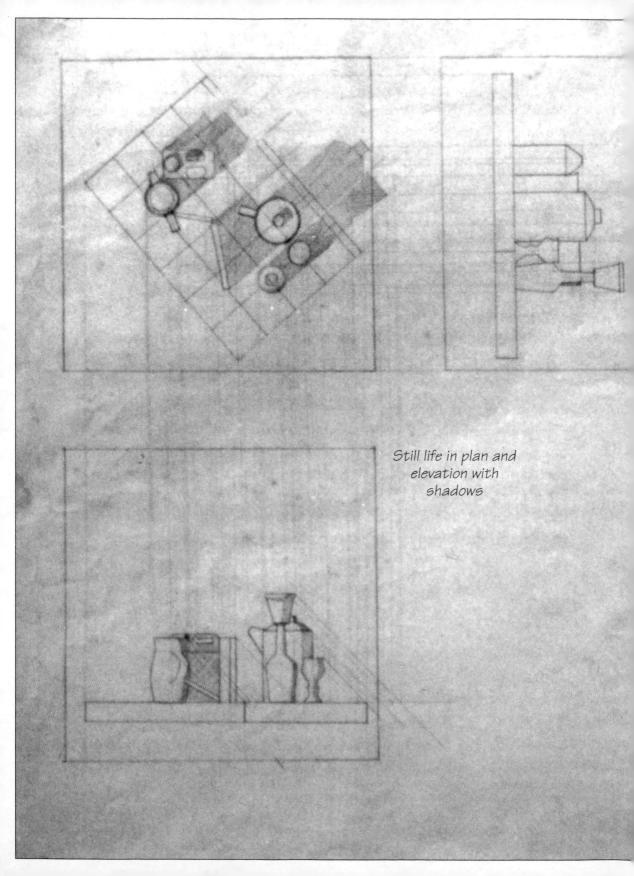

A certain license has been taken with the shadow on the curved section of the body of the bottle. (When you are familiar with sciagraphy you can make judgements about the shadow shapes that may not be strictly bound by the rules.)

Planometric of a still life

CHAPTER 6

THE PICTURE PLANE

THE PICTURE PLANE

still life was set up in a class, and the students were directed to draw it "as they saw it." A cup was one of the objects in the still-life group. Most students drew or attempted to draw the cup in perspective (Figure A). One student, however, drew it with a circle for the top and a flat bottom (Figure B). The student was quizzed as to whether he actually saw the cup in the way he had represented it, and he replied that he did.

When the other student drawings were pointed out to him, he drew attention to the fact that with a curved bottom, as they had drawn it, the cup would never balance on a flat tabletop nor would one be able to get one's lips into the peculiarly shaped and narrow opening at the top. However, although he had a valid point of view, he had not considered his viewpoint. He was then asked to consider what he would see if he were to look down on the still-life group. He came up with a solution in which the object was drawn with the right-hand vertical edge of the picture format acting as direction for the ground (Figure C). In fact, he had turned his picture plane 90 degrees.

This student's drawings were object-based not viewer-centered (as is required in a perspective drawing). By combining the plan and elevation in one drawing, he

Figure A

Figure C

could articulate the details he found pertinent in the object. His viewpoint was not of primary importance in these projections. However, when asked to consider his viewpoint, he found a solution in the format of the drawing, thereby inventing a key for the reading of a different orientation. It would be difficult to know which way to display the drawing if one did not know or could not guess at the key and there was only the one orientation depicted. This example illustrates how we can use mixed projection systems, and how the format or picture plane itself can become a fact in the drawing.

Mixed drawing systems have been used from earliest times. The ancient Egyptians used the aspect of an object that gave the most information. The representation of this aspect is termed *iconic*. In Egyptian art, the iconic representation of a town was the plan, of a house the elevation, of a face the side elevation, of a torso the front elevation.

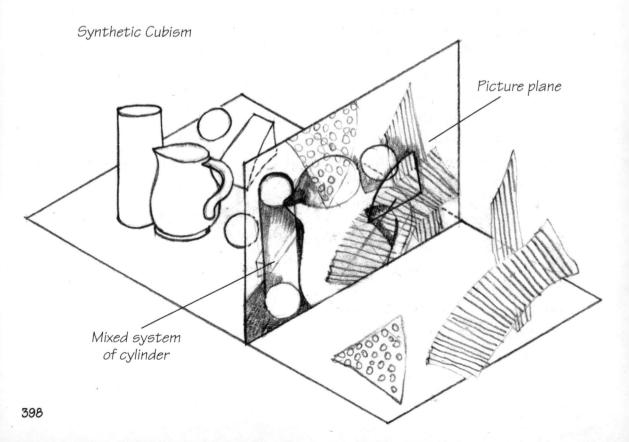

In the twentieth century, in Synthetic Cubism, objects were depicted in mixed projection systems in reaction to the limitations of perspective. The picture plane was considered as a fact in the drawing and collage was used to make the picture plane "real," by emphasizing the abstract arrangement at the picture plane while still allowing the representation of objects on it.

In Analytic Cubism, which occurred before Synthetic Cubism, the picture plane was considered as a plane shattered into fragments but containing vestiges of the three basic shapes-triangle, circle, and rectangle. The shards can be thought of as taking different projections of different details of the scene. When reassembled at the picture plane, the cracks are not fully bounded by line, making the picture plane flat like a stainedglass window; rather, they are articulated through line and shadow to create a picture plane which, although actually flat, has fluidity and life.

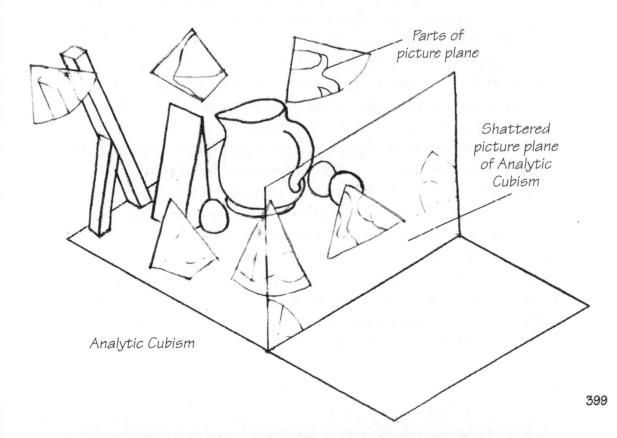

Although we have addressed Cubism as a projection system, this is a simplification of Cubist principles and purposes. It does, however, offer a reading from which to look and compare, and to use for other creative possibilities.

The picture plane can also be manipulated in other ways relative to objects and-in the case of perspective-points of view. The picture plane in perspective can be angled to the point of view. The projections onto the picture plane will be distorted when the picture is viewed flat on, but look "natural" when viewed from the point where that plane is seen flat on. In the painting *The Ambassadors* by Hans Holbein the Younger (c.1497-1543), most of the painting is in a regular linear perspective with the picture plane parallel to the viewer. There is a skull that is distorted beyond recognition when it is viewed from the same position as the rest of the picture. The plane on which the skull is painted is rotated within the picture so that it is at an angle to the plane of the rest of the painting. It looks distorted when the painting is viewed from the front, but reads correctly when seen from a position that is at an acute angle to the picture plane.

The picture plane can also have form–convex or concave–or be a form itself. For example, to draw the label on a bottle, you would have to note how the logo, picture, and text would be altered by being wrapped around a cylindrical form.

Deviations from images produced on a flat picture plane at right angles to the sight line are called *anamorphic projections*. Anamorphic distortions need to be seen in the situation for which they are created in order to be read. The question remains: Why would we need to know about anamorphic projections or to use them? Because in the illusory space of a picture, the label on a bottle, a curled photograph, a painting shown on the wall of a corridor, are all better understood as anamorphic distortions. Reflections and shadows are also images projected onto tilted, twisted, or shaped planes or forms. The following projects allow you to move freely between different projection systems and find ways of combining them and of playing with the picture plane itself.

PROJECT 1

SYNTHETIC CUBIST DRAWING

One three-hour drawing

Materials: two sheets of 22- x 30-in paper; pastels or conté chalk (sienna, black, and white); scraps of black, white, and gray sugar paper, newspaper (text not images), or other suitable paper (e.g., patterned wallpaper); plastic eraser

Join together the two (or more) pieces of 22 - x 30-in paper. If you do not have a wall or other large surface on which to work, by all means work smaller but choose appropriate drawing materials for the scale.

Set up a still life using mainly inorganic objects (ones easily understood in terms of their fundamental forms). Tear the collage materials and paste them to the cartridge paper. Then draw the objects, using a number of projection systems apart from linear perspective: orthographics, trimetrics, planometrics, and so on. You can overlap objects, considering them as transparent figures. At this stage use just black pastel or conté chalk.

Once you have mapped out the arrangement with black pastel, smudge the entire surface. Now work back into the picture with the eraser and the other colored pastels. Use areas of tone or color to map out shapes, boundaries, and edges. You can use cast shadows (guess at them as sciagraphy construction may not be appropriate), and exotropic and endotropic shadows. You can also use other collage material at any time during the process. Consider the representation of the objects in relation to the arrangement of collaged shapes on the surface; they should work together sympathetically.

Overleaf: Synthetic Cubist drawing

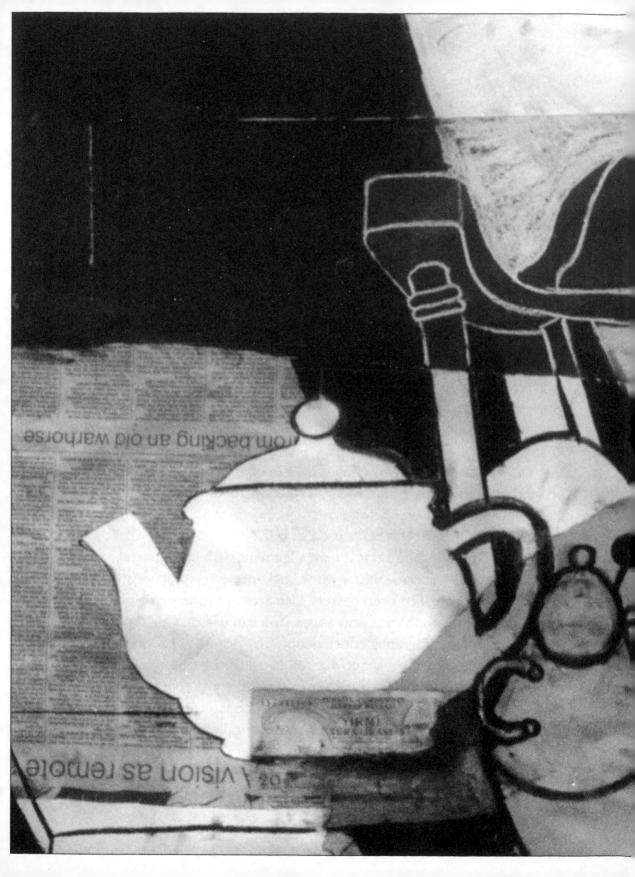

THE PICTURE PLANE

PROJECT 2 ANALYTIC CUBIST PICTURE

One three-hour drawing **Materials:** five sheets of 22- x 30-in paper; black, white, and sienna pastels; plastic eraser; scissors; glue

Set up a still life as in the previous project. Now move around the setup and draw the objects and their details in a range of nonperspective projection systems. Use the sienna pastel for this. Once you have filled four sheets of paper, cut the drawings into rectangular and circular shapes (or their sections).

Stick some of these shapes onto the remaining sheet of cartridge paper. Now smudge the drawing surface so that the sienna pastel creates a cloud over it. Using the drawn lines and the edges of the cut-out shapes, extend lines to overlap and connect with other fragments. To do this, you can introduce the other colored pastels. Resist the urge to draw lines to bound the collage fragments. Apart from the occasional detail in the drawn objects, there should be no shape enclosures. Tone can be applied to the line edges to create emphasis. You can also create tonal rhythms and patterns on the surface, bringing the fragments together.

PROJECT 3

PLAYING WITH THE PICTURE PLANE

One four-hour drawing **Materials:** 22- x 30-in paper, a range of pencils, plastic eraser

To transfer an image from one sheet of paper to another with some degree of accuracy, you can use Ptolemy's rectilinear grid as an aid. If the sheet is bent back to make a cylinder you would just need to know how the grid was transformed by the form in order to plot the

Playing with the picture plane-gridding the image

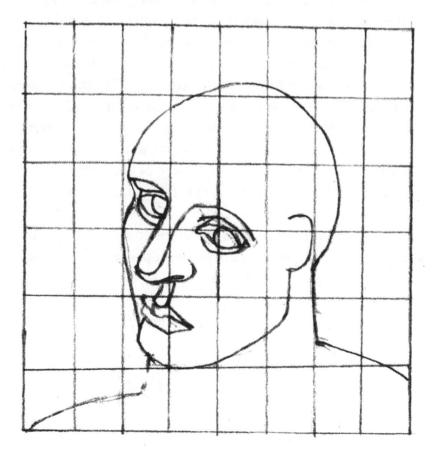

image on a cylinder. In the following exercises you are going to place an image in a perspective space on a plane twisted back into space and on a cylinder.

Select a photographic image or images that are clear and simple. The easiest to work with are those with a strong, simple design. Draw a regular rectilinear grid over the image. Now set up on the paper a two-point perspective grid. Plot, measure, and draw the plane of the image back into the space. You can try it in different positions on the grid. Divide the plane by the "Union Jack" method (see "Linear Perspective," Project 2, page 353) into the same divisions as the gridded photo. Now transfer the features in each unit of the photograph onto the gridded plane and complete the picture.

Follow the same procedure for a cylinder. Using the method for drawing the ellipse given in Chapter 5, "Sciagraphy" (page 382), you can break the ellipse into equal divisions to use as the divisions of the grid. It is harder, but not impossible, to calculate the circumference of the ellipse to match the length of the format of the flat image. Try to approximate it by eye. The verticals of the grid are given by the equal divisions of the ellipse at its circumference. The horizontals are a series of ellipse cross sections evenly spaced up the cylinder. These can be accurately measured on the central axis of the cylinder. The center of each ellipse will be on this axis. Once you have a grid on the cylinder, you can plot the image. The same procedure can be followed for a sphere.

Finally, set up a number of forms (three or four) in perspective and make a composition of different images wrapped around these forms. You can create perspective grids around these forms. If they are cropped by the format of the drawing surface so that only a section of the surface of a form can be seen, you can imagine that the picture plane itself is formed.

Play around with these notions, creating different grids on forms and planes and plotting out different images and spaces.

Right: An image plotted on a sphere and a cylinder

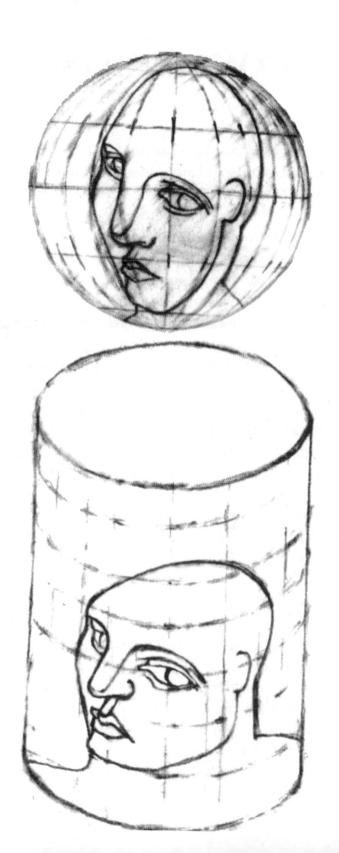

CONCLUSION

he art critic Bernard Berenson accused Piero della Francesca (1420-92) of not always availing himself "of his highest gifts" because of being "clogged by his science." This seems somewhat unfair criticism when leveled at an artist like della Francesca, but there is a lesson in it. You should use the information in this section only as an aid in expressing your ideas, observations, and emotions. Do not allow yourself to become "clogged" by the science of projection systems. These systems are there to be used and enjoyed when necessary; do not anguish over them.

Finally, it is worth noting that the picture plane is an invisible presence in every drawing, and the image created has a particular relationship to the picture plane/support. There are four possible relationships between image and support, and they can be understood by four readings of the accompanying doodle: a tunnel; a telescope; a target; three concentric rings.

The first reading is a view. The tunnel lies "behind" the picture plane. Most, but not all, perspective images claim this territory. The second is a specimen. The telescope is "above" the invisible plane. Drawings of single objects for sculpture or design are of this kind. The third, a target, has the image and support as one. Playing cards, flags, and hieroglyphics are in this category. The fourth category is conceptual and carries the other three. Cubist space, and whatever else does not fit into the other three categories, fall into this one. To use this book well, you must use it advisedly. What is the most appropriate system to use in a drawing to realize its meaning? Perspective or trimetric? Specimen or view? The answer depends on what you wish to describe.